The Art of
Pastel

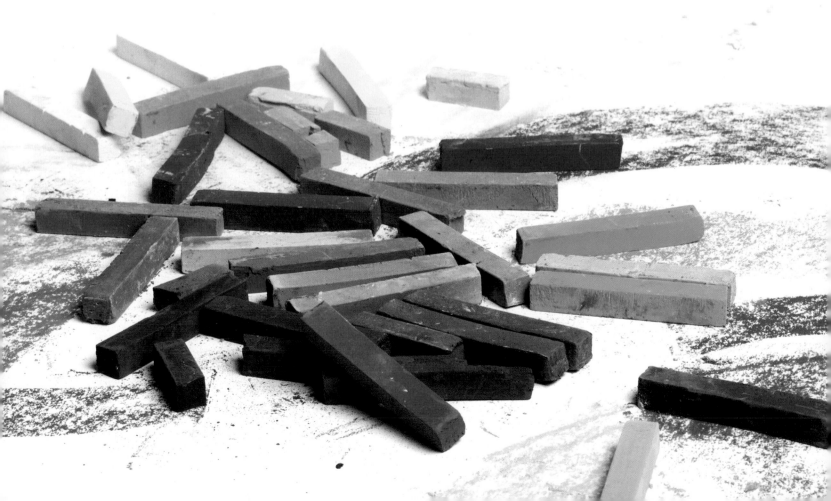

10 9 8 7 6 5 4 3 2

The Art of
Pastel

with William Schneider, Marla Baggetta, and Nathan Rohlander

Designed by Shelley Baugh

Project Editor: Rebecca J. Razo

Production Artist: Debbie Aiken

Walter Foster Publishing, Inc.

3 Wrigley, Suite A

Irvine, CA 92618

www.walterfoster.com

INTRODUCTION TO

The Art of Pastel

The velvety strokes of pastel have enchanted artists for more than a century. From airy strokes and swift, bold marks to soft hues and vibrant shapes, the versatility of pastel makes this medium suitable for a wide range of subjects and moods. A comprehensive guide filled with easy-to-follow step-by-step demonstrations, *The Art of Pastel* features three accomplished artists who offer their unique insights and methods of instruction for using soft, hard, and oil pastel to create beautiful portraits, rich landscapes, colorful floral scenes, and many other works designed to appeal to a variety of artistic sensibilities. In this book, you will also learn about color theory, as well as how to choose pastels, work with supports, store and display your work, set up your studio, and create various textures using several different techniques. Discover just how fun and rewarding working in pastel can be!

Tools and Materials

You don't need many supplies to begin painting in pastel; unlike oil or acrylic paints, pastels don't require additives or brushes. All you really need to get started is a set of pastels and a variety of papers (or *supports*). Then just add a few additional tools and materials described on these pages, and you'll be ready! (For oil pastel materials, see page 92.)

PURCHASING SOFT PASTELS

Pastels are available in several forms, including oil pastels; hard, clay-based pastel sticks; pastel pencils; and soft pastels, which are chalklike sticks. Soft pastels produce a beautiful, velvety texture and are easy to blend with your fingers or a cloth. When purchasing pastels, keep in mind that pastel colors are mixed on the paper as you paint, rather than premixed on a palette. (See page 9.) It is helpful to buy a wide range of colors in various *values*—lights, mediums, and darks—so you will always have the color you want readily at hand.

APPLYING FIXATIVE

Because soft pastels have less binder than hard pastels, they crumble easily, and your finished work can be smudged. Many artists use some type of spray-on sealer or fixative to set their work and prevent it from smearing. (See the demonstration at right.) Some artists don't fix their paintings because they don't like the way the varnish affects the quality of the pastel. Instead they preserve the artwork by keeping the layers of pastel very thin as they paint. Then they tap the support several times so that the excess pigment falls off. To preserve your painting, you may want to have it double-matted and framed under UV light-protected glass. A pastel painting that's properly mounted on archival paper will last for centuries.

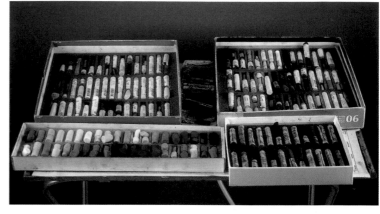

Picking Soft Pastels Here is a basic set (shown above) that consists of an assortment of 90 medium soft pastels, another assortment of 40 very soft half-sticks, and a set of 24 deep darks. If you've never worked in soft pastel, you might want to invest in a 45- or 60-stick set created specifically for beginners. Look for a set that has a wide range of reds, blues, and yellows. If you prefer to buy individual colors, start with black, white, and four values (3, 5, 7, and 9) of permanent red, ultramarine blue deep, and cadmium yellow light (See page 9 for a description of the numbering system.) You can create additional tones by layering and blending these basics, and you can always add more colors later as you develop your own style and preferred palette of colors.

Fixing, Stage One To determine whether the fixative you have will adversely affect the colors, test it first by laying down a thick layer of pigment on a piece of pastel paper.

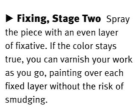

▶ **Fixing, Stage Two** Spray the piece with an even layer of fixative. If the color stays true, you can varnish your work as you go, painting over each fixed layer without the risk of smudging.

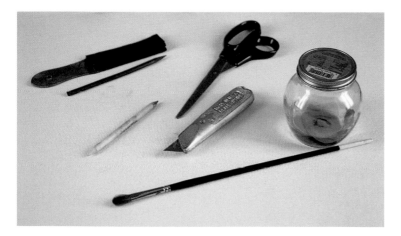

Gathering Extras There are other tools that will help you as you paint, such as scissors to trim supports; vine charcoal to lay out designs (it's easy to erase and can be painted over with pastel); a sandpaper block as a sharpener; a paper stump for blending; and a razor blade to break the pastels cleanly. You can also paint over your work with denatured alcohol on a soft brush to wash the color thoroughly into the paper.

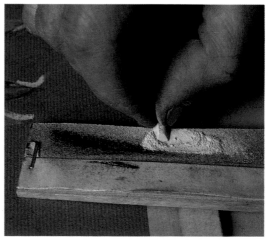

Sharpening Pastels A sandpaper block is a good sharpening tool for both charcoal and pastel. You can also hone pastels with a razor blade, but rubbing the stick gently across sandpaper or another rough-grained surface is a safer way to form a point or chiseled edge.

CHOOSING SUPPORTS

The texture and color of the support you choose will affect your
pastel painting. Because of the delicate nature of soft pastels, you
need a paper that has some *tooth,* or grain, for the pigment to
stick to. A rough support, such as sanded paper (made especially
for pastel application), will "break up" the applied strokes and
create texture. A smooth surface, such as pastel or watercolor
paper, will make the unbroken colors appear more intense. Pastel
supports are also available in a variety of colors; you can choose
a color that offers a contrasting background tone or one that is in
the same color range as your subject. (For more on using colored
supports, see the examples below right and on page 28.)

Using Textured Grounds Rough
papers are perfect for creating textured
effects—the rougher the paper, the more
it will break up the color. Rough-grained
supports can also help convey the look of
foliage, stucco, or fur.

Painting on Smooth Paper Smoother
papers are wonderful choices for render-
ing detailed work and soft blends. The
smooth side of pastel paper actually holds
more pigment than the rough side.

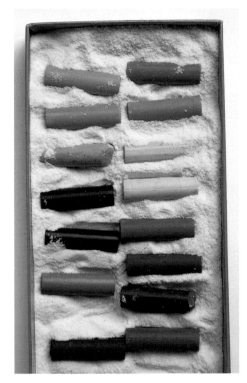

Keeping Pastels Clean The powdery texture of
pastels can make them messy to handle and store, but
you can avoid this problem by storing your soft pastels
in raw rice.

▶ **Working with Colored
Supports** Here you can
see how the color of the
paper affects the same flower
image. On the beige paper,
the dark center has the great-
est visual impact; on the gray
paper, the green stem has
less strength; and on the
black paper, the contrasts
are very striking.

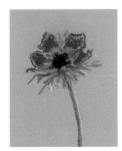
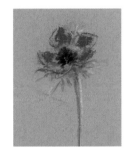

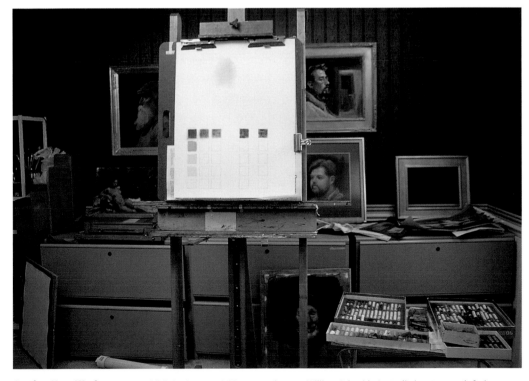

Storing Your Work To protect your finished artwork
from smudging or smearing, always store your pastel
paintings between a board and a cover sheet. You can
purchase artist's tissue paper by the roll and cut it to
fit your painting; then affix the paper to the back of the
support with low-tack artist's tape.

Setting Up a Workspace Good lighting is essential in any workspace. William Schneider's studio has two north-facing
windows that provide constant, cool light. Directly above each window is a large fluorescent floor-lamp with color-corrected
bulbs. William works on a large, studio easel on rollers that can easily be moved. He also built an 18-inch high platform (on
rollers) for models, so he can see them at eye level while he paints. He keeps the pastels in their original boxes, sorted by
color and value, and he always returns each pastel to its original slot to prevent them from getting lost. Lastly, William keeps
a large mirror mounted on another easel nearby. He frequently examines his work in the mirror while he paints; the reflection
offers another viewpoint to check for inaccuracies.

Introducing Color Theory

There are a few basic terms and concepts to know about color theory. The *primary* colors (traditionally red, yellow, and blue) are the three basic colors that can't be created by mixing other colors; all other colors are derived from these three. *Secondary* colors are each a combination of two primary colors, and *tertiary* colors are a combination of a primary color and a secondary color. *Complementary* colors are any two directly across from each other on the color wheel, as shown at right, and the term *hue* refers to the color itself.

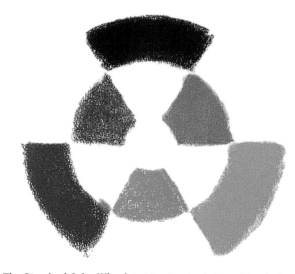

The Standard Color Wheel In this color wheel, the traditional primary colors of red, yellow, and blue are shown on the outer ring. The inner ring illustrates the traditional secondary colors: orange, green, and purple. In this system, you can see that the complementary colors are red and green, yellow and purple, and blue and orange.

USING THE MUNSELL COLOR SYSTEM

The Munsell Color System is a variation of the traditional color wheel. In the Munsell system, purple and green are also treated as primary colors, which shifts the placement of blue and yellow on the color wheel (below right). This in turn creates different complementary colors. For example, on the traditional wheel, the complement of red is green; in the Munsell system, the complement of red is blue-green. The difference between the two systems is subtle but important; when you mix complements in the traditional system, you don't get true neutral grays—for example, red mixed with green produces a warm, brownish gray. But if you mix red and blue-green, you get a truer, more neutral gray.

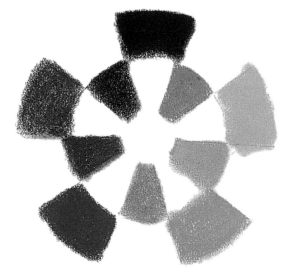

The Munsell Color Wheel On the Munsell color wheel, the primary colors are also on the outer ring and the secondaries are again in the inner ring. But with green and purple as additional primaries, the complementary pairs in this system are red and blue-green, yellow and blue-purple, green and red-purple, blue and orange, and purple and yellow-green.

UNDERSTANDING COLOR "TEMPERATURE"

We often refer to colors in terms of temperature, meaning they convey a sense of warmth or coolness. In general, reds, yellow, and oranges are considered warm; blues, greens, and purples are considered cool. But there are also cool and warm variations of every hue. For example, a red with more yellow in it would be a warm red, and a red with more blue in it would be a cool red. Consequently, your painting will impart an overall feeling of warmth or coolness depending on which colors dominate.

▶ **Applying the Concept of Color "Temperature"** In practice, colors are perceived of as warm or cool only in relation to one another. Here, a square of the same red is painted on different backgrounds. Next to a cool blue, the red appears warm. Against red-violet, it also appears warm, but with much less temperature contrast. When placed on red-orange, the red seems cooler, and next to a warm orange background it appears quite cool. When painting, always view each area in terms of the temperature of the colors around it.

▶ **Working with Gray** Many artists use grays as the base for their color harmonies. While you can buy gray sticks, a better approach is to blend and layer various hues to create your own grays. In the example at near right, cobalt blue is blended with its complement (orange) and some white. If you look closely, you'll notice that this mixture produces a range of warm and cool grays as well as a true neutral gray. Next, cobalt blue is blended with yellow-green and white, followed by cobalt blue with red-purple and white. Although these other two mixtures don't result in the creation of true grays, they do create a range of neutral gray tones.

UNDERSTANDING VALUE

Pastel manufacturers produce each hue in a variety of full-strength colors. They also make a wide range of dark and light values by adding black (creating a *shade*) or white (creating a *tint*) to the pure color. And most manufacturers label their pastels using a numbering system to identify the strength of each color. Unfortunately these numbering systems are not standardized among brands. With some pastels, a value of 5 indicates the pure color. A value of 3 or 1 indicates a darker value of the hue, and a value of 7 or 8 indicates that some white has been added to the pure pigment to create a lighter value. The higher the number above 5, the lighter the value. A value of 12 is almost completely white. When you purchase pastels, it's a good idea to create a labeled chart like the one at right to help you identify the various pastels you have at your disposal.

MIXING COLORS

Although it is more convenient to have a wide range of colors and values in your pastel set, you can mix additional colors directly on your support by layering and blending your soft pastels. The chart at the bottom of the page demonstrates various ways you can mix colors on your paper. You can blend the strokes thoroughly to create a solid area of smooth color, or you can leave visible strokes of various hues if you want more texture.

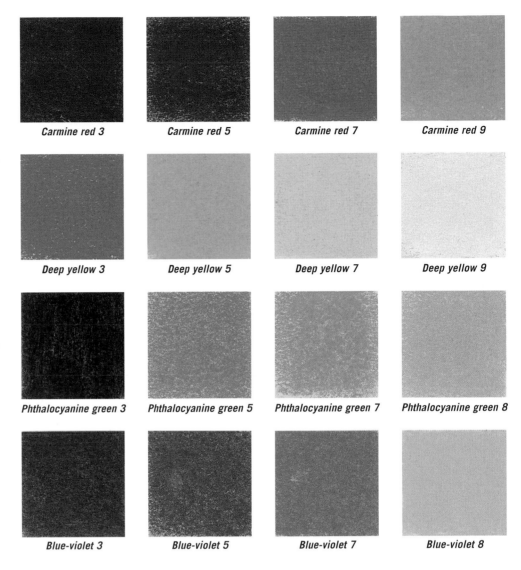

Carmine red 3 Carmine red 5 Carmine red 7 Carmine red 9

Deep yellow 3 Deep yellow 5 Deep yellow 7 Deep yellow 9

Phthalocyanine green 3 Phthalocyanine green 5 Phthalocyanine green 7 Phthalocyanine green 8

Blue-violet 3 Blue-violet 5 Blue-violet 7 Blue-violet 8

Purchasing a Variety of Values You can buy just about any value you'd want, but it's easy to get carried away. However, you can keep expenses to a minimum by starting out with just 4 basic values. This chart shows four different values of four different colors. To substitute for the values you don't have, you can always blend in a little white to create a lighter value (creating a tint) or a touch of black (creating a shade) to give yourself more options.

Smooth Blend Here side strokes of yellow are layered smoothly over blue to create a bright green, which has more life and interest than a manufactured green.

Unblended Strokes Choppy, unblended strokes of yellow and blue create the impression of green. Instead of blending the colors on the paper, the eye visually mixes them.

Three Color Mixes Here strokes of lavender and turquoise are layered over blue. This creates a richer color than does a mix of just two colors.

Pastel Techniques

Unlike painting with a brush, working with pastel allows you to make direct contact with the support. Therefore you have much more control over the strokes you make, the way you blend the pigment, and the final effects. Once you learn and practice the techniques shown here, you'll know which ones will give you the results you desire.

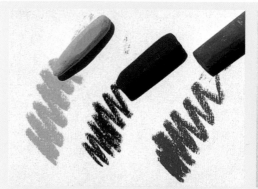

Firm Strokes Use the ends of the pastel sticks to create thick, bold strokes. The more pressure you apply, the thicker the stroke will be. These strokes are ideal for rendering large textured areas, such as fields of grass.

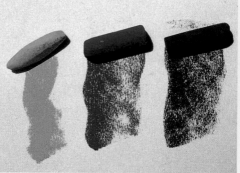

Side Strokes To quickly cover the support and fill in areas of broad color, drag the side of the stick across the support. This technique is effective for creating skies, water, and underpaintings.

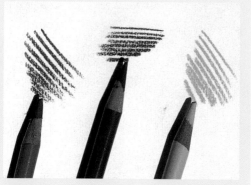

Pencil Lines Pastel pencils offer the most line control, as they are less likely to crumble or break than other types of pastel. If sharp, they can produce a very fine line, which is ideal for creating details or textures, such as fur or hair.

EXPERIMENTING WITH STROKES

The way you hold and manipulate the pastel stick or pencil will directly affect the resulting stroke. Some grips will give you more control than others, making them better for detail work; some will allow you to apply more pigment to the support to create broad coverage. The pressure you exert will affect the intensity of the color and the weight of the line you create. Experiment with each of the grips described below to discover which are most comfortable and effective for you.

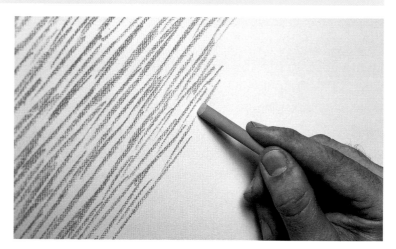

Linear Strokes To create linear strokes, grip the pastel stick toward the back end, and use your thumb and index finger to control the strokes. This grip is ideal for creating fine lines and details; however, it offers less control than the other grips.

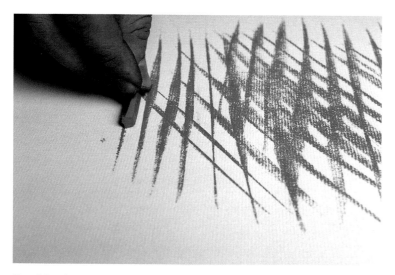

Broad Strokes Place the pastel flat on the paper and slide it back and forth to create broad linear strokes. This grip is also useful to create a "wash"; use the length of the pastel to cover large areas and create backgrounds quickly.

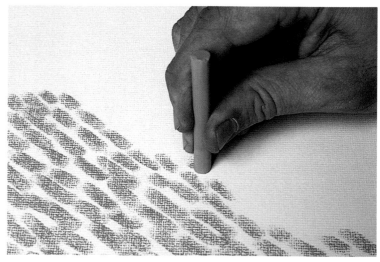

Round Strokes Turn the pastel stick on its end and grip it toward the front to create short, rounded strokes. This grip is perfect for creating texture quickly in large areas. Try overlapping the rounded strokes to create a denser texture.

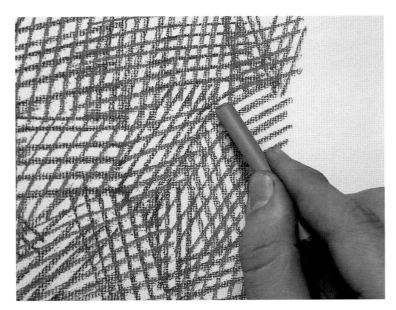

Crosshatching Hatched strokes are a series of parallel lines; crosshatched strokes are simply hatched lines layered over one another, but in opposite directions. You can cross-hatch strokes of the same color to create texture or use several different colors to create an interesting blend.

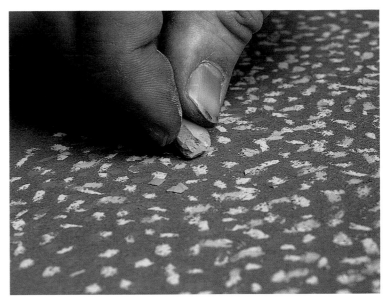

Pointillism Another way to build up color for backgrounds or other large areas of color is to use a series of dots, a technique called "pointillism." This technique creates a rougher, more textured blend. When viewed from a distance, the dots appear to merge, creating one color.

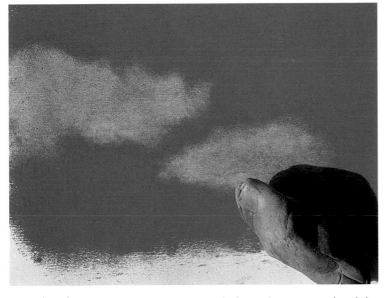

Removing Pigment When you need to remove color from a given area, use a kneaded eraser to pick up the pigment. The more pressure you apply, the more pigment will be removed. Keep stretching and kneading the eraser to expose clean, new surfaces.

Creating Patterns To create textures or patterns when rendering fabric or clothing, first lay down a solid layer of color using the side of the pastel stick or pencil. Then use the point of a pastel pencil to draw a pattern, using several different colors if you wish.

Using Tape You can create straight, even edges by using house painter's tape. Just apply it to your support, and make sure the edges are pressed down securely. Apply the pastel as you desire, and then peel off the tape to reveal the straight edges.

Gradating on a Textured Support Creating a smooth, even gradation on a textured ground can be a little tricky. Add the colors one at a time, applying the length of the stick and letting it skip over the texture of the paper by using light pressure.

Glazing Create a "glaze" just as you might with water-color by layering one color over another. Use the length of the pastel stick with light pressure to skim over the paper lightly. The result is a new hue—a smooth blend of the two colors.

BLENDING PASTELS

There are a number of ways to blend pastel, and the method you use depends on the effect you want to achieve and the size of the area you're blending. Smooth, even blends are easy to achieve with a brush, a rag, or even your fingers. You can also use your finger or a paper blending stump to soften fine lines and details. Still another method is to place two or more colors next to each other on the support and allow the eye to visually blend them together.

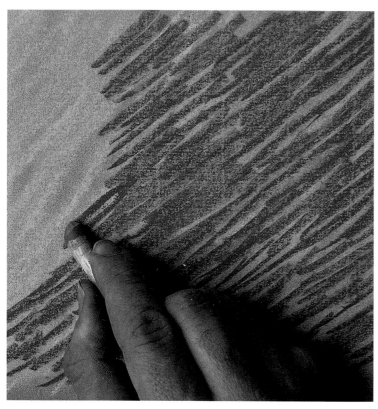

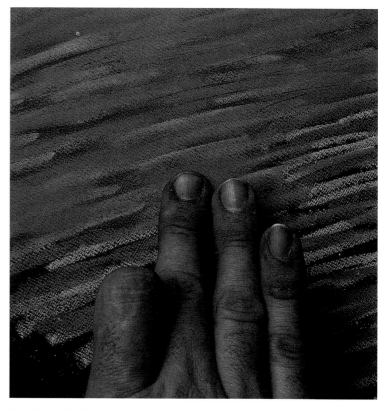

Applying Unblended Strokes In this example, magenta is layered loosely over a yellow background. The strokes are not blended together, and yet from a distance the color appears orange—a mix of the two colors.

Blending with Fingers Using your fingers or the side of your hand to blend gives you the softest blend and the most control, but be sure to wipe your hands after each stroke so you don't muddy your work. Or use rubber gloves to keep your hands clean.

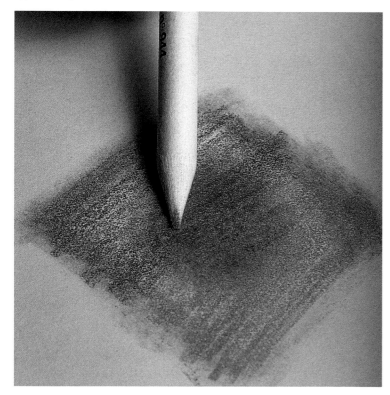

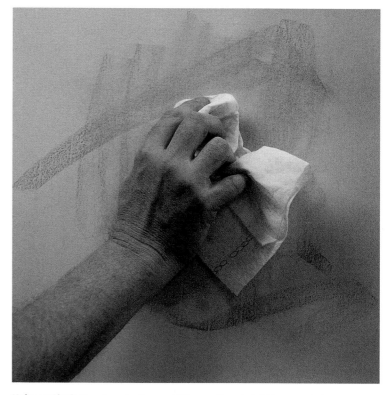

Blending with a Tortillon For blending small areas, some artists use a paper blending stump, or tortillon. Use the point to soften details and to reach areas that require precise attention.

Using a Cloth For a large background, it is sometimes helpful to use a cloth or a paper towel to blend the colors. To lighten an area, remove the powdery excess pastel by wiping it off with a soft paper towel.

MASKING

The dusty nature of pastel makes it difficult to create clean, hard edges; but employing a simple masking technique is a great way to produce sharp edges. To mask, use a piece of paper or tape to create a straight edge (see page 11), or create a clean-edged shape with a special mask you make yourself. Of course, you would use tape only to save the white of the paper; never apply it to a support that already has pigment on it.

Cutting the Shape Begin by drawing the shape on a piece of tracing paper and cutting it out.

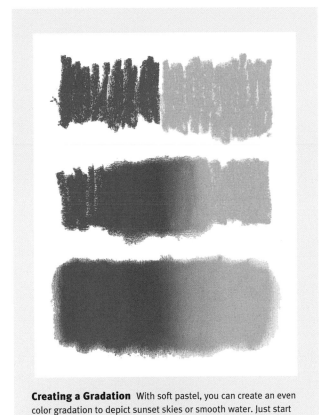

Creating a Gradation With soft pastel, you can create an even color gradation to depict sunset skies or smooth water. Just start with two spots of color, and then blend the area where they meet.

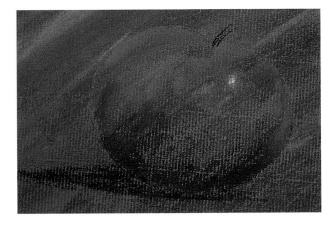

Applying the Color After painting the background, place the mask on top and then apply color.

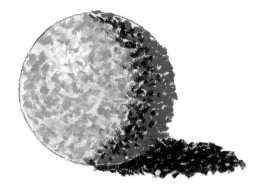

Removing the Mask Carefully peel away the mask to reveal the crisp shape underneath.

USING A COMBINATION OF TECHNIQUES

These techniques are useful in and of themselves, but you won't truly understand the effects you can achieve until you apply them to an actual subject. Here you can see how the same subject is rendered using three different methods; notice the different look of each.

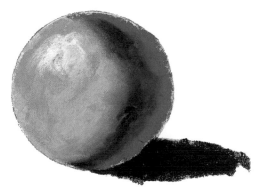

Blending Here the colors were applied thickly and smoothly. The even layers of color create the appearance of a slick, smooth object.

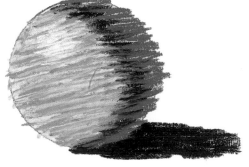

Linear Strokes Linear strokes are layered over one another to create a more textured appearance. From a distance, the colors still appear to blend together.

Pointillism Pointillism is used to create the form of the sphere. Although the same colors are used, the surface of the object appears much rougher.

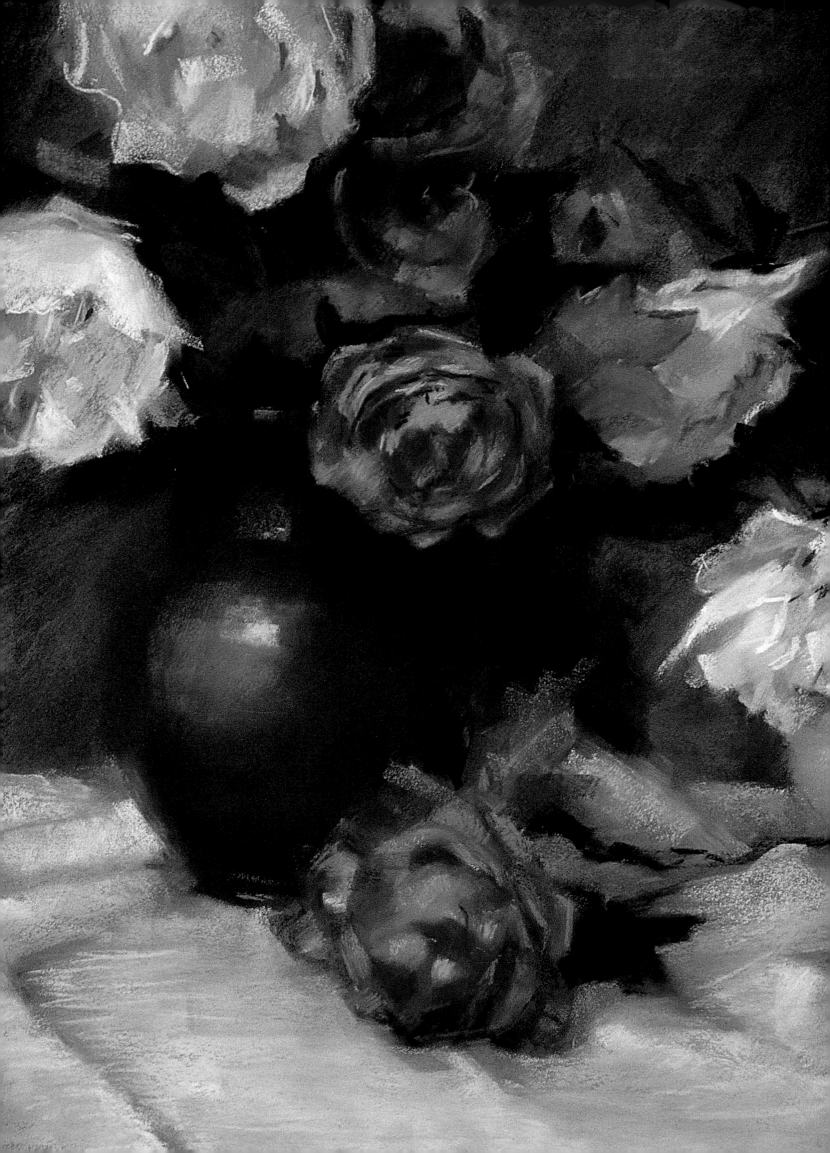

Pastel
WITH WILLIAM SCHNEIDER

Pastel is a fascinating and versatile medium that is a joy to work with. The colors can be rich and vibrant or soft and subdued, and you can create many interesting and varied textures. There are no colors to mix or thinners to use, and the fact that it's dry makes it a wonderful medium for traveling and painting outdoors. Most important, pastel allows for a variety of blending and layering techniques that are virtually impossible with any other medium. In this chapter, I'll share my methods for painting a number of pastel subjects—from sketches to finishing touches. And I'll explain my approach and techniques with simple, step-by-step lessons to give you a new appreciation of this wonderful art form. I hope you will be inspired to explore the many creative possibilities that pastel has to offer!

Planning a Composition

A successful painting has both an appealing subject and an appealing composition. *Composition* refers to the way objects are placed in a painting and how they relate to one another. The elements in a good composition are grouped into a balanced unit, and there is a distinct center of interest, or *focal point*. A strong composition comprises interesting colors, shapes, and lines, which lead the viewer's eye through the painting and toward the focal point. Here I arranged the onions to create a visual path toward the white carafe, which is placed off-center. The onion peel on the far left counterbalances the forms on the right, whereas the peel on the far right acts as a "stopper," preventing the eye from wandering off the paper and keeping the focus on the onions and carafe.

Conveying a Concept

Although beginning artists often believe the intent of a painting is to depict objects as accurately as possible, more advanced artists use objects to convey an abstract idea or concept. The objects in this still life are not as important as what the composition itself communicates. What matters is creating the sense movement of light from left to right; therefore, I make the nonessential elements—the table and background—very dark. I also place the onions so they lead the eye to the center of interest. This way the onions are brighter the closer they are to the light, naturally drawing the eye in the same direction.

Step One The tone is dark, so I paint the background with layers of black, carmine brown 2, and purple 3, blending well with my hand. I paint the table with burnt sienna 3 and yellow ochre 3, working these colors into the tooth of the paper with the side of my hand. I apply a strip of black and carmine brown 2 to indicate the space beneath the tabletop.

Step Two Next I paint the highlight on the carafe with phthalocyanine ("phthalo") blue 9. I block in the carafe with blue-gray 7 and chrome green 7 for the light side and mouse gray 5 for the shadow side. This establishes the destination for the movement of light. I block in the foremost onion with ultramarine blue 3, burnt sienna 5, and phthalo green 5.

Starting with a Drawing I start by placing the center of interest about a third of the way from the right. Using a centerline to keep my drawing straight, I sketch the shape of the carafe with vine charcoal. Then I outline the onions and peels. At this stage, I draw the onions as a single mass—I'll separate them later as I paint.

Step Three Now I block in the rest of the onions. I use raw umber 3 and carmine 3 for the shadow sides and raw sienna 3 and 5 for the light sides. I anchor the onions to the tabletop with accents of carmine brown 2, and I use brown ochre 3 for the reflections. Then I draw in the shapes of the peels with raw sienna 3. Next I blend my strokes with the side of my finger to keep my rendering soft.

MASKING

The dusty nature of pastel makes it difficult to create clean, hard edges; but employing a simple masking technique is a great way to produce sharp edges. To mask, use a piece of paper or tape to create a straight edge (see page 11), or create a clean-edged shape with a special mask you make yourself. Of course, you would use tape only to save the white of the paper; never apply it to a support that already has pigment on it.

Cutting the Shape
Begin by drawing the shape on a piece of tracing paper and cutting it out.

Applying the Color
After painting the background, place the mask on top and then apply color.

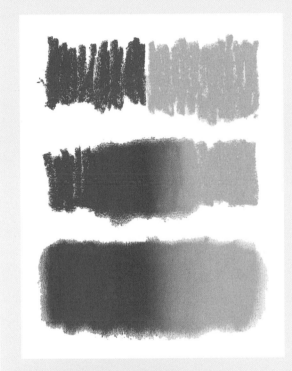

Creating a Gradation With soft pastel, you can create an even color gradation to depict sunset skies or smooth water. Just start with two spots of color, and then blend the area where they meet.

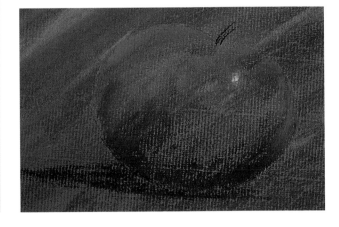

Removing the Mask
Carefully peel away the mask to reveal the crisp shape underneath.

USING A COMBINATION OF TECHNIQUES

These techniques are useful in and of themselves, but you won't truly understand the effects you can achieve until you apply them to an actual subject. Here you can see how the same subject is rendered using three different methods; notice the different look of each.

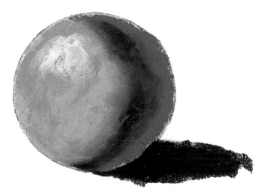

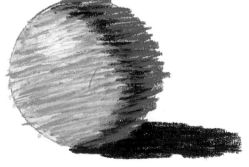

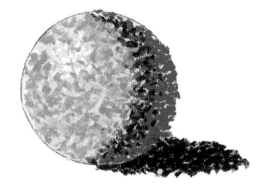

Blending Here the colors were applied thickly and smoothly. The even layers of color create the appearance of a slick, smooth object.

Linear Strokes Linear strokes are layered over one another to create a more textured appearance. From a distance, the colors still appear to blend together.

Pointillism Pointillism is used to create the form of the sphere. Although the same colors are used, the surface of the object appears much rougher.

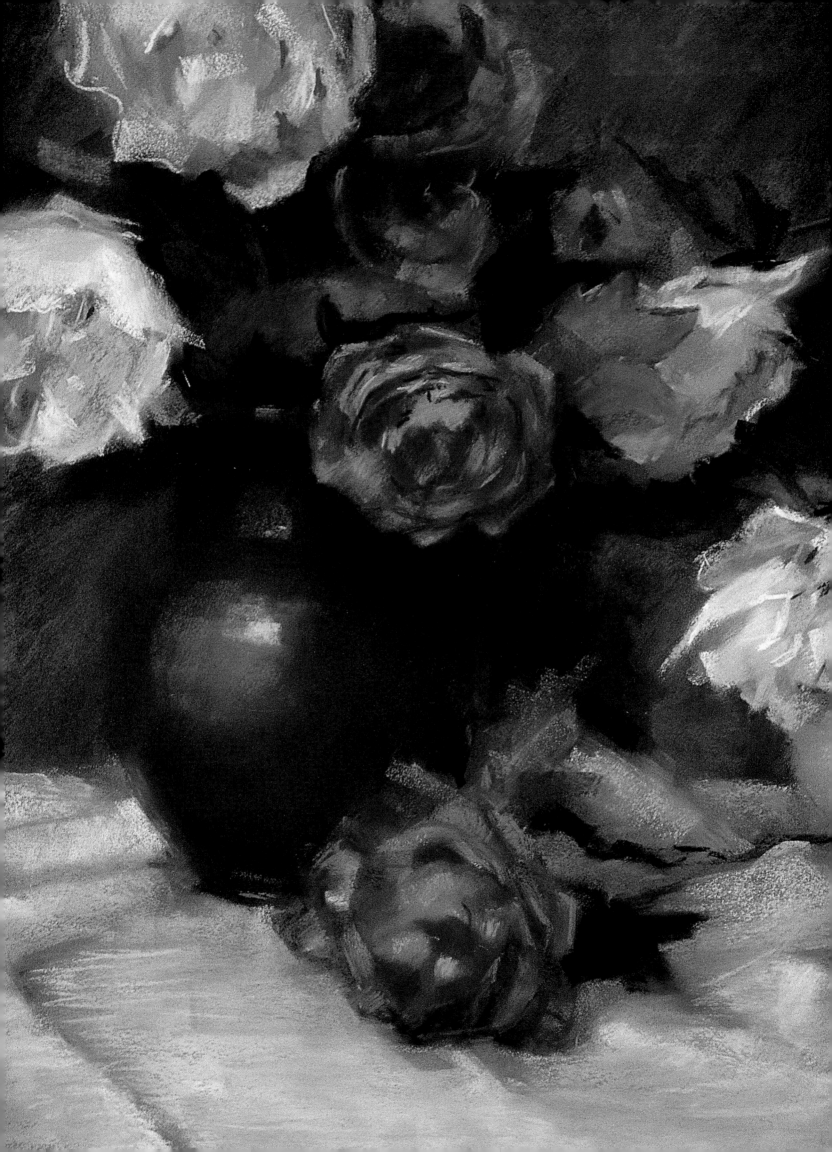

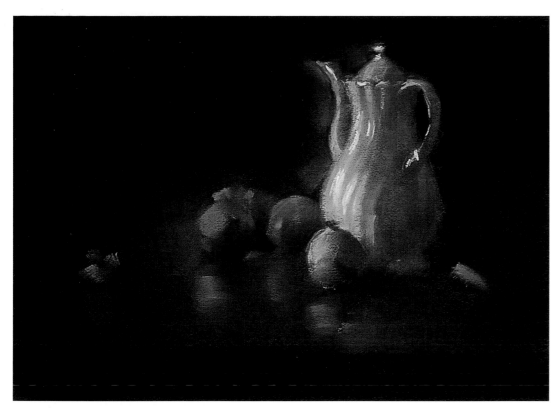

Step Four I blend vermilion 5, orange 3, and purple 5 into the area around the carafe and add some permanent red dark 5 above the onion closest to the carafe. I lighten the carafe with chrome green 9 and sharpen the highlights with white. I lighten the other three onions and their reflections with gold ochre 5 and phthalo green 5, and I stroke in some light behind the left onion with violet 5. Next I paint the stem on the foremost onion with madder brown 3 and add highlights on the other onions with red-violet 5 and phthalo green 9. I cool the "halo" around the carafe with blue-violet 5 and ultramarine blue 5, and I use black and carmine brown 2 to blend the background into the halo. I refine the ridges in the carafe with blue-gray 5 and 7. To sharpen the lower edge of the carafe, I apply some bistre 3. Then I warm the light behind the left onion with yellow ochre 5. Next I draw the peel and stem with yellow ochre 3 and indicate the skin with English red light 3 and 5.

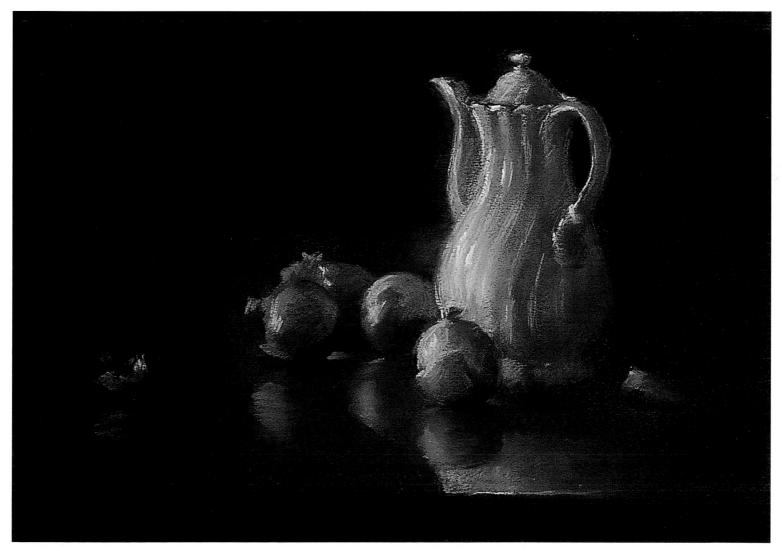

Step Five I refine some of the edges on the carafe with madder brown 2 and brighten some highlights with cobalt blue 7. Then I sharpen some of the dark accents near the onions with burnt sienna 3. I add a final highlight of turquoise blue 9 on the edge of the table so it appears to come forward and establishes the foreground edge. The finished piece conveys the movement of light from right to left.

Creating Depth

One rewarding aspect of painting a landscape is creating the illusion of depth and distance. I use a variety of visual cues to convey a sense of depth, including atmospheric perspective. *Atmospheric perspective* refers to particles in the air—such as moisture and dust—that block out some of the red wavelengths of light, making objects in the distance appear less distinct and cooler in value than those in the foreground. Therefore, I paint the objects closest to me with the most texture, detail, and intense colors, and I use increasingly less detail and more muted colors for the objects that are farther away. I also suggest depth by overlapping objects and painting nearer objects larger than those in the distance. In this rural landscape, I emphasized the texture and size of the warm and brightly colored hay bale and stubble in the foreground, overlapped the trees in the middle ground and background, and blurred the edges and smoothed the forms of the cool and distant fields, trees, and sky.

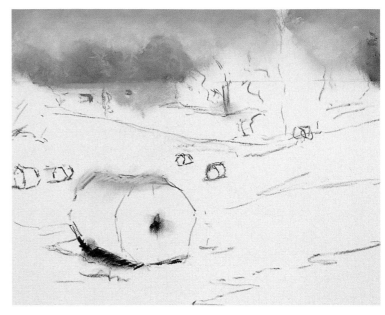

Step One I lay out my design with vine charcoal on an off-white sheet of sanded pastel paper. I establish the lightest light (the sunlight on top of the hay bale) with permanent red light 5, deep yellow 7, and orange 9. Next I lay in the darkest dark shadow underneath with Mars violet 5 and black. It's important that the two value extremes are in the foreground to help create the sense that this area is closest to the viewer. Now I work from the back to the front, overlapping objects as I go. I lay in the sky with ultramarine blue 5, cobalt blue 7, and phthalo blue 9. Where the sky lightens near the horizon, I work in deep yellow 9, red-violet light 8, and permanent rose 10, blending these colors with the side of my hand. Then I use blue-gray 7, blue-violet 5, and olive green 8 for the distant row of trees, blending the strokes with my palm.

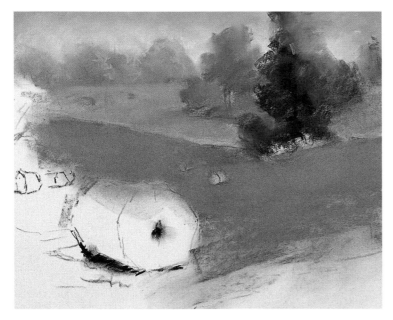

Step Two Working my way forward and blending virtually every stroke, I paint the distant grass with olive green 5, phthalo green 7, and red-violet deep 5. Remember that the atmosphere cools and grays things in the distance—the red-violet I use cools and neutralizes the greens. For the middle trees, I use red-violet deep 5, olive green 5, blue-green 5, and gray 5. The two trees closest to the viewer are blocked in with red-violet deep 3 and blue-green 3, while their dark shadows are bistre 3. For the red of the field, I use burnt sienna 5, red-violet 5, and gray 8.

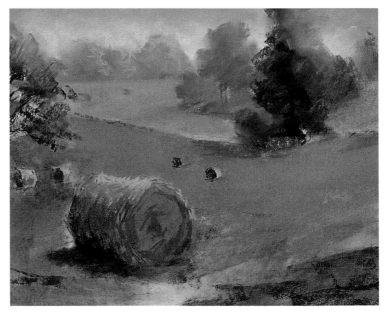

Step Three Next I paint the middle-tree shadows with red-violet 5 and blue-violet 3. The shadows on the smaller hay bales are olive green 5 and burnt sienna 5. The shadowed side of the foreground bale is olive green 3, light oxide red 3, and orange 3. Then I render the end of the bale with caput mortuum red 7, permanent red light 5, and gold ochre 5, blending these strokes less so the details are sharper. I establish a base tone for the foreground with scarlet 5 and burnt sienna 5, and I use caput mortuum red 3 and red-violet 3 for the shadow on the near right. Then I paint the left tree with chrome green deep 3, olive green 5, and deep yellow 5.

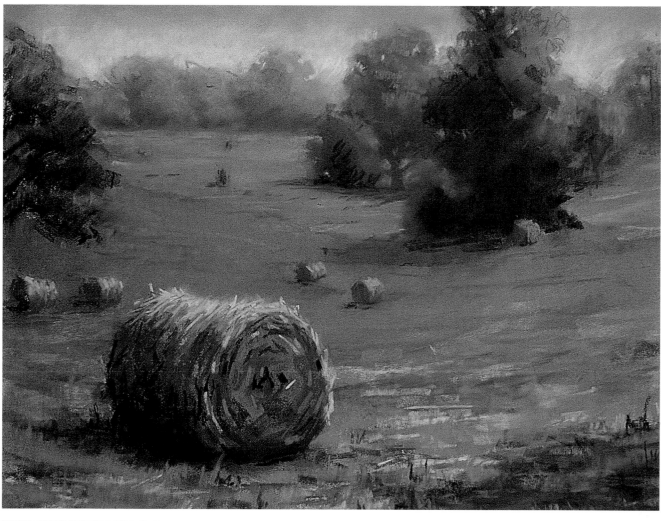

Step Six To finish, I add a number of unblended strokes to the foreground to give the area the most texture and detail. I place some gold ochre 9 highlights to indicate the pieces of mown hay on the ground. Then I work some burnt sienna 5 to suggest the ground in the spaces between the shadowed grass patches. For the hay bale and grass highlights, I use chrome green 10 and deep yellow 5 and 7. Finally I add a few more dark strokes in the hay bale with raw umber 3.

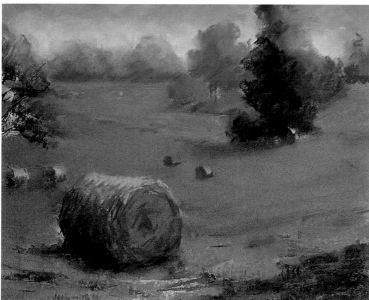

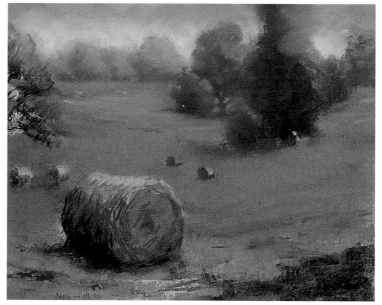

Step Four I gray the field slightly with blue-gray 7 to contrast with the foreground hay bale and make it "pop" forward. Then I paint the foreground grass with chrome green 5 and phthalo green 5. I also use chrome green deep 5 to add some grass into the shadows. Next I work olive green 5 and 8 into the distant fields and overlay strokes of red-violet 7 to create a hazy atmosphere. Then I adjust the distant row of trees with blue-gray 5 and cobalt blue 5, using blue-purple 5 for the shadow areas.

Step Five I add the look of sunlight on the distant trees by applying olive green 8. Then I darken the middle ground trees with ultramarine blue 5 and blue-violet 5 and add the sunlit areas with olive green 8, orange 5, and mouse gray 5. I define the shape of the trunk using olive green 8 by painting the area around it rather than painting the trunk itself. (This is referred to as "painting the *negative spaces*"; the trunk and foliage are the *positive shapes*, and the spaces between and around them are the *negative shapes*.)

Expressing Mood

Color has a tremendous effect on people. Warm colors—such as reds, yellows, and oranges—convey energy and excitement. Cool colors—such as greens, blues, and purples—are more calming. Muted, grayed tones also have a soothing effect. Knowing how colors relate to and interact with one another will help you express emotion in your paintings. In this landscape, I want the viewer to experience the serenity of the fog-shrouded dawn, which I will convey through a toned-down palette. Before I begin painting, I determine what the dominant value and color will be. In this case, the values and colors are subdued by the mist, so the dominant value is a light middle tone, and the dominant color is a muted yellow-red with complementary touches of grayed purple and green.

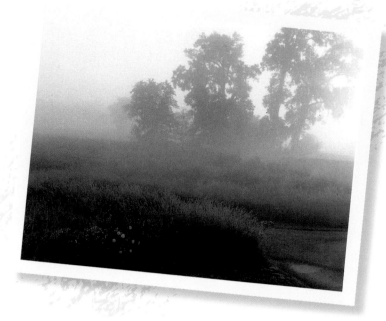

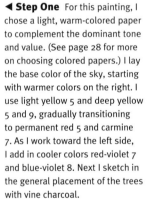

◄ Step One For this painting, I chose a light, warm-colored paper to complement the dominant tone and value. (See page 28 for more on choosing colored papers.) I lay the base color of the sky, starting with warmer colors on the right. I use light yellow 5 and deep yellow 5 and 9, gradually transitioning to permanent red 5 and carmine 7. As I work toward the left side, I add in cooler colors red-violet 7 and blue-violet 8. Next I sketch in the general placement of the trees with vine charcoal.

▲ Taking Photographs If you are unable to paint on site, taking good reference photos is the next best alternative. (For more on painting outdoors, see page 38.) Referring to my photo helped recapture the way I felt when I first saw this sunrise.

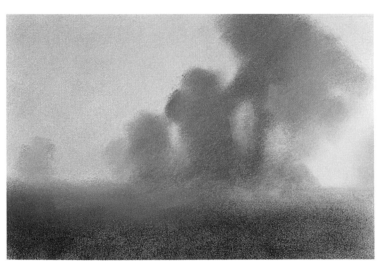

Step Two I block in the general tones for the silhouetted trees, creating a warm-to-cool transition of color and blend virtually every stroke with the side of my hand. I start with orange 5 and chrome green 10 on the right and then move to red-violet 7 and olive green 5 and 8 in the middle. Then I use red-violet 7, blue-violet 5, and olive green 5 on the left side of the tree mass. I establish the cooler, darker mass in the foreground using olive green 3, blue-green 3, burnt sienna 3, and blue-violet 5. Pay attention to the color temperature relationship between light and shadow; in general, a warm light source will cast cool shadows.

Step Three I indicate the trunks of the trees with Indian red 3 and 5. I also paint in the negative spaces in the foliage where the sky is visible using deep yellow 7 and 9. With pastel, it is often easier to create a solid tone for the tree and then paint the negative spaces on top, rather than the other way around. But you need to be careful of the edges; if they're too hard, the sky may seem to pop forward in front of the trees. Keep in mind that these negative spaces appear to be darker than the sky itself.

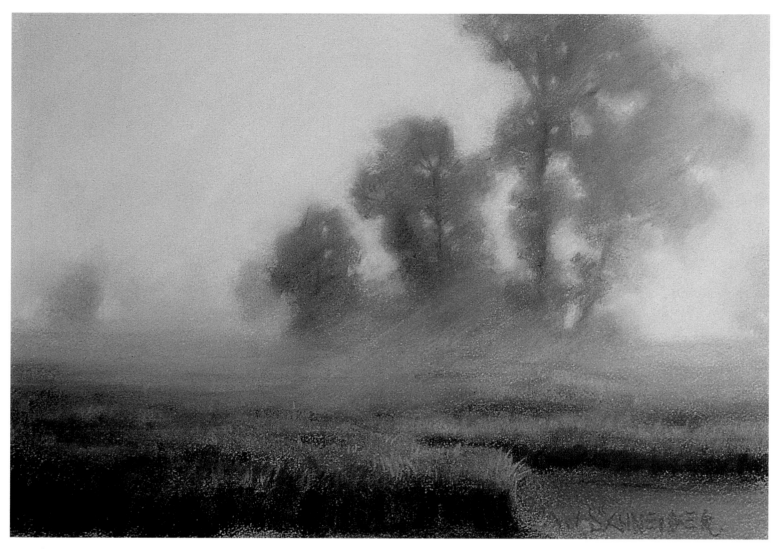

Step Six I sharpen the image a bit to create greater visual impact. To increase the contrast, I lighten the sky on the right with orange 9 and white. I lighten the sky on the left side with a well-blended layer of Mars violet 10. Then I paint in a few smaller sky holes into the trees using English red 7 and deep yellow 7. Next I darken the foreground with bistre 7, burnt sienna 3 and 5, and olive green 3. Finally I add a few sharp strokes of orange 5 and 3 to depict individual grass stalks that are illuminated by the sun.

Step Four I lighten and gray the sky with blue-violet deep 9 and deep yellow 7. Then I drag some yellow deep 5 over the trees to indicate light streaming into the mist. The rich color not only helps create the effect of light, but the diagonal strokes also add little bit of action to the composition. Next I use some well-blended strokes of phthalo green 8 and blue-violet 8 to indicate the middle ground mist on the left side.

Step Five Next I complete the foreground. The darkest values are in the front: red-violet 3, burnt sienna 3, and black. I use a light touch of denatured alcohol and a brush to solidify those darks. Then I indicate some of the grasses with olive green 5 and chrome green 5. I use strokes of burnt sienna 5, caput mortuum red 5, and orange 5 to indicate the tops of the grasses that are bathed in the warm light of the rising sun. The trees have almost no detail; they exist primarily as silhouettes against the sky.

Rendering Light with Value

Light is one of the most fascinating elements in a painting. You can capture the effect of light by using both value and color temperature contrasts, such as placing light and dark values next to each other and pairing warm colors with cool colors. The contrast doesn't have to be dramatic; in fact, if the darkest and lightest colors are closer in value, the painting will seem more realistic. Contrasts in color temperature between the warm, light areas and the cool shadows have great impact. In this outdoor scene, I played up the contrast between the red and yellow light and the blue and green shadows. The warm-colored adobe dwelling appears to be intensely lit both because it is bathed in warm light and because it is placed against cool colors.

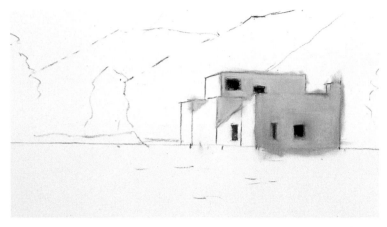

Step One I sketch the scene on off-white, sanded pastel board. (I chose off-white so my lightest values would appear rich and dark against the paper.) Next I paint the lightest value—the sunlit adobe walls—with a blend of permanent red 5, orange 5, and gold ochre 7. Then I paint the darkest value—the window—with a combination of bistre 3, carmine brown 2, and gray-green 3.

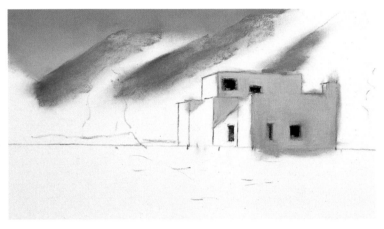

Step Two I want to establish some of the contrasting cool colors right away, so I paint the sky with a blend of turquoise blue 5, cobalt blue 5 and 7, and ultramarine blue 7, with phthalo blue 9 near the horizon. Note that the sky is not only cooler but also slightly darker than the house. I use olive green 5 and turquoise blue 5 for the hill shadows.

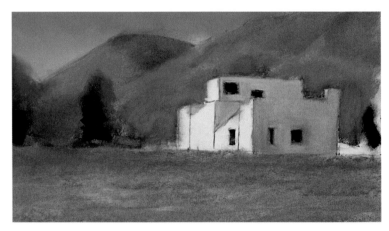

Step Three I use gray 5 and blue-gray 7 to block in the mountains, blue-violet 5 for the distant hill, and carmine brown 3 for the shadowed trees. For the light on the hills, I blend orange 3 and permanent red 5 into the cooler gray tones. Next I paint the foreground with orange 3 and blue-violet 5 near the horizon.

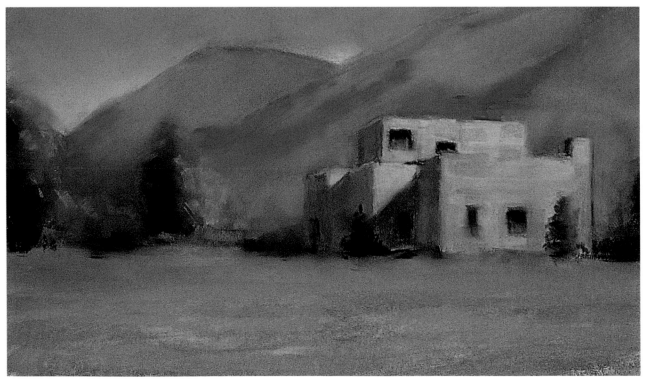

Step Four Next I paint the shadows on the house with olive green 3 and orange 3 and refine the shadows on the mountains with blue-gray 5 and turquoise blue 5. I paint the light areas of the trees with olive green 7, adding some of the same color to the ground. I apply carmine brown 3 and chrome green deep 5 to the trees by the house. Then I warm the shadows on the adobe with burnt sienna 5—particularly on the edge between light and shadow—and define the edges more clearly with gold ochre 5. I lighten the shadows on the hills with Prussian blue 7 and redraw their edges with turquoise blue 3. For the shadowy darks on either side of the house, I use Indian red 3.

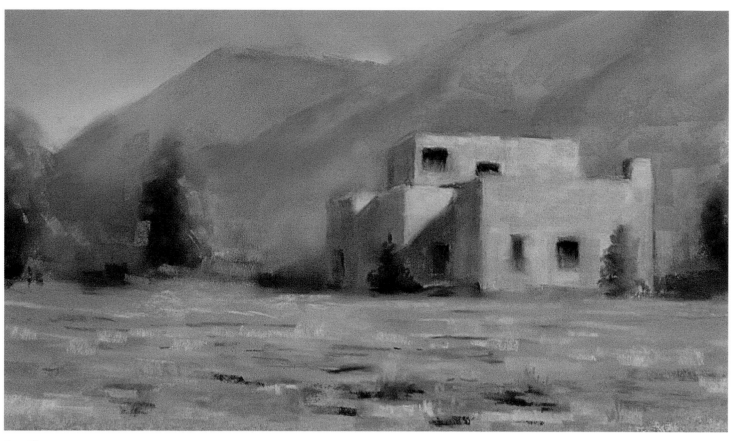

Step Five Now I indicate some of the foreground texture with burnt sienna 3 and yellow ochre 3 and 5. To create the effect of sparse vegetation on the desert floor, I add different shapes of olive green 5, gold ochre 3, chrome green 7, lemon yellow 7, and light English red 7. Adding texture to the foreground makes that plane seem to come forward, and I also use these spots of vegetation to draw the viewer's eye into the painting and direct it toward my center of interest: the adobe house.

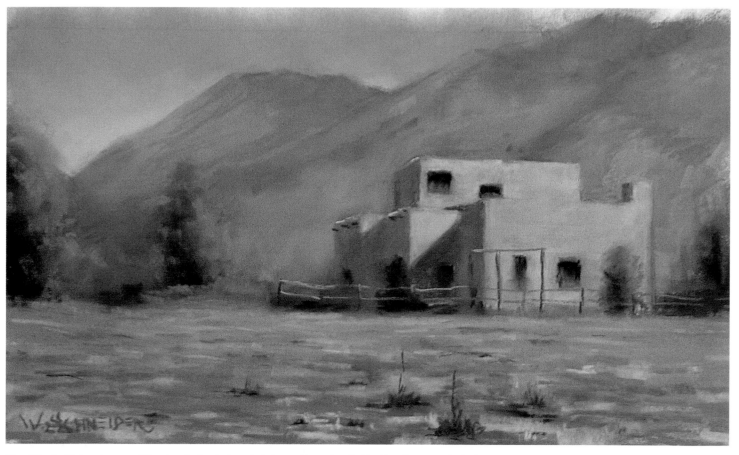

Step Six Next I sharpen some of the edges in the shadowed windows with purple 3. I add a hint of autumn color in the trees with orange 3. I draw the fence posts with burgundy 3 and indicate the fence rails with mouse gray 5. The details I place in the foreground plants help the rest of the color shapes "read" as vegetation. I notice that I drew the windows and the chimney with a slight lean, so I correct those lines. I also straighten the alignment on the top of the house by painting in some of the hill color. Then I add a few dark accents to the house and the surrounding trees.

Portraying Animals

Animals offer a range of shapes, lines, and textures to intrigue an artist. Painting animals is like painting anything else—you simply need to see shapes of color and put them in the correct place on paper. But when painting animals, I also want to capture the unique qualities of my subject, such as the animal's skin or hair texture and its features and body type. Consult books or magazines for appealing photographs, or take pictures of your pet. Look for subtle types of movement, like the twist of the body or the direction of a gaze. Don't worry if your rendition doesn't look exactly like your subject—an animal painting doesn't have to be a perfect likeness to be appreciated.

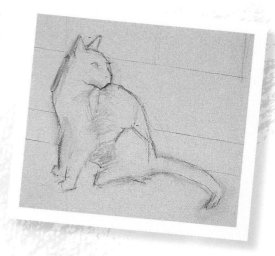

▲ **Sketching basic shapes** The design of this painting is simple: The cat is silhouetted against the light of a patio door. I begin by drawing the main shapes, roughing in the outlines and sketching the lines of the glass and wood door. This pose shows movement even though the cat is sitting still. (See page 30 for more on movement and the line of action.)

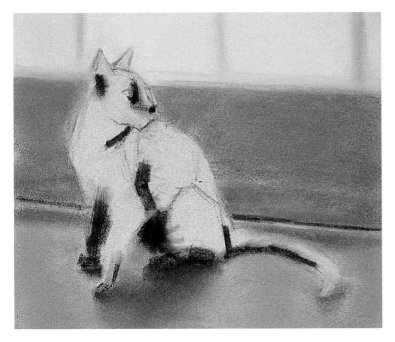

◄ **Step One** First I establish the light area of the window with cobalt blue 9; then I mix black with denatured alcohol, and paint the darks in the fur with a brush. Because I want to blend the softness of the cat's fur into the surroundings, I paint the background first. I render the wall with blue-gray 5 and gold ochre 5, blending them with my hand. Then I use burnt sienna 5 and chrome green 5 for the molding. The basic tone of the floor is gold ochre 5. Next I block in the shadow of the cat on the floor with light English red 3, carmine brown 5, and burnt sienna 5.

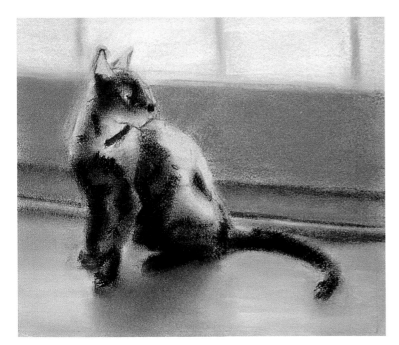

Step Two I lighten the floor with phthalo green 8, red-violet deep 9, and phthalo blue 9 to show the reflected light from the door. I lighten the value on the window with permanent rose 10 and use carmine 3 for the dark of the molding. Next I use a well-blended mix of carmine brown 3 and bistre 3 for the lighter colors in the fur and black for the deepest shadows in the fur.

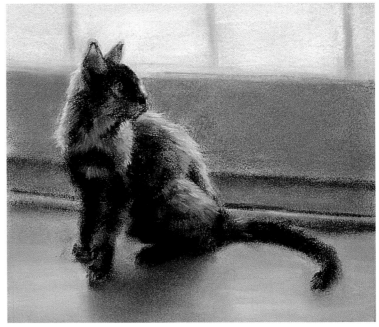

Step Three Next I use raw sienna 5 to paint the shadows in the lighter areas of fur, making unblended strokes that follow the direction of the fur growth. For the eye, I paint the pupil black; then I draw around it with chrome green 5 grayed with scarlet 5 (its complement), touching lightly with my finger. Next I use caput mortuum red 7 for the warm color in the ear, and I use gold ochre 5, gold ochre 7, and yellow ochre 7 for the highlighted fur.

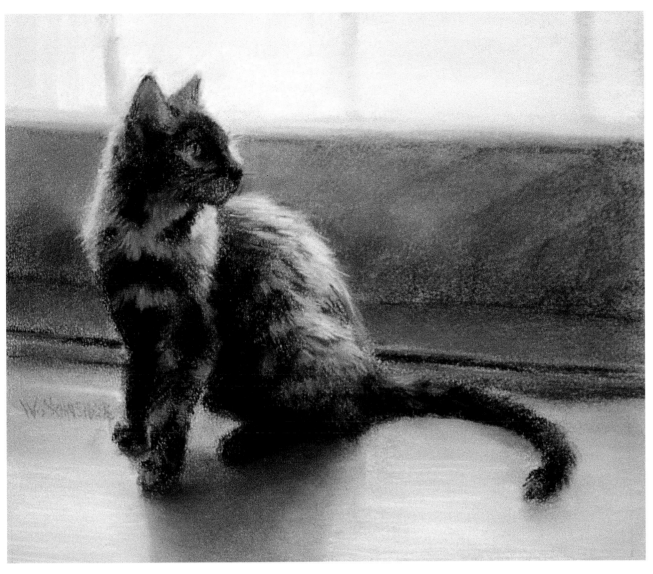

Step Six To complete the painting, I lighten the window with white to create more contrast and make it appear as if the light were shining through it. Then I add a little phthalo blue 10 to the sunlit areas of the floor, and I highlight the fur with yellow ochre 10 and phthalo blue 10.

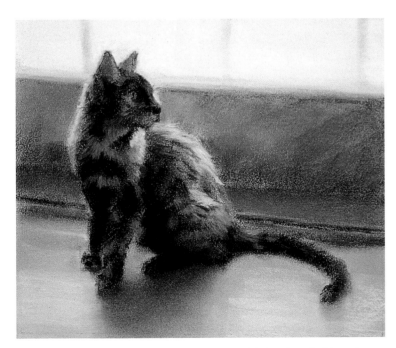

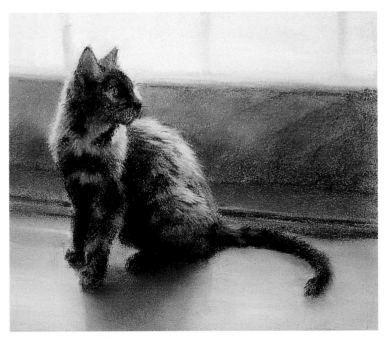

Step Four I lighten the window with viridian green 9 and darken the wall with purple 3 and blue-gray 7. Then I add vermilion 3 and olive green 3 to the molding. For the dark accents in the shadowed fur, I add unblended strokes of carmine brown 3 and bistre 3. Next I add more detail with English red 3. I indicate the reflected light on the muzzle with cobalt blue 5 and use scarlet for the light shining through the ear. Then I add a little crimson 5 to add depth to the corner of the eye.

Step Five Now I decide to shorten the muzzle, using Mars violet 5 to paint the background into the nose a bit to define its shape. Then I go over the dark patches of fur with black, particularly in the tail. I use light English red 9 and cobalt blue 9 for details in the light areas, and I add thin strokes of cobalt blue 9 that trail off into the background to create the illusion of backlit fur. Then I paint into the edge of the tail with the floor color (gold ochre 5 and phthalo green 8).

Capturing a Likeness

As an artist, creating a recognizable portrait is extremely satisfying. Although it may seem challenging at first, painting a portrait is similar to painting an animal, landscape, or any other subject; look for the basic shapes and contours, and paint what you see. The key is noticing the subtle differences in the features of each individual, such as a small nose, thin lips, or a high forehead, and then making sure they're in the correct place and proportion. So when painting a portrait, I first define my subject's main features, beginning with the general outline of the head. For this portrait of Bethany, I first sketched the loose contours of the face and hair; then I focused on the features and what makes each unique, carefully observing and copying the shapes and measuring the distances between them. (See "Measuring for Accuracy" on page 27.) As long as you draw what you *really* see (not what you *expect* to see), your portrait will look like your model.

Focusing on Features I want to capture Bethany's calm gaze, so I focus on carefully defining the features of her face that contribute to that feeling. I pay close attention to rendering her wide eyes, set lips, and outstretched neck.

Step One I begin by working a light cool tone into the tooth of the paper with the side of my hand, painting around the area where her face and neck will be. I want to enhance her beautiful red hair and skin tones, so I use a thin blend of permanent red dark 8 and phthalo green 8. Then, with vine charcoal, I establish the general size of her head and the placement of her features. I also place a few strokes of ultramarine blue 3 in the background and lightly blend them with a paper towel.

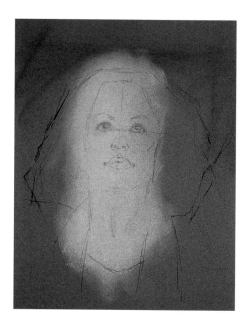

Step Two I establish the "extremes" of value, color, and definition (sharpness). I paint the darkest dark first—the shadows in her hair—after wiping off some of the green base tone with a paper towel. Then I paint over the black with a little denatured alcohol and a brush to saturate the paper so none of the white shows through. I establish the lightest light—the blouse—with blue-gray 9, followed by the most intense color for the scarf with scarlet 5. The sharpest edge is her right cheek; all other edges will be softer.

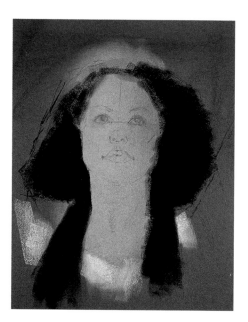

Step Three Next I paint in the warm shadow patterns. For the shadow on the side of her face and under her chin, I use primarily Indian red 3, with a little olive green 3 to cool it slightly. I paint the darks under her upper eyelids with Indian red 3 with a little black. I use vermilion 3 for her nostrils, madder lake deep 5 for her lips, and alizarin crimson 3 for the dark corner of her mouth. I establish the pupils of her eyes with black, and place some olive green 3 to indicate the irises. I'm not concerned with the large shapes and colors at this point.

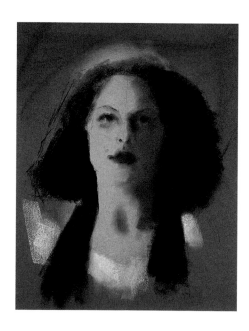

Step Four Here I block in more of the background tones with a deep gray-green. Then I paint the cool color of the "white" in her left eye and the shadows on her blouse with blue-gray 3. Next I darken her upper eyelashes with black and add some strokes of burnt sienna 5 for the dark red of her hair. I place madder lake deep 3 in the corners of her mouth and in her nostrils to darken them. I blend every stroke with the side of my finger to keep the edges soft.

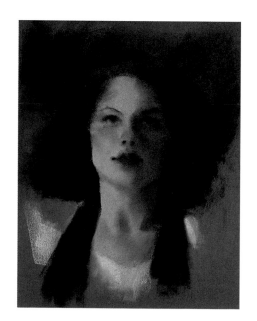

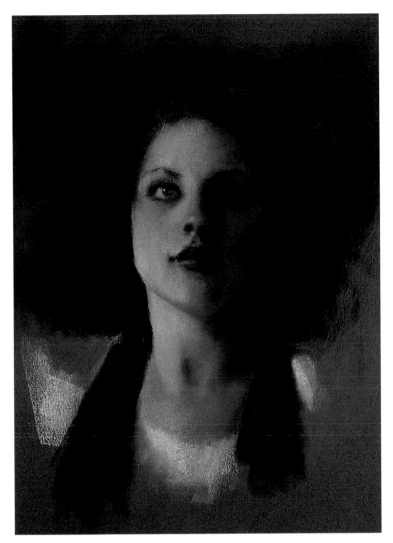

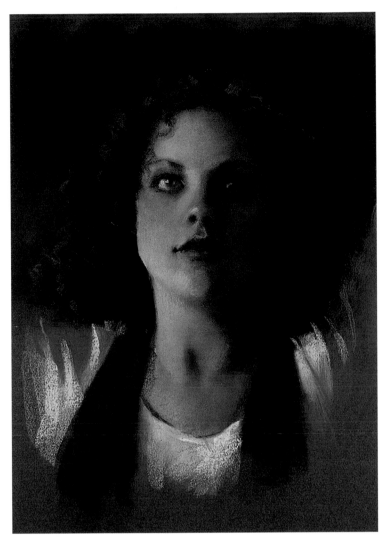

Step Five I use a few strokes of orange 3 to indicate the light areas of her hair and then move to the light side of her face. I apply layers of permanent red deep 8 and phthalo green 8, blending well in the light areas. For the highlight on the right side of her nose, I use cobalt blue 8 and permanent red deep 9. Then I add some burnt umber 3 and alizarin crimson 3 to her eyelashes. I use two different values for the "whites" of her right eye: On the light side of the eye, I use blue-gray 7; on the shadow side, I use blue-gray 5 and 3. Note that the edges in eyes are all very soft; the only sharp stroke in the eye is the highlight of cobalt blue 9. Opposite the highlight, I place some olive green 5 on the iris. I use carmine 7 for the midtone on the front plane of the nose and chrome green 8 for the highlight. I darken her upper lip with Indian red 3 and vermilion 3, and use carmine 7 for the highlight on her lower lip.

Step Six Now I paint the light masses of the hair with broad strokes of scarlet 5, permanent red deep 5, and madder lake deep 5. I add touches of cobalt blue 7 to the light areas of her skin and lighten the highlight on the side of her nose with phthalo blue 9. I add a highlight on her left eye with blue-gray 5. Then I paint the highlight on her lower lip with red-violet 5; for the highlight above her lip, I use phthalo green 8. I add more darks to the background with black-green 3. Then I draw in a few light strokes for the curls in her hair. I add the curl on her forehead with Indian red 3 and burnt sienna 5. I also add some olive green 5 to her hair to give it some variety and contrast. Finally, I place a few bold strokes of permanent red light 5 in her scarf and use Indian red 3 to indicate the cast shadows on the edges of her blouse and scarf.

MEASURING FOR ACCURACY

For portraiture, an accurate drawing will automatically produce a likeness. Accuracy is really nothing more than careful measurement. At the beginning stages, I'm not concerned with details—I just want the placement of the features to be correct. First I establish a basic unit of measurement (usually the width of one of the model's eyes). Then I use this unit to measure and mark the distances between each facial landmark. (See photo and caption at right.) I also consider the angles between the features by comparing my model's face to the face of a clock. I use a pencil to represent the hands of the clock, which helps me determine the angle at which to place the features. (For example, I might decide the eyes should be placed at 10:00 and 2:00.) Once I'm confident my measurements are correct, I look carefully to see what is unique about each feature and draw their basic shapes. I assess my work from a distance and make any necessary corrections.

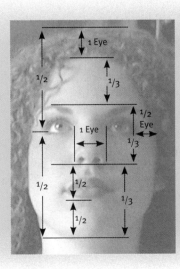

Choosing a good unit of measurement
In this example, I use the model's right eye as a unit of measurement, and then I measure all the other facial proportions based on one "eye-width." (See diagram at left.) For example, the highest part of her eyebrow is one eye-width above her lower eyelid. I also look at general proportions—the distance from the top of her eyebrows to her hairline is a bit less than the distance from the base of her nose to the top of her eyebrows. Angles are also important; the pupil of her right eye is at about 9:30 in relation to the inner corner of her eye.

Using Colored Paper

When you work on colored paper, the support becomes an integral part of the painting, instead of just a surface to be covered with pastel. Unless the color is applied very heavily, the pigment sits on top of the raised grain, allowing the paper to show through the strokes. Therefore the paper you choose can either set the overall tone for the painting—light, medium, or dark—or provide a warm or cool color contrast. The paper color can also be used to either add weight and depth to your painting, stand in for a dominant color, harmonize with the palette, or provide a contrasting tone. You can also choose a colored ground that will serve as a middle value and remain uncovered, so that all you need to paint are the light and dark values. For this painting of Katherine, I chose a warm burgundy paper as the base color to complement and mingle with the warm reds and yellows in the shadows, beautifully offsetting the cool, reflected light on Katherine's face. And by letting the paper stand in for some of the color, I was able to keep the background loosely painted, maintaining the focus on my subject.

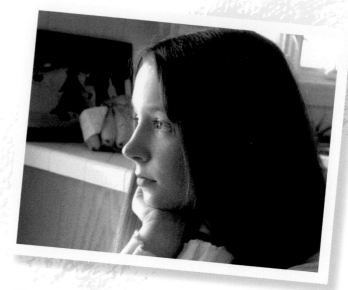

Candid Photos Normally it's best to paint from life; our eyes see colors, values, and edges much more accurately than a photo can reproduce them. But a camera can be useful for capturing fleeting expressions, such as this one of Katherine gazing wistfully out the window.

▶ **Step One** I first apply a thin, light base tone of alizarin crimson 8 with a layer of phthalo green 8 around the area where I will place the face. I blend the color with circular movements and work it into the tooth of the paper with the side of my hand. Then, using soft vine charcoal, I draw in the main features. This is the most important step in capturing a likeness, but is also the most mechanical. I start by defining the top and bottom of the head and the general profile. I go from one facial landmark to the next, comparing each to the previous feature. (See pages 26 and 27.)

Step Two Next I establish the darkest dark (the shadow areas of her hair and sweater). I use a soft paper towel to wipe off the light pastel where her hair will be, and then I cover the area with black. I dip a soft brush in denatured alcohol and paint the dark pigment thoroughly into the tooth of the paper. Then I place a swatch of ultramarine blue where the highlight in her hair will be. I also establish some of the background colors with olive green 5 and blue-gray 5. I like to work on the background and foreground of a painting at the same time—this way the whole piece has a sense of color harmony.

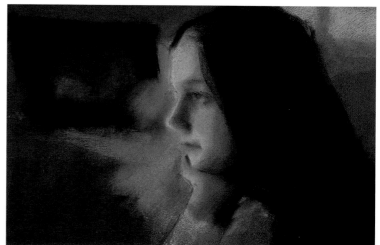

Step Three Now I establish the shadow pattern on her face, keeping in mind that the cool light produces warm shadows. I use Indian red 3 for the deepest shadows under her chin and a 5 value for the lighter shadows on the side of her nose and around her eye. For the halftone (middle value) on the side of her cheek, I use carmine 8, blending the colors to produce a soft, even tone. I add a few strokes of dark vermilion to indicate some of the deeper shadow in her hair. I also block in the brown rectangular shape on the left side with burnt umber 3. Then I suggest the window with mouse gray 7 and cobalt blue 7, and I add warm orange strokes of burnt sienna 5 to the foreground.

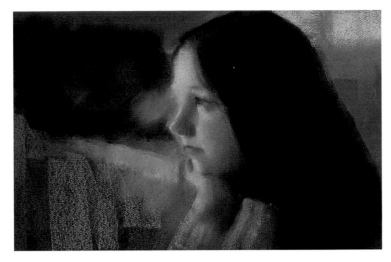

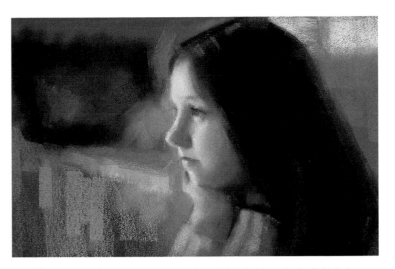

Step Four I work the halftones by applying alternating layers of carmine red 7 and olive green 8. On the lower third of her face, I use the same colors in a 5 value with more emphasis on the green. I use the side of my finger to wipe and blend the strokes, so the skin to appears smooth. Next I cool the shadow under her chin with olive green 3 and use Indian red 5 for the shadows on her upper lip and in the corner of her eye. I paint the shadowed sleeve of her left arm with mouse gray 5 and blue-violet 5, adding gold ochre 7 and phthalo green 7 for the lighter areas. I work burnt umber 3 into her hair and lighten the highlight with cobalt blue 7.

Step Five I use thin layers of permanent red 9 and phthalo blue 9 for the lights in her forehead and permanent red 8 and cobalt blue 8 for the lights in the middle of her face. I add the lights in the lower third of her face with permanent red 8 and chrome green 8. Then I darken the shadow of the upper eyelid with a little black; I also touch black in the center of the eye to indicate the pupil. I work more colors into the background, with strokes of gold ochre 3, carmine 3, and olive green 5, blending them slightly.

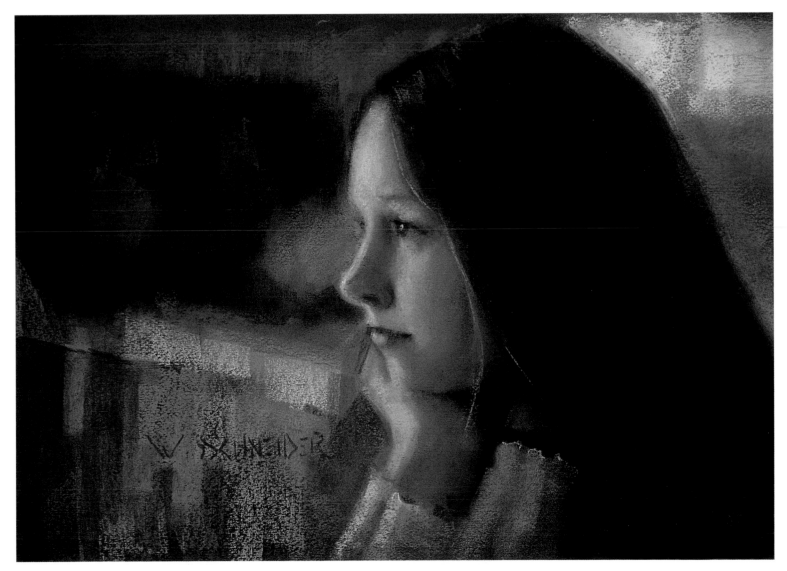

Step Six To finish, I use burgundy 2 to indicate the deepest dark tones under her chin and in the corner of her mouth; then I place umber 2 in some of the recesses of her hair. I add the highlight in her eye with a single dash of turquoise blue 10. Opposite and below the highlight, I place a touch of chrome green 5. I blend in a stroke of chrome green 10 for the highlight on her nose. I sharpen the edge of the sweater on her left sleeve with blue-gray 5. Then I blend strokes of orange 8 and olive green 8 to show where the light catches a few strands of hair. Finally, I add a red-violet deep 7 highlight on her lower lip.

Developing the Human Form

Throughout the ages, artists have been captivated by the beauty of the human form. Learning to paint the human figure is just a matter of seeing how the basic shapes flow together into a form. Think of the body as composed of a series of cylinders—or rounded oblongs—and the head as a sphere. After drawing the basic shapes, simply develop them into solid forms with varying values, shadows, and highlights. Before you start sketching, examine your subject to determine the *line of action*—an imaginary line (or lines) that establishes the extent and direction of the pose. It can be a simple curve in the back, as in this seated figure, or the complex angled limbs of an athlete in motion. Just make sure that all the parts of the body conform to the line of action. In this woman's graceful pose, the curve of her body extends from her head through her leg, which is then counterbalanced by her supporting right arm.

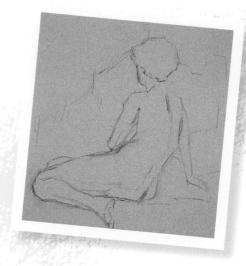

Establishing the Pose First I sketch the outline of the figure using vine charcoal. All I want is the overall gesture of the pose and the line of action. I also indicate where I will block in some background around the figure.

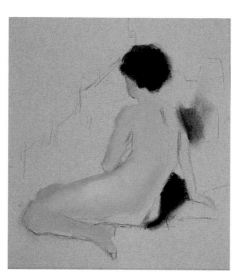

Step One I place my extremes first. Then I paint the lightest light—the hip and upper leg—with permanent red deep 8 and phthalo green 8 and rub them into the tooth of the paper with my hand. The darkest dark is the black of her hair and the shadow to the right. To ensure that none of the paper shows through, I blend the black into the paper with a light wash of denatured alcohol. Then I block in the most intense color: the vermilion red to the right of her shoulder.

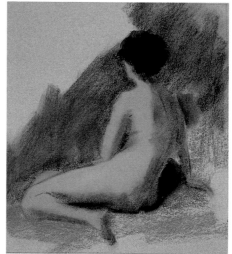

Step Two Next I paint the shadows on the figure with olive green 3 and 5 and caput mortuum red 7. I use umber 3 for the darkest part of the shadow, which lies between the halftone and the reflected light. Then I add some background colors to set off the figure. I use burnt sienna 3 for the darkest areas in front of and to the right of the figure. I wipe it with a paper towel to blend the strokes and to remove all but a thin layer of pastel. I then use turquoise blue 5 and phthalo blue 3 for the area below and behind the figure.

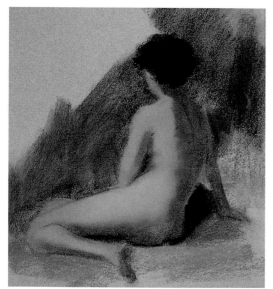

Step Three I add a few bold, unblended strokes of permanent red 5 to the right of her head and above her left shoulder. I cool the edges of her leg with phthalo green 7. This helps create the illusion that the leg is turning away from the viewer. Next I lighten the highlight on the thigh with permanent red deep 9, cobalt blue 7, permanent rose 10, and gold ochre 9.

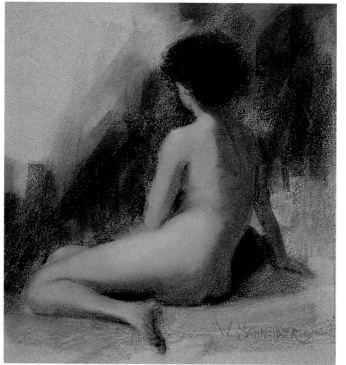

Step Four To soften the curve of her body, I paint some of the background red into the edge of her shoulder and add turquoise blue 5 to the space between her right arm and her back. I lighten her leg by adding pure white and blend each stroke of the skin tones with a swipe of my finger. Next I add ultramarine blue 5 to her hair for the highlights. For the reflected light on her buttocks, I use blue-green 5; for the reflected light on her arm, I use scarlet 5. I add a stroke of gold ochre 9 for the highlight on her left leg and burnt umber 3 to indicate the dark shadow above her calf.

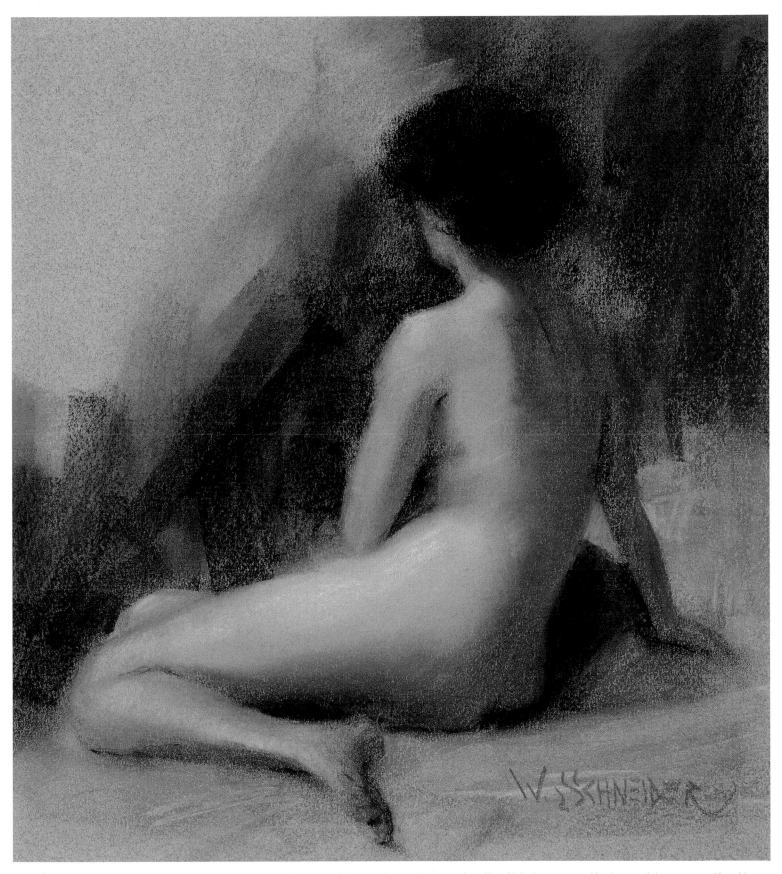

Step Five I add a few more bold strokes of color to the background. Then I use bistre 3 to sharpen the upper edge of her thigh, the area around her knee, and the area around her chin. I also slightly sharpen the edges around her buttocks. Finally I add a few strokes of red-violet 7 to lighten the background on the far right. I step back again and assess the painting. I am satisfied that I have captured the pose accurately and have rendered the forms well without overworking the piece.

Depicting Flowers

Flowers are wonderful subjects for pastel. There are so many varieties of flower that you can produce dozens of paintings without ever portraying the same flower twice. A bouquet of several flowers offers the opportunity to use the brilliant pigments of pastel to their fullest. When arranging a group of flowers, strive for an asymmetrical setup to add a sense of movement. Your painting will be much more effective if the arrangement is dynamic and the blossoms aren't carbon copies of one another.

Step One I draw the main shapes using vine charcoal on a dark-toned, sanded pastel board. I place the center of interest (second peony from the left) slightly off-center and position another blossom in front of the vase. I sketch in a vertical centerline for the vase and then measure how far the sides are away from that line. I establish the darkest values using ivory black and carmine brown 2. Because this is a sanded support, I won't blend with my hands. I work the colors into the support with a brush dampened in denatured alcohol.

Step Two I use blue-gray 7 and lemon yellow 7 to establish the lightest light. Then I apply madder lake deep 5—the most intense color—for the center of interest. Next I paint in the background flowers with Indian red 5 and blue-gray 3, and I block in the tabletop with mouse gray 5. I use blue-violet 3 for the vase and blend the strokes with a paper stump and an occasional swipe of my fingers.

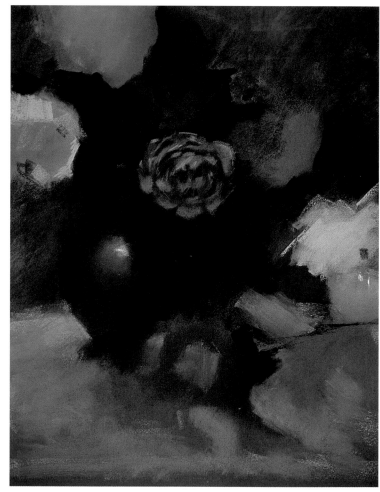

Step Three Next I fill in the background with gray-green 3 and indicate some of the leaves with olive green 3. I create the flowers on the table with madder lake deep 5, and I paint the bud on the right with Indian red 5. Then I add Indian red 3 to the vase and add blue-gray 5 to the middle white flower.

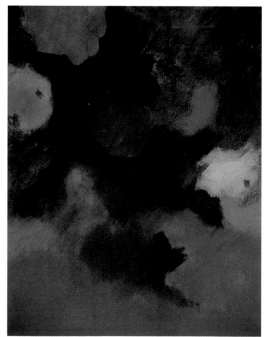

Step Four I paint around the center flower with cobalt violet 2. Then I use blue-violet 5, carmine 5 and 7, and permanent rose 7 for the lighter areas; for the deep recesses between petals, I use burgundy 3. I paint a few strokes of gray 7 to show where the light is hitting the two white flowers, and then I draw the stems of the peonies on the table with blue-green 3, adding yellow 5 for the lighter petals. I paint the darker parts of the vase with cobalt violet 2 and use a little black to help define the area below the top rim. I indicate the main highlight by first creating a lighter area with blue-violet 5 and then adding a sharp (unblended) stroke of phthalo green 8. I sharpen the edge of the vase on the lower-left side with gray 5 and blend the rest of the vase into the background.

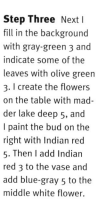

Step Seven I darken the center of interest with permanent rose 5 and blue-violet 5. I also refine the outline of the petals to make them less regular. Then I darken the vase with cobalt violet 2 and simplify the folds in the tablecloth with blue-gray 7 and 9. I use phthalo blue 10 to make the light at the edge of the table appear to come forward, and I define the outer petals of the three top white peonies with simple strokes of blue-gray 7. Finally I add a couple of small, sharp strokes of cobalt blue 9 to indicate the highlights at the neck of the vase.

To add visual interest, avoid making all of the flowers in the composition the same size and shape, or placing them in even rows.

Step Five I add blue-gray 5 and 7 to the white flower on the lower right. I paint the dark recesses between petals with blue-violet 3, olive green 5, and yellow ochre 3. Then I use Indian red 5, red-violet 7, and lemon yellow 5 for the pink flowers lying on the table and burgundy 3 for the dark shadows. I paint the leaves with olive green 5, and I highlight the lower peonies' leaves with turquoise 7. I blend virtually every stroke to keep the edges soft.

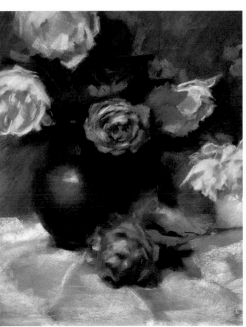

Step Six For the lights on the distant pink flower and buds, I add blue-violet 5. Then I refine the light peony at the top left with simple strokes of blue-gray 5 and 7 and indicate the recesses with yellow ochre 3. As I move away from the center of interest, I add less detail, which reflects the way we see. When we look directly at an object, we see sharp edges and a wealth of detail, whereas objects in our peripheral vision appear less sharply defined.

Detecting Color in White

Like any white object, snow has a wonderfully reflective surface—therefore, it mirrors the colors of the sky and other elements around it. I love the way the interlocking light and dark shapes in a snowy winter landscape create visually interesting patterns, while the roughness of the terrain adds more variations in color temperature and value. In this scene, the only true white areas are the lightest highlights, where the sun hits the snow directly. Rather than making my shadow areas a flat gray, I fill them with touches of the cool blues and greens reflected from the sky and the surrounding trees and bushes. Reflected colors don't have to be dramatic to make an impact; subtle variations can be just as effective.

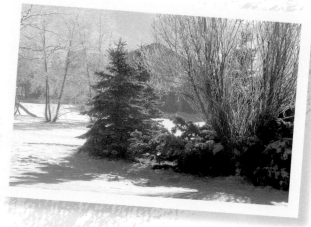

Simplifying a Subject This photo shows the intricate details of these trees, but I simplified them greatly in my painting. You don't have to render every branch and leaf to make a believable tree; just paint the shapes you see, and the viewer's eye will fill in the details.

Step One I want the dominant color of this piece to be blue-green to help evoke the cold feeling of this day. I begin by toning the sky with blue-green 7, deep yellow 9, red-violet 9, and phthalo green 8, making the top part of the paper a little darker than the lower part. Then I draw in the main shapes with vine charcoal, indicating where I want the dark shapes to be sandwiched between lights. Now I'm ready to establish the darkest darks.

Step Two I paint the trees with a warm mixture of vermilion 3 and ivory black. Then I brush a denatured alcohol wash over the area to make sure none of the light paper shows through. Next I indicate the background with turquoise blue 5 and the wispy clouds with blue-gray 8. I then create the lightest light in the snow with deep yellow 9 and 12 and scarlet 10. These colors are almost white, but they maintain a bit of warmth that helps to portray the bright sunlit snow.

Step Three Because the snow reflects the blue sky, there is a cool tone to the shadows in this piece. Here I use blue-gray 5, mouse gray 7, and blue-violet 3 and 5 to indicate the shadows that mirror the trees and bushes. I make the more distant shadows a little lighter and more violet in tone, and then I blend all the shadows with the side of my hand.

Step Four Now I block in the pine trees. I add black and scarlet 3 for the shadowed branches and ultramarine blue 3 near the deepest darks. For the rest of the pine trees, I use a mix of blue-green 3 and olive green 3. Because the trees are backlit, there are very few variations in value; however, I paint some of the places where light shines through the branches with olive green 5.

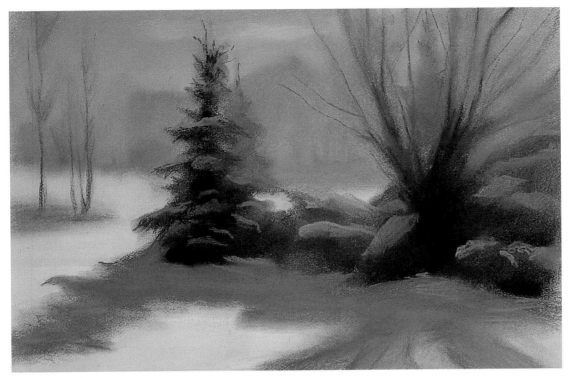

Step Five Next I render the branches of the pussy willow with mouse gray 3 and burnt sienna 3, keeping the edges soft by blending every stroke. I also add the trunks of the bare trees on the left with mouse gray 5 and raw sienna 5. I draw in the shadowed clumps of snow on the pines with gray 7 and ultramarine blue 7. Because I notice a warm tone in the shadow near the base of the trees, I paint it with olive green 5. Look for changes like this in temperature (not value); these details will strengthen the sense of realism in your paintings.

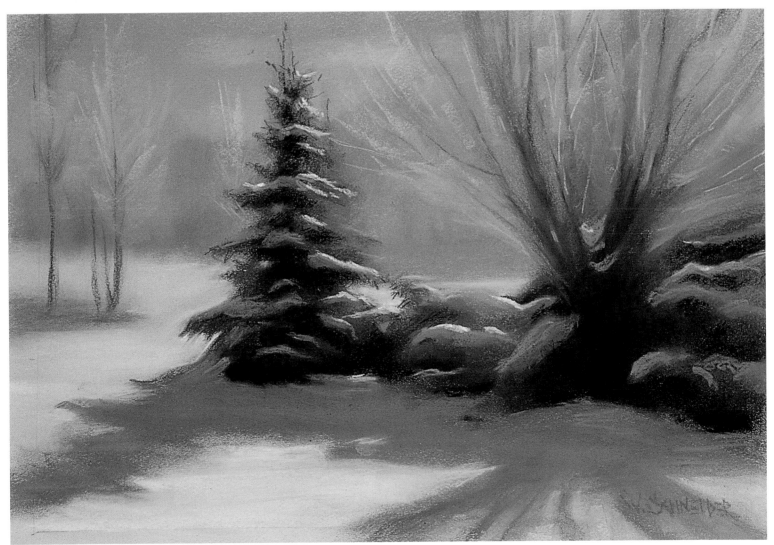

Step Six Here I add deep yellow 12 and white for the snow highlights on the edge of the boughs. I outline the white in some areas with permanent red light 5 and blend it away from the snow. This creates the effect of warmth in the air above the snow. I use green-gray 9 to indicate the frosty, backlit branches of the trees on the left and the pussy willow branches on the right. To sharpen the edge on the left side of the pine, I use deep yellow 12 and leave those strokes unblended. I make sure there is always at least one sharp edge in any subject. If all the edges are equally soft in a painting, the subject can look fuzzy. And if all the edges are hard (a common mistake), the painting will look as if the objects were flat cutouts pasted onto the background.

Deciding What to Paint

Selecting what to paint is a wonderful expression of your personal style, taste, and creativity. The more strongly you feel about your subject, the more your emotions will show through in your work, and the more successful your paintings will be. So try to pick something that you care about or that inspires you—your children, your garden, your pet, vacation photos, or natural wonders. For this painting, I was moved by the majesty of Mount Rushmore, and I like the composition and sharp perspective of this scene. Looking up from a worm's eye view emphasizes the grandeur of the monument. And for me, the dramatic contrast between the solid, pristine blue sky and the numerous gray colors in the rocks makes this painting that much more inspiring and compelling.

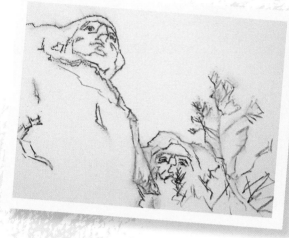

Transferring a Drawing Because this drawing needs to be precise and the sanded board I'm using makes it difficult to erase any lines, I first work out the composition on a piece of translucent paper. Next I punch tiny holes in the paper along the lines of the design. Then I place the perforated drawing (called a "cartoon") on top of the pastel board and apply charcoal dust to the outline with a soft brush. The charcoal dust goes through the holes, thus transferring the design to the pastel board. Then I connect the dots on the board with a piece of vine charcoal.

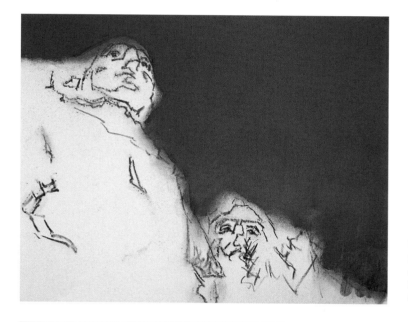

◀ **Step One** I start by blocking in the blue of the sky. (I won't be distributing the colors in an equal ratio; more than half of the picture area will be blue sky.) I apply a base of sapphire blue 5 and wash it into the tooth of the board with denatured alcohol and a brush. Although the sky seems very even, it is actually composed of a number of colors: I add ultramarine blue 5, cobalt blue 5, lemon yellow 7, and red-violet 7 and blend them with the side of my hand. Then I add a little more lemon yellow and red-violet at the bottom.

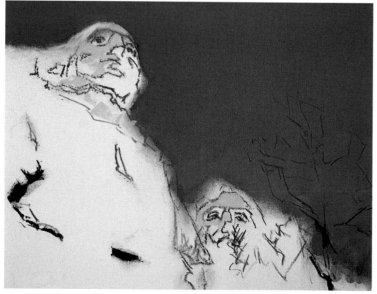

Step Two Next I paint my darkest dark, bistre 3, in the crevices of the rocks. I am careful to select those crevices that emphasize the perspective; notice that they point toward Washington's head. Then I apply lightest light with yellow ochre 7 and 9, and I add a little permanent red light 5 for a "halo" effect at the top of Washington's head. Next I redraw the tree on the right with charcoal; this tree is important to the design because it helps establish the scale of the massive stone sculpture.

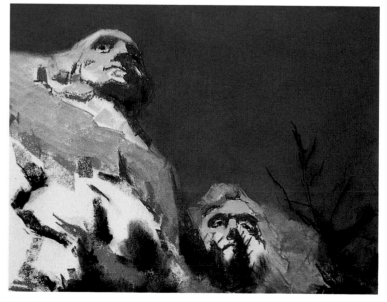

Step Three I paint in the shadow pattern on the mountain with mouse gray 3. The sunlight is warm, so the shadows are cool (they're picking up some of the blue of the sky). Since I'm rendering stone, I blend my strokes much less than I normally would. Harder edges "read" as more angled planes, which is perfect for painting rocks. Then I place the darks in the trees with Mars violet 3, carmine brown 3, and bistre 3. I block in the rest of the trees with blue-green 3, and I apply gray 8 to the roughly chiseled stone below Washington's face.

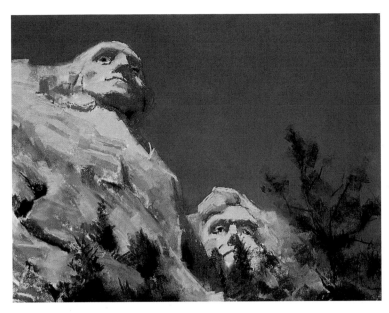

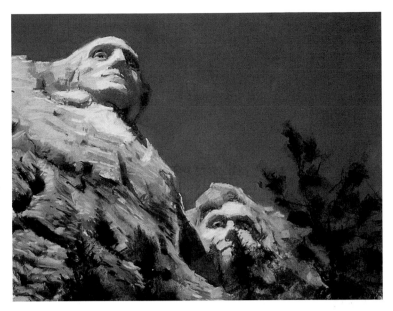

Step Four Although the tone of the mountain is much less intense than the bright blue sky, it's still very colorful and more than a compilation of various shades of gray. I begin by applying strokes of blue-violet 5 and turquoise blue 7 to block in the base colors of the mountain. Then I tone down these hues with green-gray 9 and gray 8. I want to keep harder edges here, so I do not blend these strokes to any great degree.

Step Five I deepen some of the key dark areas with carmine brown 3, bistre 3, and black-green 3. The reflected light under Washington's chin and brow helps define the form, so I paint it with permanent red light 5, burnt sienna 5, and caput mortuum red 7. Then I modify the green in the rocks with olive green 8 and green-gray 9, and indicate some smaller cracks and recesses with carmine brown 3. Next I lighten the sunlit areas of the heads with yellow ochre 10 and orange 12.

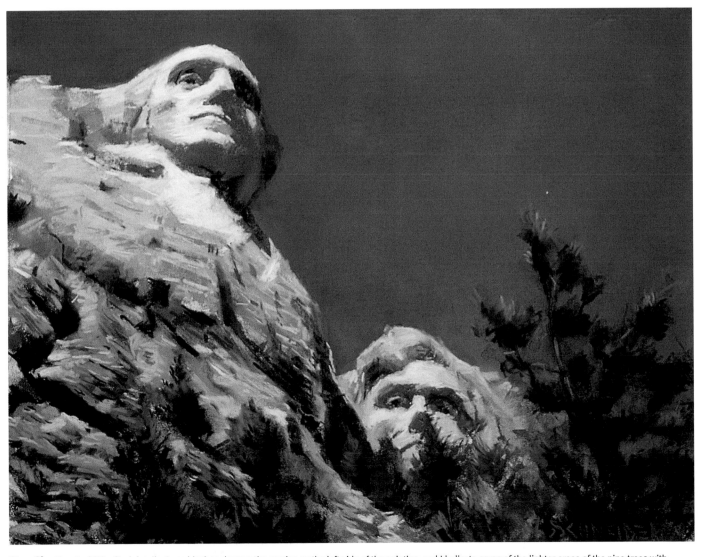

Step Six Here I add the final details. I use black to deepen the crevice on the left side of the painting, and I indicate some of the lighter areas of the pine trees with chrome green 5 and blue-green 7. Then I sharpen some of the sunlit edges on Washington's head with gold ochre 10 and orange 12. Finally I use burnt sienna 5 to render the dead pine needles on a few of the branches.

Painting Outdoors

The best thing you can do to hone your artistic skills is to go outdoors and paint directly from life. And because pastel is such a rapid and responsive medium, it is ideal for painting *en plein air* and recording the effects that often change so quickly in nature. Morning dew, shifting clouds, and crashing waves all can be captured with a few quick, decisive strokes. For this painting, I was able to re-create the cool morning light before the sun warmed and the colors shifted. Another advantage of pastel is that I don't have to premix my pigments, wait for the colors to dry, or worry about keeping brushes clean—in short, there are no tiresome procedures. And because I don't need the extra supplies, such as brushes, knives, or mixing mediums, my traveling art pack is light and portable.

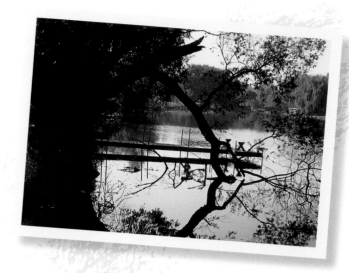

Working from Life Photos are convenient, but they still only offer pale imitations of nature. This photo lacks many color nuances and values compared to my final painting. And squinting only allows you to simplify values or see hard edges when you are working outdoors.

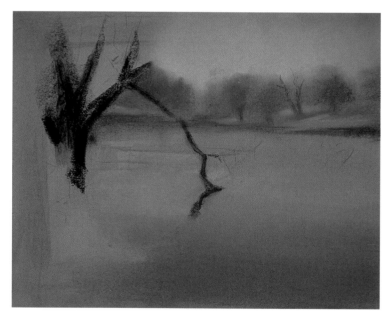

Step One I begin by toning the light areas of my light blue paper with thin layers of light yellow 5, red-violet 7, and cobalt blue 5, using the side of my hand to rub the pastel into the tooth of the paper. I sketch in the main elements of the scene with vine charcoal and begin painting the black in the tree mass. Next I paint the sky with layers of cobalt blue 5 near the top, turquoise 7 and raw sienna 7 in the middle, and cobalt blue 7 near the bottom. I also add lemon yellow 5 near the horizon, since clear skies tend to be darker at the top and lighter near the horizon. I paint the trees on the far shore with mouse gray 5 for the trunks and the deepest shadows, and olive green 5 for the light areas. I gray the trees further with a layer of red-violet 5 to enhance the sense of depth. For variety I add blue-green 5 to a few trees and burnt sienna 5 to another, blending each stroke with my finger.

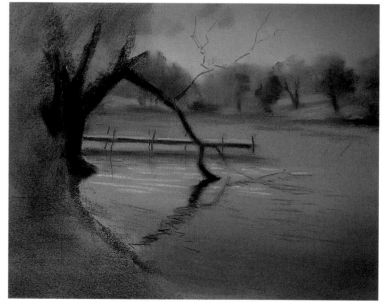

Step Two Water is like a mirror—it reflects the colors in the sky and nearby objects. Because the darker area of the water is closest and the lightest area is farthest away (reflecting the horizon), I add blue-violet 5 and cobalt blue 5 to the foreground water and red-violet 7 to the background. Then I blend the color transitions in the sky and water with the side of my hand, and add a few strokes of lemon yellow 7 for highlights on the water. For the light areas of the dock, I use gold ochre 7; for the darks, I use mouse gray 5 and red-violet deep 3. I block in the general mass of the closest tree using olive green 3. Then I add a warmer Indian red 3 to the trunk. I paint dark reflections on the water with olive green 3 and gray-green 3, and I work chrome green 8 grayed with red-violet 8 to the light areas on the far shore to indicate the sunlit grass.

SETUPS FOR PAINTING *EN PLEIN AIR*

When I paint outdoors, I use a French easel that is light and easy to transport. I place my support on a board with clips, and I use a TV tray to hold my pastels (although you can buy portable pastel boxes that attach easily to a portable easel). You may also want to bring a folding chair or collapsible stool if you prefer to sit while painting. I've found it's best to work on smaller supports when *plein air* painting—they are easier to transport and there is less surface space you have to cover in a limited timeframe. Plastic bags are handy for disposing of any trash, and you might consider bringing along some clips or twine to secure your setup in case it gets windy. Sunscreen and/or a hat are essential (even on cloudy days), and you should never hike out too far without some food and water. The more flexible you can be when you're painting outdoors, the more you will enjoy the experience. Nature provides an endless array of subject matter—so go outdoors and have fun painting in pastel!

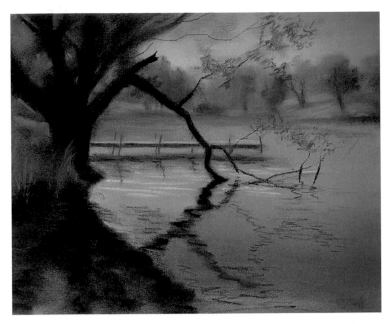

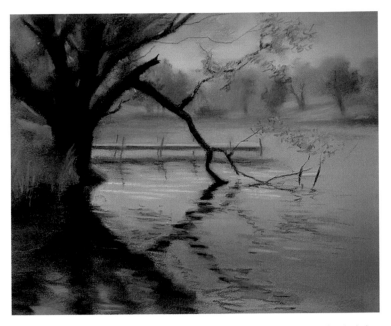

Step Three Because water is an imperfect mirror, the reflections are darker than the objects reflected (but very dark objects appear slightly lighter in reflections). Here I darken the tree mass and the reflection with gray-green 3 and burnt sienna 3. Then I sharpen the edges of the broken branch by painting some of the sky color into its edges. Next I add leaves with olive green 3 and define the spaces between the branches with strokes of olive green 8 and orange 5. I use a few strokes of olive green 5 to indicate the grass near the tree trunk.

Step Four Next I add strokes of ultramarine blue 5 in the water to represent the sky holes in the reflection of the tree. Here I blend my strokes less so they appear bolder; then I apply cobalt blue 5 to indicate ripples cutting across the reflected branches. Next I add a few more warm darks to the trees with burnt sienna 3, and I add a hint of the sky color behind the tree with cobalt blue 5 and blend it into some of the spaces between branches (the negative spaces).

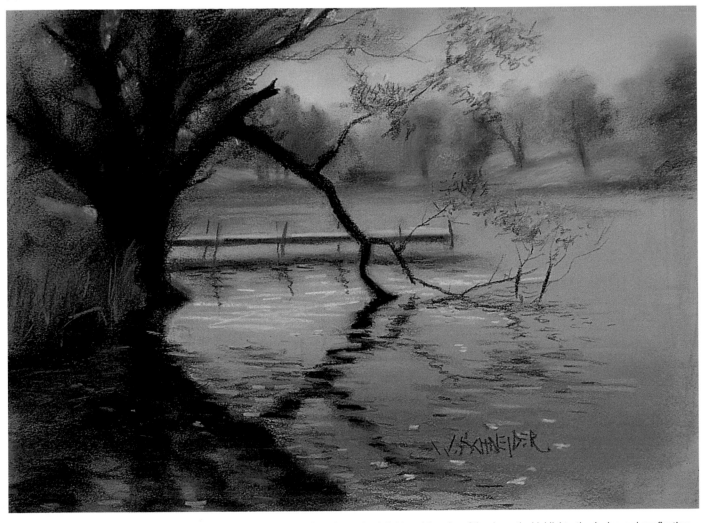

Step Five To make water appear flat, it helps to somehow indicate its surface plane—the definition of the edge of the shore, the highlights, the ripples, and any floating surface matter can all help to create that illusion. Here I add more highlights to the water with deep yellow 9 and place a few of the floating leaves on the surface of the water. I use yellow ochre 3 on the shadowed sides of the floating leaves and gold ochre 5 in the light areas. Then I draw a thin, dark shadow with Indian red 3 below some of the leaves to deepen the cast shadows. As a finishing touch, I add strokes of orange 5 in the foreground tree to indicate some backlit leaves. Finally I place a few strokes of gold ochre 3 to deepen the green grasses near the trunk.

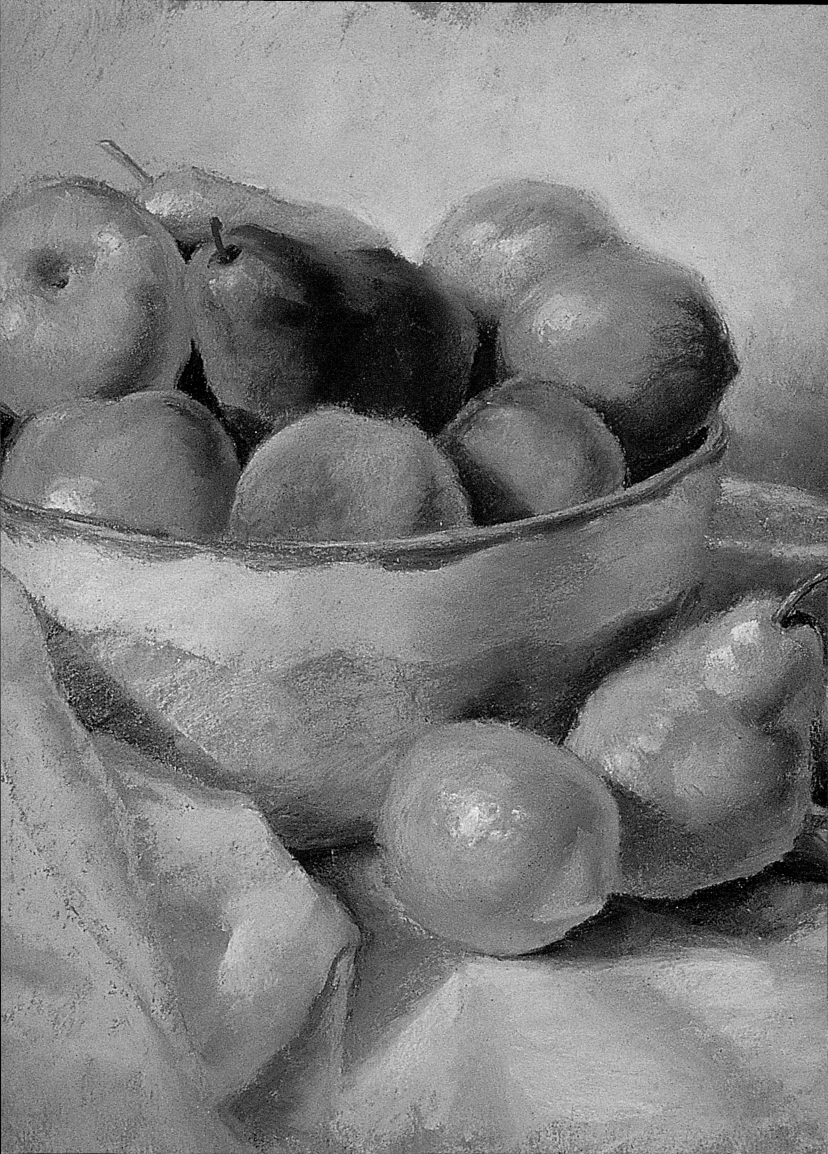

Pastel
WITH MARLA BAGGETTA

If you like working with color, then you'll love pastels! Pastel has recently experienced a renewed popularity as a serious painting medium, and several manufacturers now make high-quality materials readily available to artists. Pastels are easy to use, and you don't have to worry about drying times, toxicity, or odors—as you might if you were working with paint. Pastel is also attractive to many artists because of its versatility—it is both a painting and a drawing medium; moreover, you can create a seemingly endless variety of textures and effects with the vast number of hues that are available. And pastel is an extremely fluid and forgiving medium, which makes it great for beginners.

I've tried many other media throughout the years, but I always seem to come back to pastel. It is now my medium of choice, and I work almost exclusively in soft pastel. In this chapter, I'll demonstrate a variety of techniques and show you how to render an array of subject matter—we'll even explore working with different artistic styles. As you learn more about the vibrant and fascinating world of pastel, you'll begin to recognize the endless possibilities that this medium has to offer!

Approaching a Painting

The way you approach a painting in pastel is similar to painting in any other medium: Start with an undercolor and then build up the values from dark to light. I begin almost every painting I create (including the landscape shown here) by *toning* the support (applying a base color to cover the "white" of the support) with a wash of acrylic paint. Then I sketch or transfer my drawing to the support and begin blocking in and filling the main shapes. Next I determine the direction and intensity of the light source and begin to define the shapes. Then I work toward harmonizing the colors in the piece, developing the forms and values, and creating interest. Finally I refine the shapes and edges and add the details. When I'm done, it's easy to go back and adjust any areas that need attention by moving or even removing pigment.

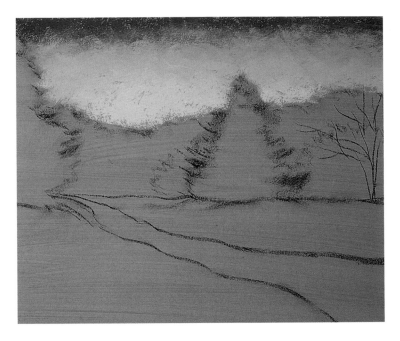

Step One I begin by toning a piece of sanded pastel paper with a diluted wash of acrylic paint. Toning assures that none of the unpainted support will show and allows a bit of color to sparkle through subsequent layers of color, harmonizing the finished piece. For the wash, I make a mixture of half yellow ochre paint and half water, and then I brush it evenly over the entire support. (I use an inexpensive brush because the sanded paper will eventually destroy it.) I let the support dry for about 20 minutes, and then I roughly sketch the scene with a pastel pencil, using a color that matches the subject. I start adding color from the top so that the pastel dust falls on the unpainted portion of the support, preventing it from contaminating any areas I've already worked on.

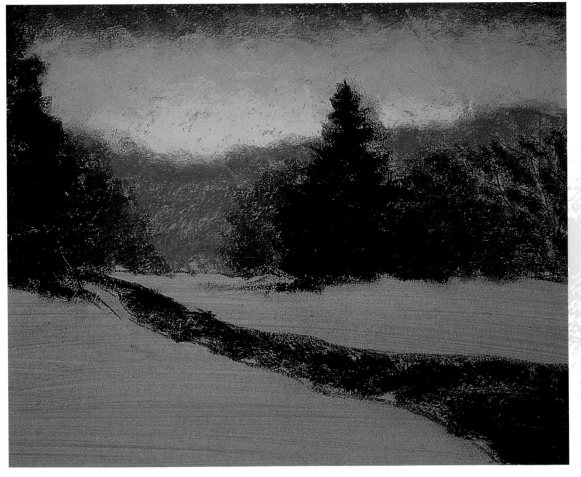

Step Two Next I block in the shapes of the darkest values in the scene, establishing the value relationships throughout the piece. Once I've placed the darks, I can judge the values of the midtones and lights based on how they compare to that darkest value. I always compare the values of the shapes in the subject to those around it; this way, I can determine the darkest darks and the lightest lights.

Contrasts in value create a sense of depth and realism in a painting.

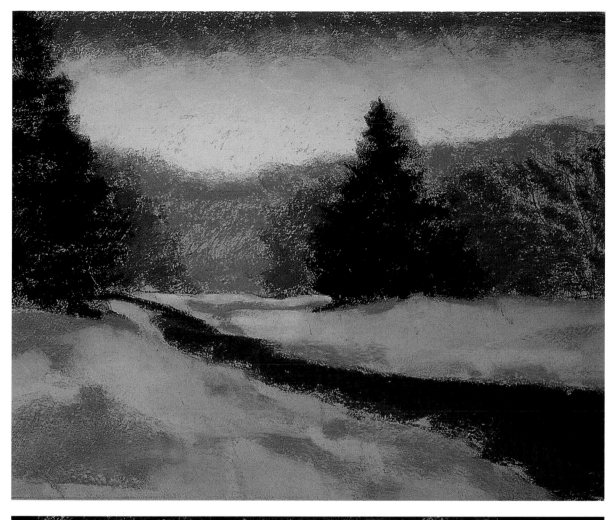

Step Three Now I block in the rest of the elements in the scene, building the values from dark to light. I weave in bits of the same colors throughout the piece to unify the color scheme and to create a sense of color harmony. I am continually adjusting the forms and values as I work, judging them against one another to make sure they are accurate compared to my reference photo.

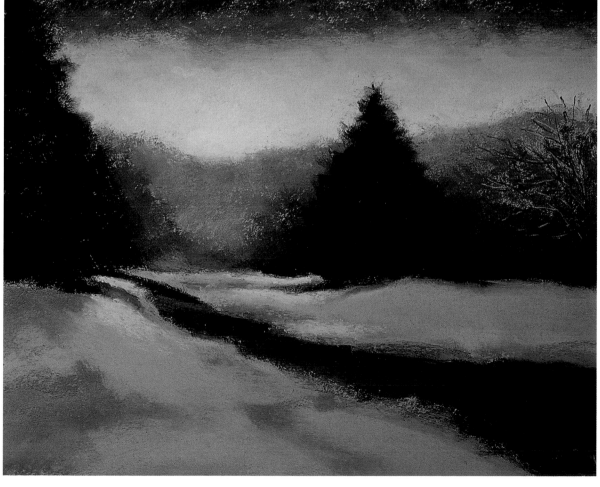

Step Four Finally I add the lightest lights—in this case, the highlight on the snow at the end of the pathway—and create the final details. When working with pastel, keep in mind that less is more—you don't want to overwork the piece. One of the most important aspects of painting in pastel is learning to recognize when to stop.

Composing Landscapes

Every good painting begins with a dynamic composition. *Composition* refers not only to the design or layout of a scene, but also to the relationship among the objects in the scene. Whether your subject is a still life or a landscape, the same rules of composition apply: A good composition uses a visual path to lead the viewer's eye in and around the painting, toward the focal point (also called the "center of interest"), which is typically placed off-center. The easiest way to create a visual path in a landscape is to include curving lines that lead from the foreground of the scene toward the focus. Another way to attract the eye is to place bright, warm colors near your focal point. In this example, the curve of the road and the bright yellow trees draw your eye toward the car, which is the center of interest (see page 46). The dark trees on the right act as a *stopper;* they prevent your eye from wandering away from the focal point.

Color Palette

SOFT PASTELS:
black
burnt umber
cadmium orange
cold medium gray
dark gray-blue
light gray
neutral gray light
olive green
peach
permanent red pale
quinacridone violet
red oxide
rich umber
white

HARD PASTELS:
black
cold light gray
dark red

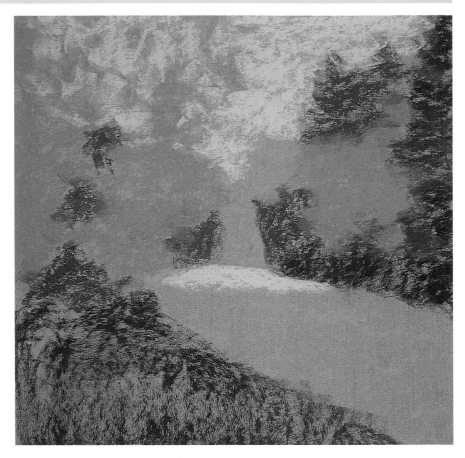

Step One Once I have toned my support, I start blocking in the main shapes of the elements in the scene. I use burnt umber in the foreground, cadmium orange for the tree masses, and light gray for the road. I want to allow the color of the paper to show through in the orange trees, so I'm careful not to make the underpainting too thick.

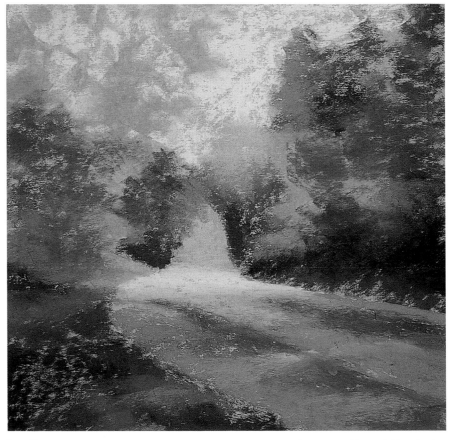

Step Two Next I add red oxide to the middle ground tree shapes and add dark gray-blue and rich umber in the foreground. Then I start to darken the road in the foreground with blue-gray to achieve a clear separation of dark and light—this will create a greater sense of drama in the finished scene.

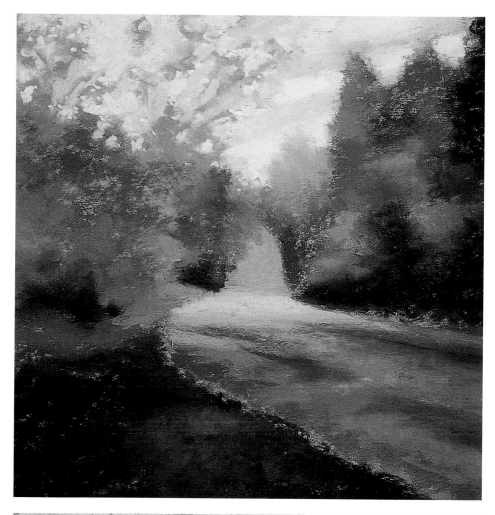

Step Three Now I use permanent red pale and white for the negative shapes in the sky (the spaces between the leaves and the branches of the trees). I want the orange trees to seem airy and lacy, so I alternate between working on the negative shapes in the sky and on the positive shapes in the trees to achieve the illusion of the light sparkling through the leaves. I add black to some of the foreground shapes, as well as to the end of the road, and blend slightly with my finger. I place these darks carefully (and sparingly) to lead the viewer's eye to the focal point of the painting.

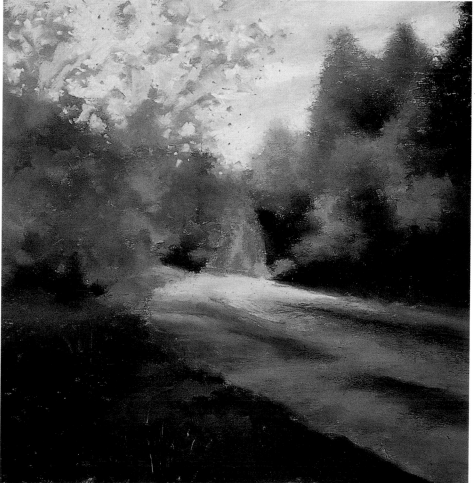

Detail

Step Four In the foreground and middle ground, I weave in some beautiful, rich fall colors: olive green, quinacridone violet, and red oxide. Here I blend the colors with my finger, taking care not to overblend. I don't want to cover every bit of paper completely—this way, the ground will shimmer through in places, contributing to the color harmony in the piece.

Setting Up a Still Life

Composing a still life gives you a great deal of control over the subject because all the decisions are up to you! You can choose the lighting, the background, the type of objects you want to include, and what textures you want to depict. Try selecting objects with a variety of shapes and sizes, and be sure to overlap the elements to avoid a stagnant composition. Also keep in mind that it's easier to control an artificial light source rather than relying on natural light—with artificial light, the shadows will remain constant throughout the painting process. Because careful observation is so important in still life painting, I place my setup slightly below eye level, and I stand close to it so I can see the details. For this painting, I tested a number of light sources and arrangements before settling on the most visually interesting setup—a slightly asymmetric arrangement with a strong light source coming from the left.

Color Palette

SOFT PASTELS:
burnt umber • fern green
light Naples yellow
light sap green • light turquoise blue
light warm gray • nut brown • viridian green
white • yellow ochre

HARD PASTELS:
carmine • cold deep gray
lemon yellow • light blue
light sap green • light turquoise blue
peacock blue • salmon pink • sanguine
shell pink • warm medium gray

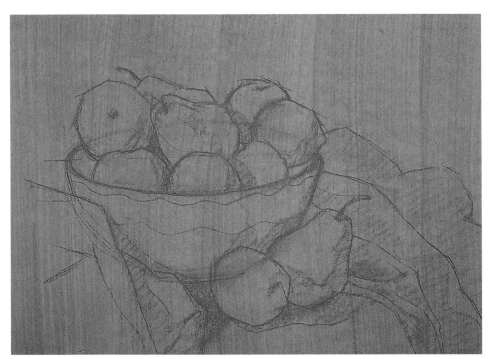

Step One I set up the elements on several different levels, and I choose objects with a variety of textures and colors to help me create a compelling composition. Then I tone the support with a wash of yellow ochre acrylic. (See page 46.) For the initial drawing, I use a cold deep gray hard pastel that will be easily covered by the subsequent layers of color. I draw the basic shapes of the bowl, the fruit, and the drape, paying particular attention to the ellipse of the bowl. I also outline some of the objects' shadows and contours.

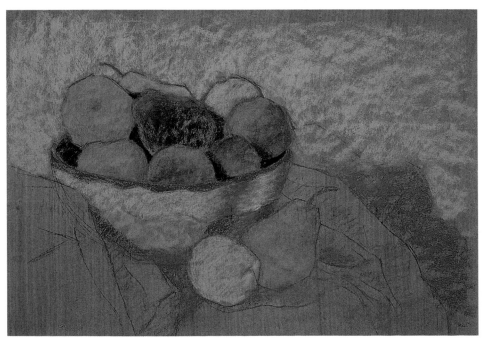

Step Two I continue using hard pastels to block in the basic shapes, working quickly and using the sides of the sticks so I don't fill in the tooth of the paper completely. I cover the background with shell pink, then paint the green apples with light sap green, the lemon with lemon yellow, and the peaches with layers of salmon pink and shell pink. I use light sap green for the green pears and a mix of sanguine and salmon pink for the red pear. For the stripes on the bowl, I apply light turquoise blue in the light areas and peacock blue in the dark areas. I also block in the cast shadow on the wall with warm medium gray. Then I use carmine to add some dark values between the pieces of fruit and on the shadows.

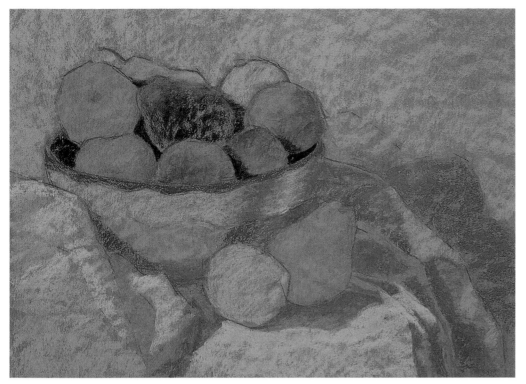

Step Three Next I block in the drape, using shell pink for the light areas, light blue for the shadows on the drape and the wall, and medium warm gray for the shadows on the fruit. Here I use the length of the pastel sticks to apply color, but I don't press very hard; I allow the texture and the color of the toned paper to show through.

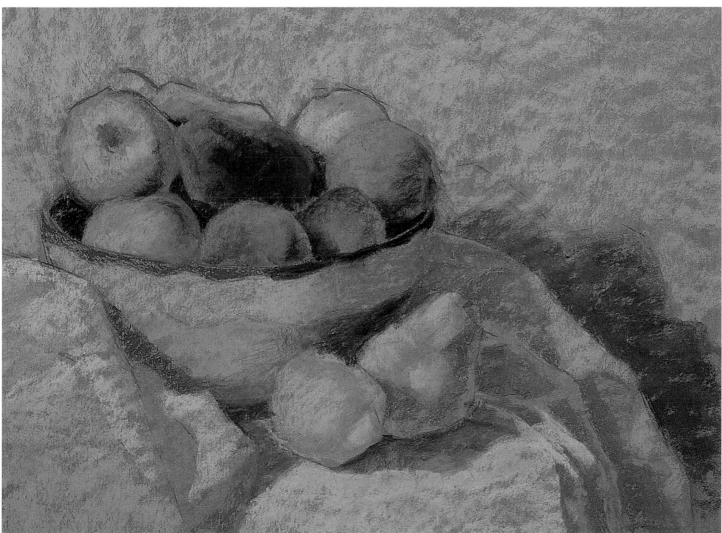

Step Four I observe my setup carefully to determine where each piece of fruit has a form shadow (a shadow on the object itself that helps to define its shape), a core shadow (the darkest part of the form shadow), and a cast shadow (a dark shadow that the object throws onto another surface). Some of the cast shadows fall on other pieces of fruit, and some fall on the drape or on the background. But each one follows and reveals the form of the objects they fall on. When I add the core shadow to each piece of fruit, its reflected light—the light bouncing off another object onto this one—is also revealed. The reflected light is a lighter value than the core shadow but slightly darker than the highlight. I use fern green for the core shadow of the lemon, and I switch to viridian green for the core shadow and the cast shadow of the green pear.

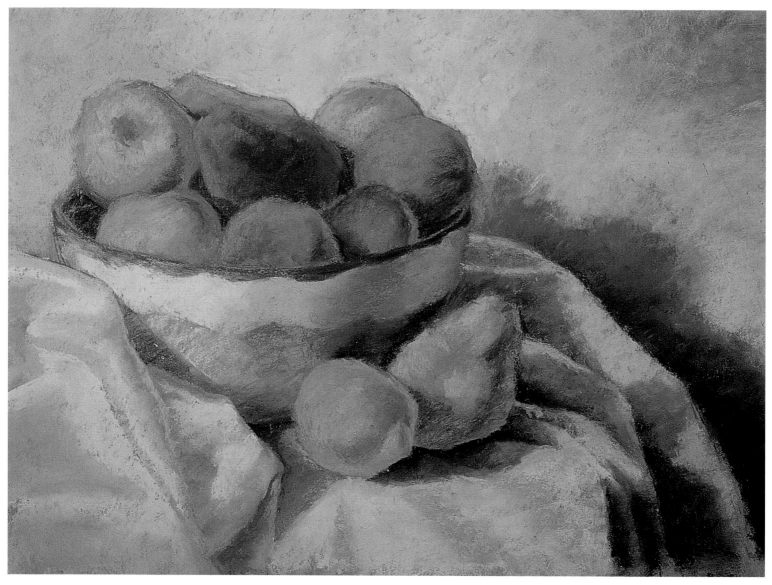

Step Five Once I have the forms of each element worked out, I begin to focus on the nuances of color and value that initially intrigued me in this scene. I add some light sap green to the top of the red pear. Then I layer the background with light Naples yellow in the center, adding light turquoise blue and warm light gray as I work toward the edges. Here I'm actually blending by layering, so I don't use my finger to blend at all. Next I darken the cast shadows against the wall with burnt umber.

LIGHTING YOUR SUBJECT

When you're working with a controlled light source, you can experiment with different angles to get various effects. But rather than lighting your subject simply from the front, try establishing your light source to one side and slightly above your subject, as I've done here, to create form and cast shadows that are more distinct.

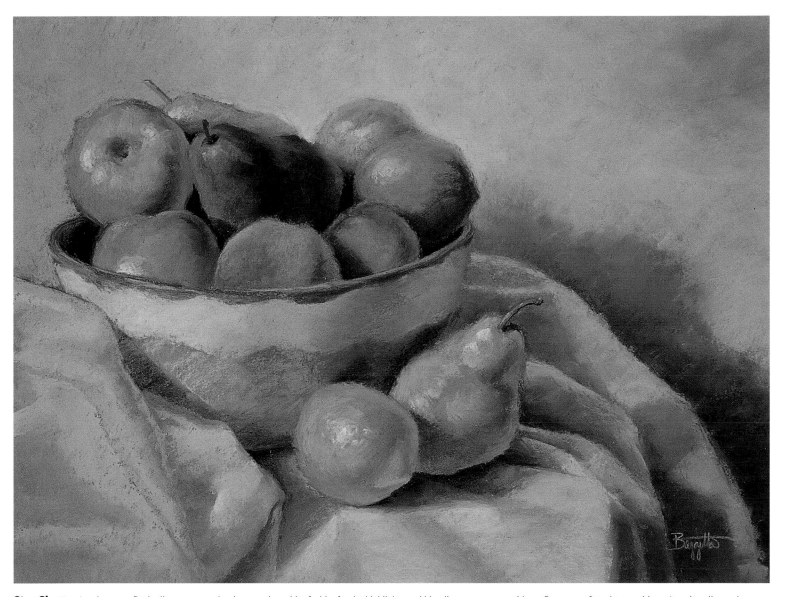

Step Six Now I make some final adjustments to the drape, using a bit of white for the highlights and blending some areas with my finger to soften the transitions. I apply yellow ochre to the center of the bowl, and I add some highlights to the fruit with a mixture of white and light Naples yellow. I also make sure that the highlights on the shiny fruits are more defined than the highlights on the surface of the fuzzy peaches. I create the stems to the fruit with nut brown, and then I add burnt umber on the shadowed side of each stem. Finally I blend the background a bit with my finger to smooth out the strokes.

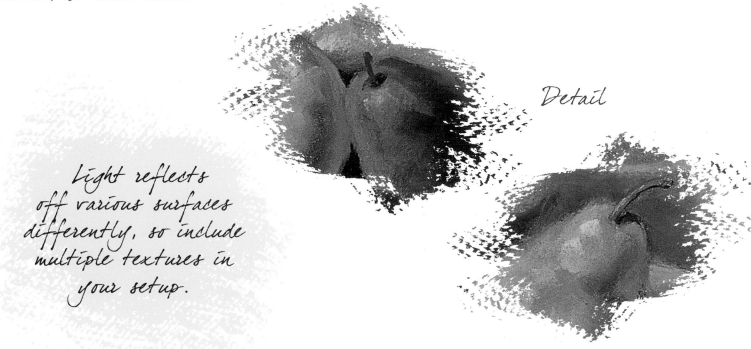

Detail

Light reflects off various surfaces differently, so include multiple textures in your setup.

Creating Depth

Every landscape painter strives to translate the feeling of a three-dimensional scene onto a flat, two-dimensional surface. But this task becomes more approachable when you understand the basic principles of *atmospheric* or *aerial perspective*. As objects (such as trees or mountains) recede into the distance, the particles in the atmosphere cause them to appear lighter, bluer, and less detailed than the objects in the foreground. In this example, I use these visual cues to depict a sense of depth: I create more detail in the objects in the foreground to make them appear closer, and I use cooler colors in the background and warmer colors in the foreground. Since warm colors appear to come forward in a scene, the oranges and yellows I use in the foreground make the foliage appear closer to the viewer than the distant trees.

Color Palette

SOFT PASTELS:
cobalt blue light • cold dark gray • cool middle gray
deep red madder • deep violet • light orange
light violet-blue • moss green • pale yellow • peach warm gray
permanent green • phthalocyanine (phthalo) blue deep
quinacridone violet • turquoise blue • violet • yellow ochre

HARD PASTELS:
fern green
spruce blue

PASTEL PENCILS:
light gray

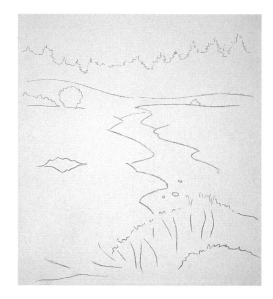

Step One I begin with a thumbnail sketch to work out the composition. To help convey a sense of depth in a landscape, it's important to establish a distinctive foreground, middle ground, and background. I also simplify my subject into areas of light, middle, and dark values. Once I've worked out the sketch, I create my final drawing on a piece of sanded pastel paper with a light gray pastel pencil that won't show through in my final painting.

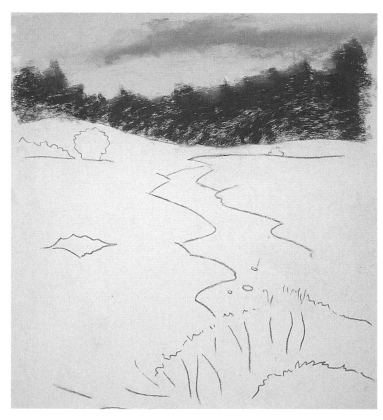

Step Two Once my sketch is complete, I leave a small border around the edge of the paper to give myself some flexibility in the composition. Starting from the top, I begin blocking in the sky with light orange and a bit of violet. I also block in the distant tree line on the horizon with turquoise blue; I want this blue to be a cool base color for the darker blue-green that I will eventually use to cover most of it. These cool colors will help create the illusion that the trees are receding into the distance.

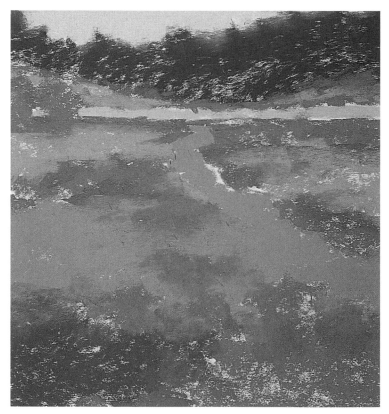

Step Three Next I use moss green, peach warm gray, and cool middle gray to establish some of the middle value shapes on the banks of the river in the middle ground. I establish the key shapes, knowing that these will change a bit as I go. I also create the larger shapes of the water with light violet-blue. The colors I use here are slightly warmer than those in the background, but they are slightly cooler than those I will use in the foreground.

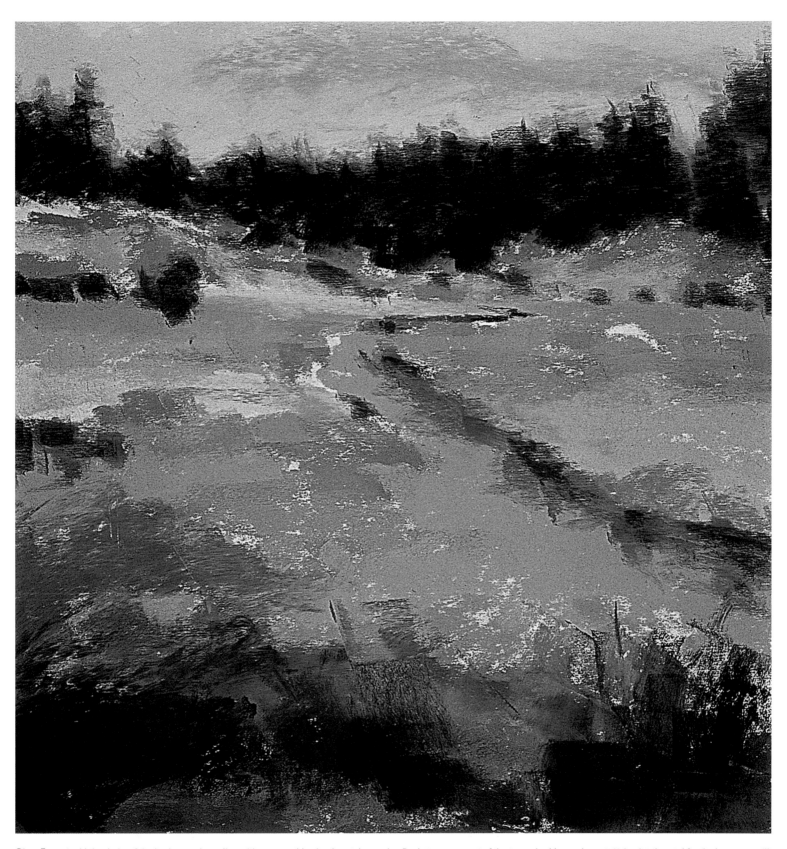

Step Four I add the darks of the background tree line with a spruce blue hard pastel, pressing firmly to cover most of the turquoise blue undercoat. Using hard pastel for the base coat will allow me to add more layers of soft pastel over it later. I add darks in the water reflections and the foreground water with phthalo blue deep, and I rework some of the water shapes. At this point, I've established most of my complete range of values. I add some darks into the water where the tree line is reflected with cold dark gray. Then I use deep violet to gradate the water in the foreground.

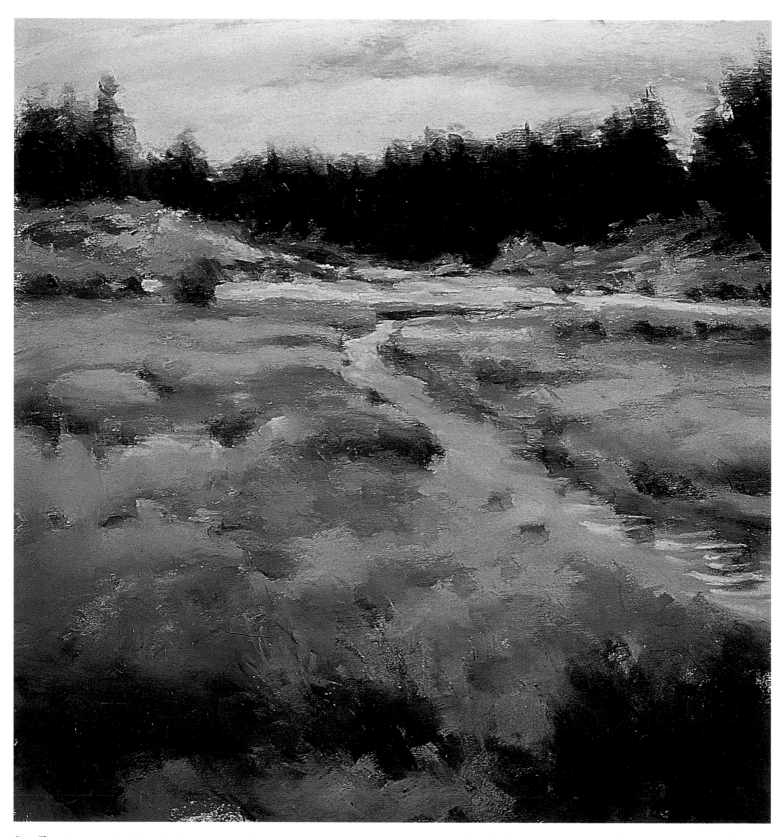

Step Five I "punch up" the light on the horizon in front of the tree line with pale yellow. Next I add deep red madder into the moss shapes in the middle and foreground, which will make them appear to "pop" forward. This is really the exciting part, where the piece is coming together and begins to take on a life of its own!

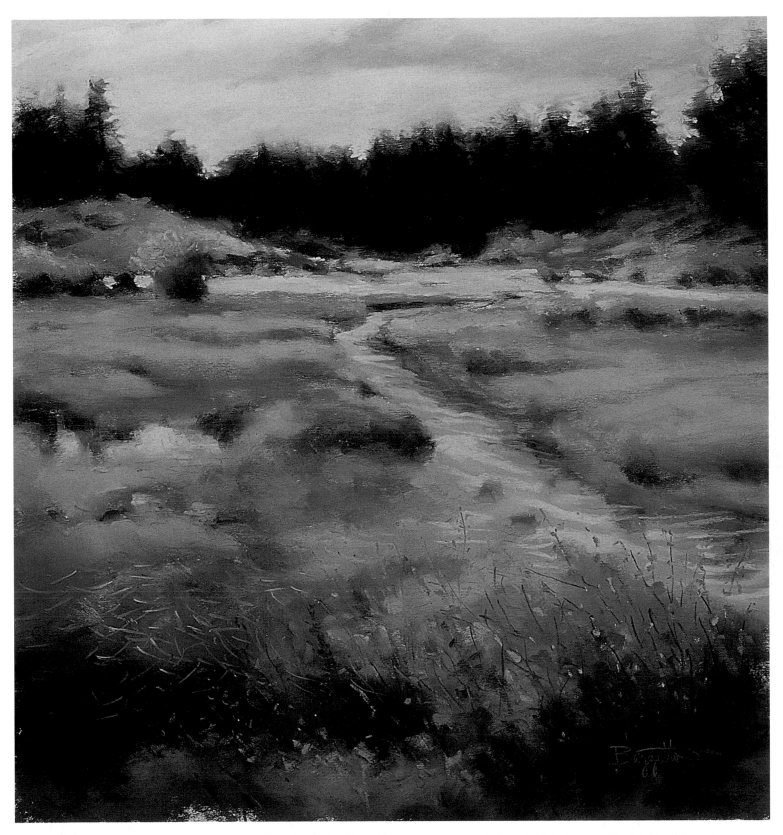

Step Six I add the details sparingly, creating some calligraphic strokes of quinacridone violet, permanent green, and yellow ochre in the foreground brush to bring it forward even more. To depict the bits of grass floating on the surface of the water, I add short strokes of a fern green hard pastel stick to contrast the dark blue of the water in the foreground. I carefully adjust some of the highlights in the water with cobalt blue light. When I feel I've achieved a sense of depth in the scene, I know my painting is complete.

Using Photo References

With traditional and digital photography, you can work in the studio at any hour and in any season. But there are a few things to keep in mind when working from photos. First you must realize that the camera is not discriminating—it doesn't decide what the most important element is in a scene, so it's your job as an artist to make choices that will make your piece more than merely a copy of a photograph. Experiment with cropping out some elements to simplify a scene, or change the angle of your shot to get a different viewpoint. Also keep in mind that photos tend to distort perspective (especially if you use a wide-angle lens), so you should never trace a photograph. It's best to use your snapshots as starting points, knowing that you can edit the image when you need to. For this painting, I took several shots of the location and then combined them to create the final composition.

Color Palette

SOFT PASTELS:
bottle green • burnt umber • dark rose
deep yellow • gray-blue • ivory
light cool gray • light sap green
olive green • palm green
peacock blue • permanent green
phthalo blue • raw sienna
rose madder • rose madder dark
rose madder light • rust • spruce blue
turquoise blue • white • yellow ochre

HARD PASTELS:
light cool gray
rust

PASTEL PENCILS:
light gray

Step One First I tone a piece of sanded paper with yellow ochre acrylic paint and allow it to dry. Then I sketch the horizon line and the main shapes with a light gray pastel pencil. Next I block in the sky with phthalo blue, leaving the paper blank where I plan to place the large cloud shapes. I block in the undersides of the clouds with gray-blue and use rose madder light on the tops. Then I add some dark rose in the middle of the cloud shapes.

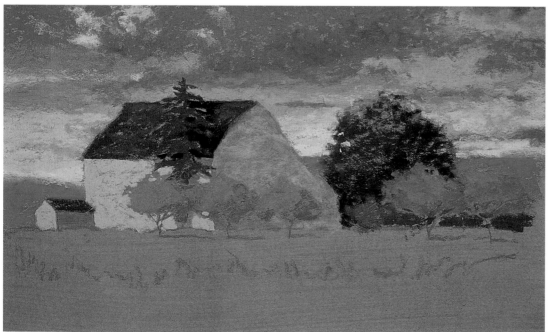

Step Two Next I block in the tree line on the horizon with peacock blue, and I rough in the large reddish tree with rust on the light side and rose madder dark on the shadowed side. I also use the length of the rust hard pastel to block in the large shape of the roof, keeping the paper showing where I'll place the pine tree in front. Then I add the shadow to the side of the barn with a mixture of dark rose and turquoise blue, using light pressure so I don't fill the entire tooth of the paper. I paint the light side of the barn with ivory, and then I paint the center pine tree and the bushes at the right of the barn with palm green. I also block in the remaining trees with olive green on the shadow side and light sap green on the highlight side.

Combining Photos

You can't always capture a scene in one shot. For this piece, I used a combination of reference photos, picking and choosing the elements I liked from each. In this case, I used the sky from one shot and a close-up of the barn from another. (For more on changing the elements using artistic license, see page 84.)

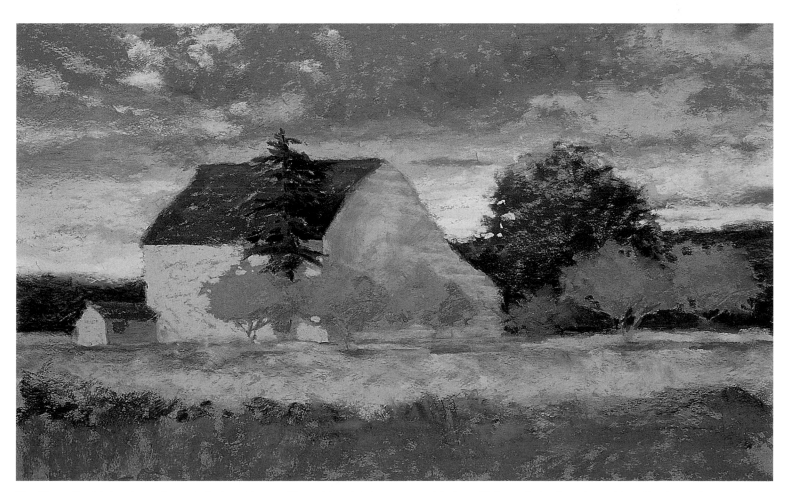

Step Three Now I darken the tree line on the horizon with spruce blue, and I rough in the grass around the barn with deep yellow, yellow ochre, and ivory. Then I create the cast shadows of the trees with olive green and turquoise blue. In the foreground, I lay in some palm green, permanent green, and spruce blue, allowing quite a bit of the toned paper to show through.

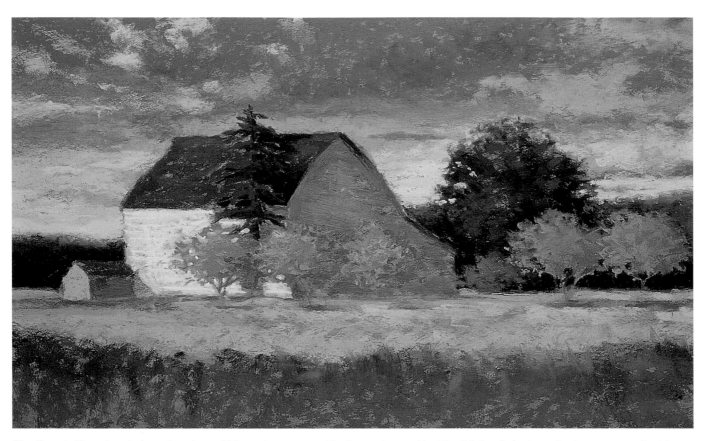

Step Four I add a variety of color to the red tree with burnt sienna, rose madder deep, and spruce blue. Then I darken the bushes under the two trees on the right. Next I add the cast shadow of the pine tree to the rooftop with rose madder deep, and then I decide to darken the shadowed side of the barn with a light layer of the phthalo blue I used in the sky. I draw in the dark overhang of the rooftop with spruce blue; then I add white to the light sides of the barn and shed, applying the pastel in even, parallel strokes to emulate the siding of the barn. I make sure to stroke up toward the vanishing point. (See "Using Two-Point Perspective" on page 59.) I add white, I use it as an opportunity to "cut in" and define the negative shapes around the tree in front of the light side of the barn. Then I give the pine tree a shadow side with bottle green.

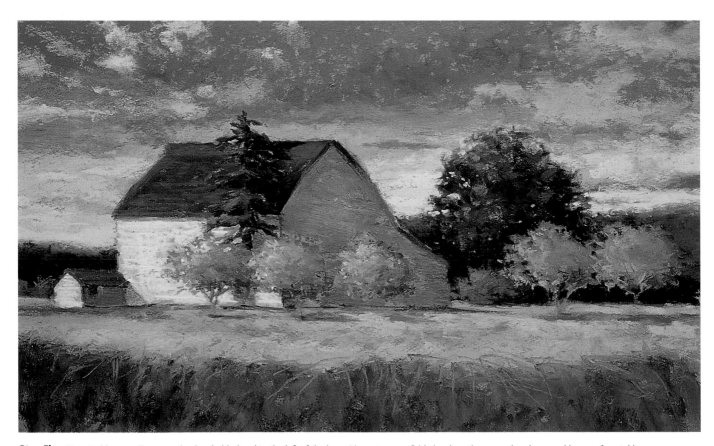

Step Five Next I add some olive green bushes behind and to the left of the barn. I have to press fairly hard, as there are already several layers of pastel here. I add a few spots of old lilac to the red tree and a few bits of turquoise to the foreground trees. I also add some ivory highlights to the foreground trees.

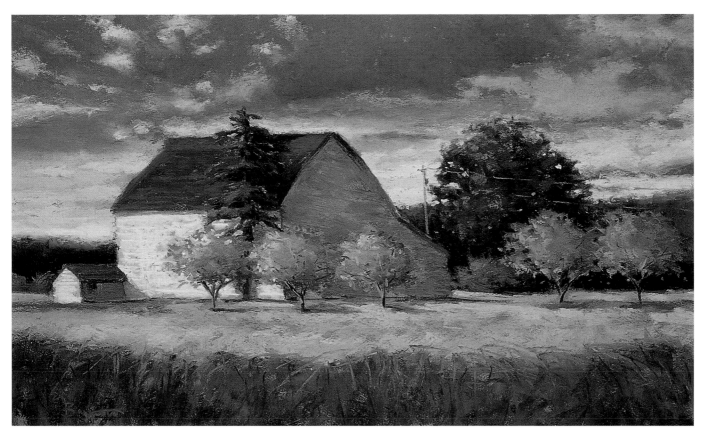

Step Six I complete the foreground trees by adding burnt umber to the dark side of the tree trunks and light cool gray for the light side. Then I add the telephone pole and wires with a sharp, light cool gray hard stick, drawing the wires with broken lines to emulate the way they appear to shimmer in the sunlight. Finally I layer the foreground with more palm green and olive green and indicate some grasses in the foreground shadows with raw sienna.

USING TWO-POINT PERSPECTIVE

The concept of perspective can be intimidating to some artists, but it's simply a way to represent three dimensions on a flat surface. When an object recedes into the distance, its receding lines seem to converge at a point on the horizon called the "vanishing point." If the lines are on one plane, the receding lines converge at one vanishing point; this is referred to as "one-point perspective." But if there are two planes involved, such as a building viewed from a corner, each plane has its own vanishing point, called "two-point perspective." In this example, the corner of the house is closest to us, and the two sides recede toward two different points on the horizon. If you were sketching this scene, you could try placing a straightedge on any line on this house and continue to one of the vanishing points to make sure the perspective is correct.

Vanishing Points In this example, the two points at each end of the horizon mark the vanishing points. Notice that the elements in the scene get smaller as they approach the vanishing points.

Depicting Clouds and Skyscapes

Clouds and skies are beautiful and interesting painting subjects, and pastel is perfect for capturing the soft, billowy nature of cloudy skies. With soft pastels, you can convey the transparency of wispy clouds by using less pigment—or you can depict the thick, dark, ominous feel of storm clouds by layering heavy applications of color. Once you've learned to render realistic clouds, you can use them to add a sense of drama in your landscapes. In some cases, the clouds are so intriguing that they become more than just elements in the painting—they become the entire focus! For example, I composed this skyscape based on a photo I took on my way home one evening. The sky was so beautiful and the clouds were so spectacular that I had to pull over and capture it on film. Later I realized if I hadn't taken the photo as proof of this amazing sky, some might think I created the painting from my imagination!

Color Palette

SOFT PASTELS:
blue-violet • burnt sienna
burnt umber • cerulean blue light
dark purple-gray • hyacinth violet
ivory • light blue • medium cool gray
permanent red light
phthalo blue deep
quinacridone violet • raw sienna
ultramarine blue light

HARD PASTELS:
red carmine
spruce blue
violet rouge

Step One First I tone my support with yellow ochre acrylic paint; once it's dry, I lightly sketch the basic shapes of the clouds. Each cloud has a form shadow and reflected light. Sometimes it may cast a shadow onto another cloud or on the ground, so be sure to observe carefully and then draw all of the shapes you see.

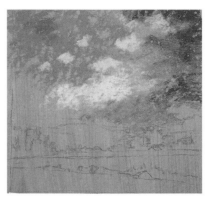

Step Two It's nearly impossible to render the complex details of each cloud, so I concentrate on capturing the main shapes, colors, and values. I choose hyacinth violet for the thinner clouds at the upper left, and paint some cerulean blue light breaking through. I use permanent red light for the lightest cloud shapes, ultramarine blue light for the clouds nearest the horizon, and phthalo blue deep for the darkest clouds at the top right. I use light pressure and stroke across the surface of the paper with the side of the stick.

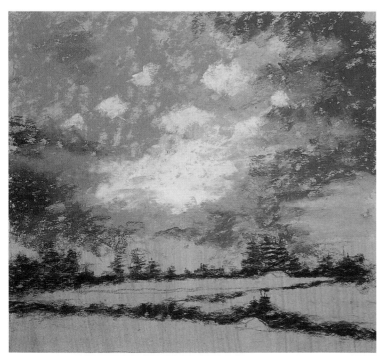

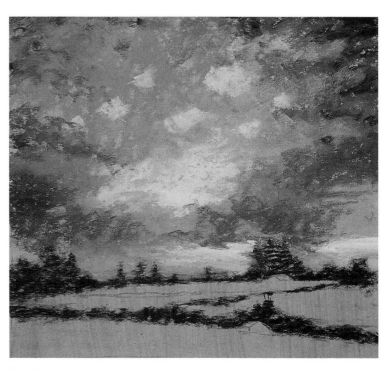

Step Three Next I work from the top down toward the horizon, adding dark purple-gray at the lower left of the sky and light blue on the right where the blue sky breaks through the clouds. Then I block in the tree line with a red carmine hard stick. This complementary base will add to the rich color of the trees when I paint over them with green.

Step Four Now I begin to work on the bright clouds at the horizon, adding ivory and permanent red light. I press hard with the soft sticks to fill the tooth of the paper almost completely. This area is the focal point of the scene—the rest of the cloud shapes and the contrast between the lightest lights and darkest darks will lead the viewer's eye here.

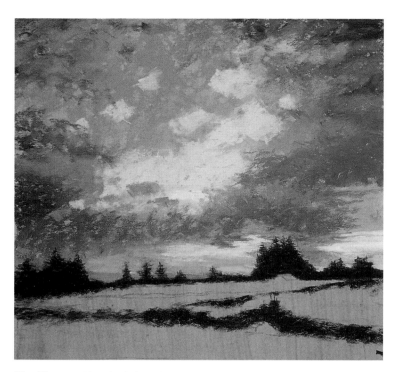

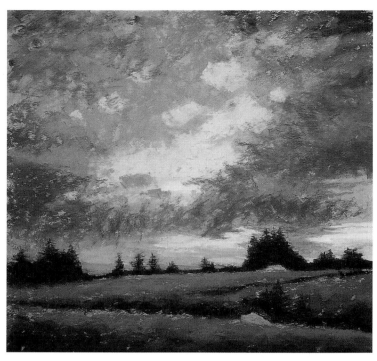

Step Five I establish the darks in the tree line with hard pastel sticks of spruce blue and violet rouge. At this point I have to use a fair amount of pressure because I'm layering these hard pastel colors over a previous layer of hard pastel. Notice how the cool greens look so much richer over the red base coat than they would on the plain paper.

Step Six Next I block in the foreground with burnt umber, burnt sienna, and raw sienna. I apply some quinacridone violet in the extreme foreground, weaving it into and skipping it across the other colors with light pressure. I leave some areas of the paper showing through, especially where I plan to indicate the buildings.

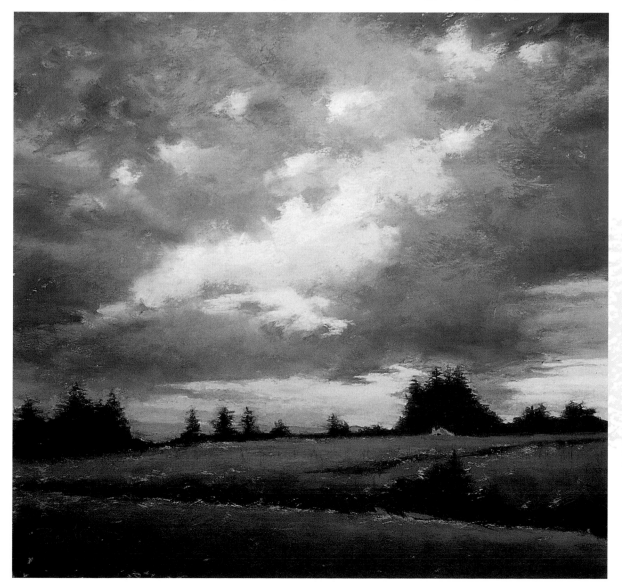

Step Seven I go back to the clouds, adjusting some of their shapes to improve the composition. I blend some of the clouds a bit with my finger, filling in some of the areas where there is too much paper showing through. Finally I indicate the buildings with medium cool gray, and then use heavy pressure to add a layer of blue-violet on top.

Creating a low horizon line maximizes the visual impact of a dramatic sky.

Working with White

When you start to develop an "artist's eye," you'll begin to see the nuances of color in everything. For example, at first glance, snow appears white, but if you look more closely, you'll see that it's actually made up of various pastel hues. Like all white objects, snow reflects the colors of the objects around it—especially the sky. So depending on the time of day, the sky may appear to be blue, green, pink, or purple, with pure white only in the brightest highlights. For this piece, I painted the snow with a variety of blues and grays, which help convey the peaceful mood. But I also included some of the brighter hues I used to paint the sky, which makes the scene look more realistic and adds color harmony to the painting.

Color Palette

SOFT PASTELS:
blue
cool gray
dark blue-gray
dark spruce blue
light gray
light orange-yellow

HARD PASTELS:
black
red
spruce blue

PASTEL PENCILS:
gray

Step One I start by toning my support with a yellow ochre acrylic wash. When my support is dry, I sketch the scene with a gray pastel pencil. Using the side of the pastel sticks, I quickly block in the sky with a gradation (see page 11) of blue and light orange-yellow, leaving some of the paper showing through. For this winter scene, I'll use a limited palette and rely on a lot of pale blues and subtle grays.

Detail

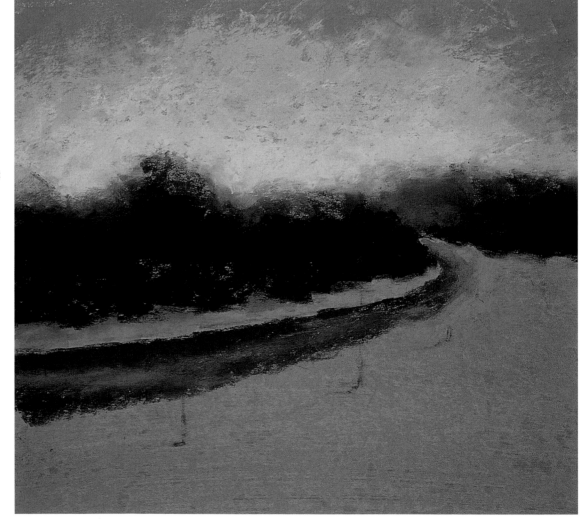

Step Two Next I block in the major elements: the background line of trees, the pathway, and the foreground snow. I use cool gray for the pathway and both dark blue-gray and dark spruce blue for the background tree shapes. I paint the middle values of the snow blue. I make sure not to apply too much pigment at this early stage.

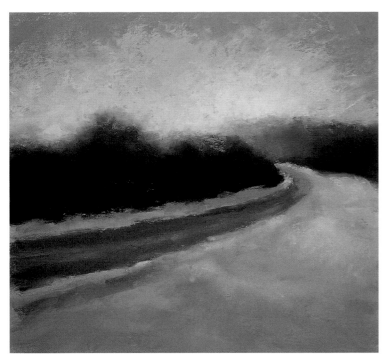

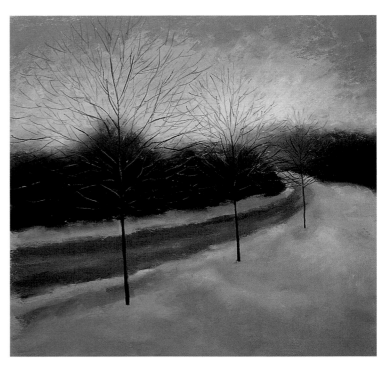

Step Three Now I add a layer of light gray in the foreground and highlight the snow with some of the same light orange-yellow I used in the sky. This helps to harmonize the piece and gives the snow some sparkle. It also leads the viewer's eye in toward the end of the pathway, which is my focal point. To give the snow a soft quality, I blend it a bit with my finger.

Step Four I go back to my reference photo to render the trees, but I keep in mind that I don't need to draw each individual branch. I place the main trunks with a black hard pastel, and then I draw the secondary branches with a hard spruce blue hard stick. Next I switch to a red hard pastel to render some of the tiny branches at the top of the tree.

Step Five Now I add the finishing touches. I give each tree a cast shadow with gray-blue, and I decide to include some simple footprints in the snow for interest. Because this isn't in my reference photo, I need to keep the light source in mind as I create the prints and their shadows. Notice that throughout this piece, I never used white!

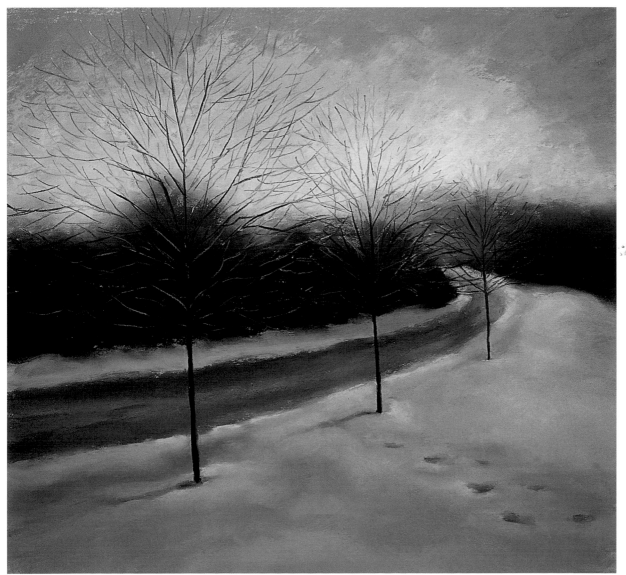

Detail

Focusing on Flowers

Flowers are timeless and attractive subjects for a painting a variety of shapes, colors, and textures. Rendering a floral bouquet gives you the chance to combine various types of flowers and foliage. Although it's probably more convenient to paint from photos, I prefer to paint floral bouquets from life. That way, I can play around with different arrangements before I settle on the one I like best. When I'm setting up a bouquet, I try to create a well-balanced color scheme; for this painting, I chose flowers with complementary colors: purple lilacs and yellow roses.

Color Palette

SOFT PASTELS:
burnt umber
cold medium gray
cool gray
fern green
gray phthalo blue-green
light blue
light gray-green
neutral gray-green
palm green
peach
shell pink
spruce blue
Van Dyke brown
warm light gray
warm ochre
white
yellow ochre light

HARD PASTELS:
blue-violet
hyacinth violet
light ochre • lilac • rust

PASTEL PENCILS:
light gray

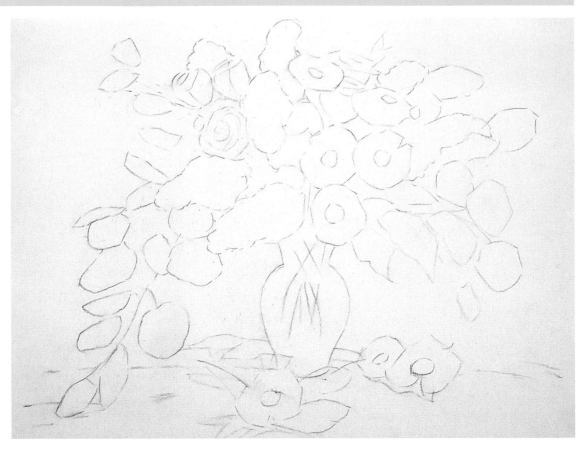

Step One For this piece, I choose a piece of white sanded pastel paper that will allow me to see my detailed drawing more clearly. First I create a careful line drawing of the basic shapes with a light gray pastel pencil. I concentrate on the largest flower shapes and think of the daisies as concave disks, facing some toward the light and placing others in shadow. I'm working from life, so I have to work fairly quickly before the flowers start to wilt or droop.

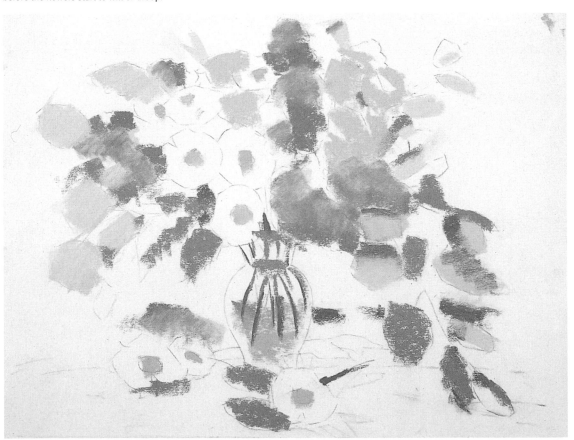

Step Two I use a lilac hard pastel for the middle tones of the lilacs and a hyacinth violet hard pastel for the darks. Then I block in the roses with a light ochre hard pastel, using medium pressure. I use fern green for the eucalyptus leaves in the light and palm green for those in shadow. I place the shadows on the daisies with warm light gray, but I leave the white of the paper showing for the light areas. The centers of the daisies are the same light ochre I use for the roses.

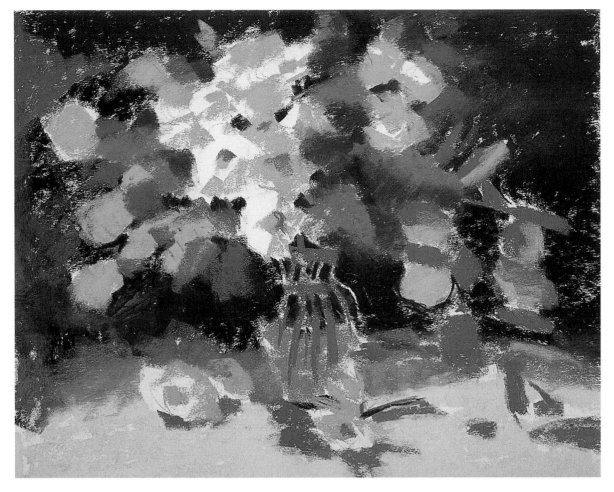

Step Three Next I block in the background with spruce blue, burnt umber, cold medium gray, and palm green. Then I rough in the foreground with shell pink. I use neutral gray green inside the vase and palm green for the stems in the vase. I let some paper show through around the edge of the vase where the glass is the thickest, letting the white paper act as the highlight.

Detail

Step Four Next I use spruce blue to draw the contours around the leaf shapes and "cut" into the lighter values to define them. I create some texture in the lilacs by using the square end of a blue-violet hard pastel to render the petals. Then I add a layer of light blue in the same manner. I create shadows in the roses with gray phthalo blue-green, and I add the edge of the table with cold medium gray. Then I create some stems throughout the arrangement with palm green, adding more in the vase with rust.

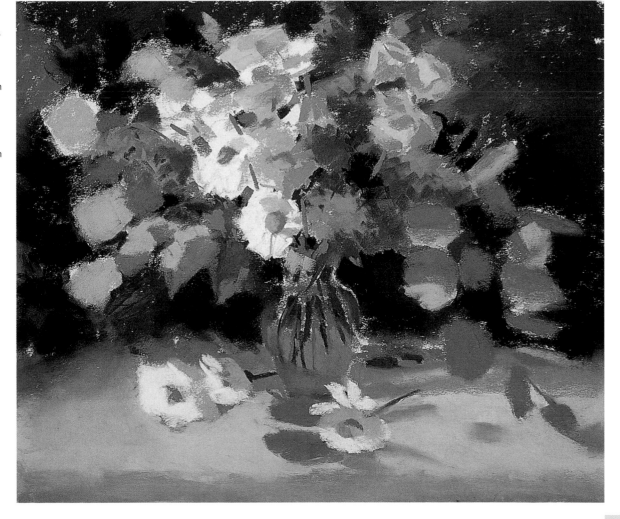

Step Five I blend in some Van Dyke brown on the right side of the vase to soften it and add some black to the background. I continue to refine the shapes of the leaves, and I add some more leaves with light blue and light gray-green. Then I focus on the daisies; I want to capture each flower without using too much detail, so I keep my strokes loose. I add peach to the shadowed sides of the daisies, and then I add a little white to the light sides, beginning to cover the paper.

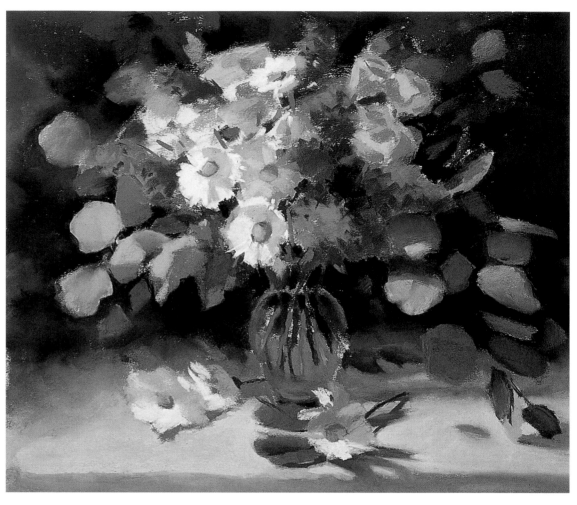

Step Six Each flower has a light side, a shadowed side, a core shadow, and reflected light. In some instances this is more obvious than in others. To define the roses, I use yellow ochre light to cut into the shapes, and I use light gray-green to depict the reflected light on them. Then I start to give the lilacs more texture, using the same colors as before but pressing harder and using a variety of strokes to shape them.

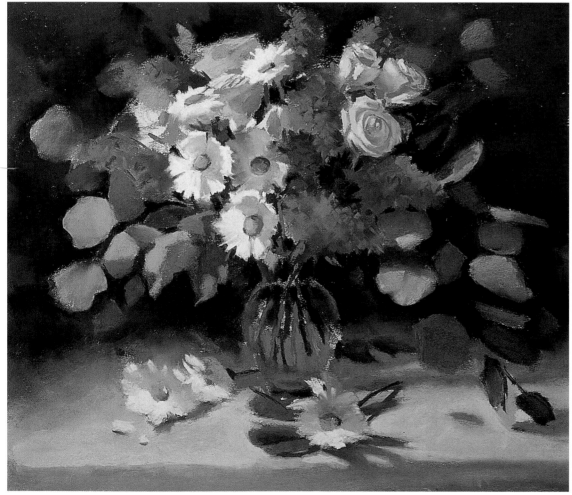

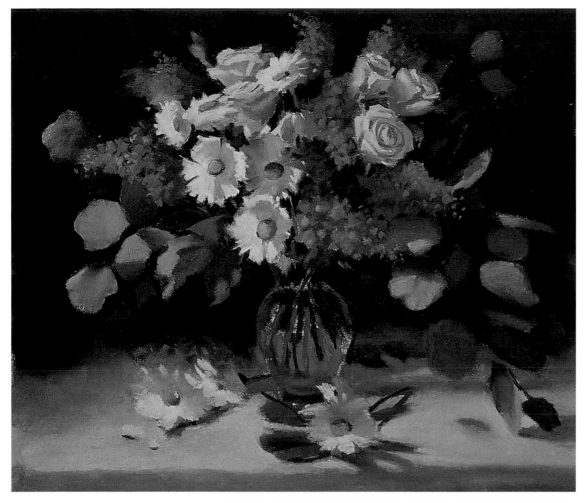

Step Seven Next I add warm ochre to the inside of the roses and continue to define the leaves and flower shapes. I add more texture to the lilacs, making the lilac on the table a little more solid by creating a dramatic contrast between the light and shadow.

Detail

Step Eight In this final stage I add some wispy branches on the eucalyptus with a sharpened rust pastel. I also add Van Dyke brown and cool gray to the vase, blending it smoothly with my finger.

Detail

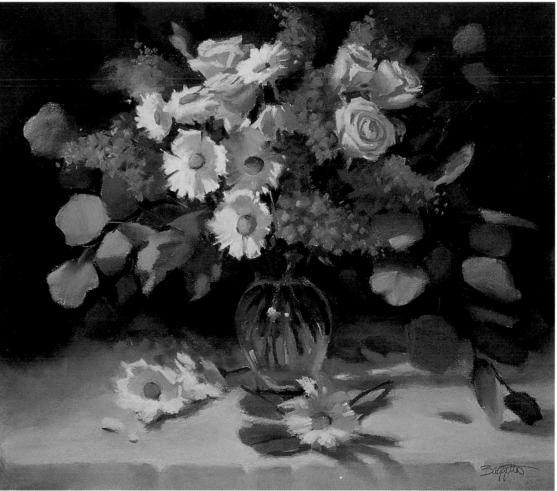

Conveying Light and Shadow

Although you can't literally create light in a painting, you *can* create the illusion of light and shadow through the effective use of color and value. When you look at your subject, try to determine the main shapes and colors of the light areas—and keep in mind that the direction and intensity of the light directly influence the colors and shadows in a scene. For example, light coming from behind the subject flattens the forms and illuminates their edges, sometimes creating a halo effect. Side lighting creates strong shadows and highlights, making the forms appear three-dimensional. And when light strikes the subject head-on, the shadows are minimal and the colors are more intense. In this example, the light source is coming from the upper left, causing the warm light to filter through the trees and creating long, cool shadows on the sidewalk.

Color Palette

SOFT PASTELS:
black • burnt sienna
cobalt blue-green
cold light gray
cold medium gray • gray-blue
ivory • orange ochre
permanent orange
permanent yellow
permanent yellow deep
permanent yellow lemon
permanent yellow light
raw umber • spruce green
turquoise blue
Van Dyke brown
walnut brown • warm olive green
white • yellow ochre light

HARD PASTELS:
black
burnt sienna
old deep gray

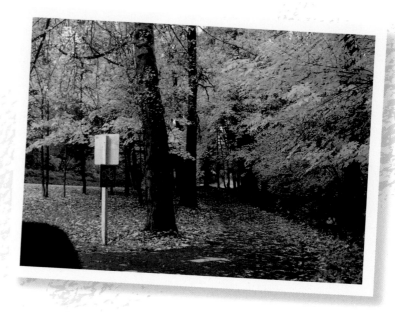

Capturing Light I love walking under a canopy of colorful leaves on an autumn afternoon; it's as though the light is coming from within the mass of trees. This is because the sunlight is filtering through the almost transparent leaves at an angle. The low viewpoint makes it seem as if we are looking slightly up at the trees, so they appear to be glowing with light.

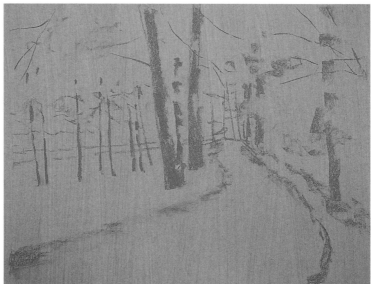

Step One First I tone my paper with yellow ochre acrylic paint and create my sketch with a cold deep gray hard pastel stick. I draw all the main elements and place the two main tree trunks in the center of the composition. I normally avoid placing the focal point in the center of the painting, but in this case the path leads the eye away from the center.

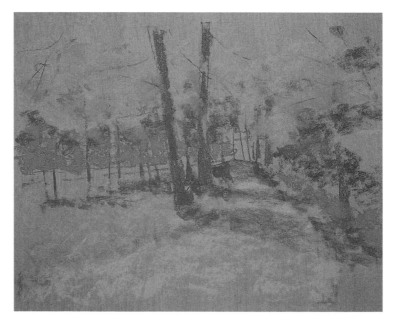

Step Two I start blocking in the main shapes of color, and adding orange ochre to the underside of the foliage. I also use this color to indicate the cast shadows of the trees on the ground. Then I add cold medium gray to block in the foliage in the background and gray-blue to start blocking in the path. I also suggest the shadow across the pathway with cold medium gray. Then I use permanent yellow light to begin building up the color in the foliage and the ground next to the path.

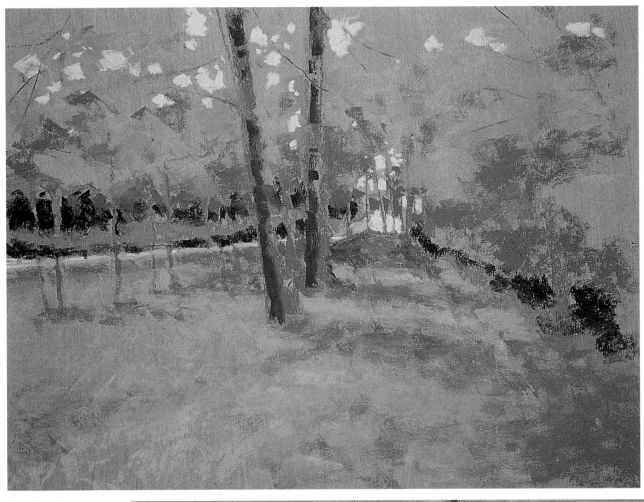

Step Three The contrast between dark and light is important in this piece, so I constantly adjust the values as I work. I darken the foliage behind the trees with spruce green. Then I use a burnt sienna hard pastel to darken the main tree trunks, being careful not to use a solid line so there is room in front of the trunk for the leaves. I add the road behind the trees and some highlights in the foliage with cold light gray, and then layer the light areas on the path with blue-gray.

Step Four I use permanent yellow light, permanent yellow lemon, and permanent yellow deep to render the sunlit foliage, and I indicate the shadowed shapes underneath with orange ochre and warm olive green. I also make sure to use some of the grays and blues from the path in the leaves. I add black under the foliage, in the background, and on the leading edge of the path on the right. Then I blend walnut brown in with the black, using my finger. I also layer black on the dark sides of the tree trunks to heighten the contrast between the dark trees and the light shapes in the background.

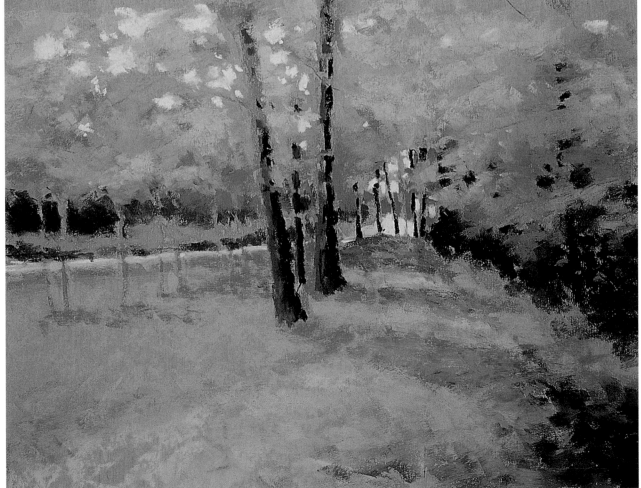

69

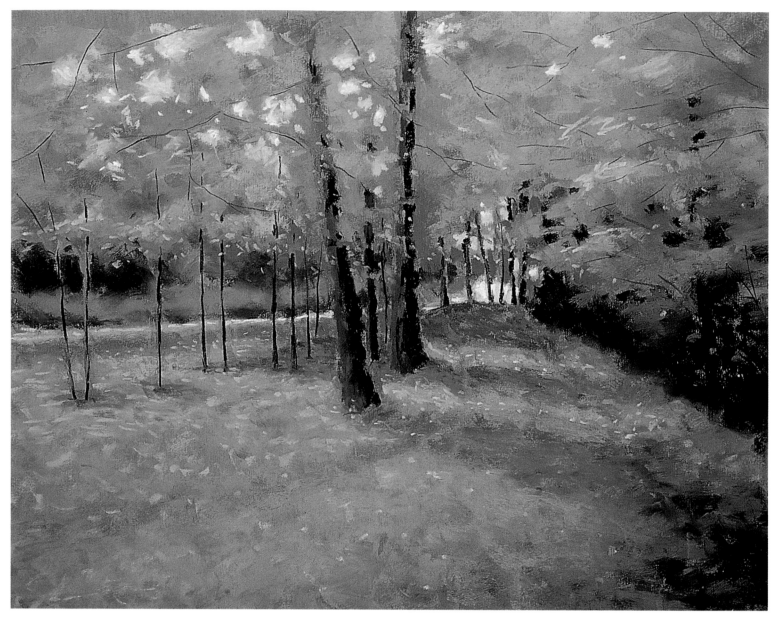

Step Five I continue to refine and adjust the color in the foliage, weaving more layers of permanent yellow and yellow ochre light into the leaves in the foreground. I use small, short strokes and dab with the end of my pastel sticks, pressing fairly hard to cover the layers I've already built up. I add some strokes of burnt sienna, raw umber, and ivory on the pathway to indicate fallen leaves. I lighten the foliage with permanent orange and then blend a few areas lightly with my fingers, but I'm careful not to overblend. Then I add a spot of cobalt blue-green to the end of the path, which helps to lead the viewer's eye down the road.

TREE DETAIL

To create the appearance of soft light filtering through the leaves, I allow bits of the toned paper to show through as I work.

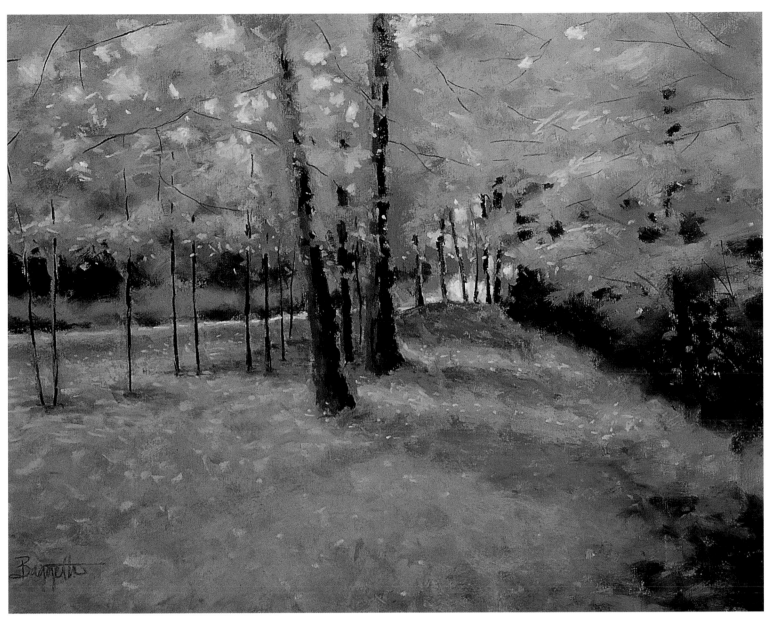

Step Six Next I add thin branches with a sharpened black hard pastel using broken lines. I also use a burnt sienna hard pastel to add some lighter branches. Then I add dabs of permanent yellow across the tree trunks and the path to indicate falling leaves and a few more strokes of white to represent the light coming through the foliage. I apply turquoise blue on the path and darken the right corner with black and a bit of Van Dyke brown. Then I blend a few spots along the path with my finger, merging the gray and the black a bit more.

Using broken lines gives the illusion that the branches are weaving in and out of the foliage.

Details

Rendering Animals

Animals have always been a favorite subject for artists, and pastels are ideal for rendering them. With pastels, you can create soft, fluffy fur using smooth blends or depict coarse, wiry hair using fine strokes of pastel pencil; you can even use a paper blending stump to drag and blend one color into another, creating the appearance of a more textured fur. But it's not just the tools and techniques that make an animal rendering realistic—the support you select is also important. Sanded paper makes an excellent support for animal paintings because its rough grain helps convey a tactile texture. However, smoother papers also work well because they can accommodate more layers of color, which is useful for depicting animals with thick fur. For this rendering, I chose a smooth, middle-toned paper, which provided a good base color.

Color Palette

SOFT PASTELS:
light ultramarine blue

HARD PASTELS:
light blue • Van Dyke brown

PASTEL PENCILS:
black • burnt carmine • burnt umber
caput mortuum • cobalt blue • cold gray
cream • dark indigo • dark umber
dark sepia • light flesh
light ultramarine blue
light yellow ochre • Payne's gray
raw umber • sanguine • terra cotta
turquoise blue • walnut brown
warm gray • white • yellow ochre

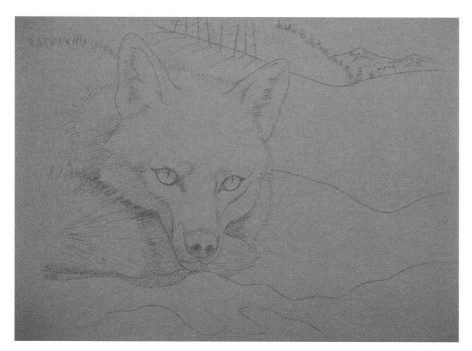

Step One I want to put the fox in a natural environment, so I create a simple background with a tree line and mountains in the distance, using a photo reference. I begin with a contour drawing of the fox and the main elements in the scene, using a Van Dyke brown hard pastel on the smooth side of a piece of raw sienna paper.

Pastel pencils are ideal for capturing fine details.

Step Two To achieve the fine details of the fox's fur and features, I use pastel pencils for the rest of this piece. First I use cobalt blue for the sky and turquoise blue for the wispy clouds and the glow on the horizon. I block in the mountains with caput mortuum and warm gray, and then I use a light flesh stick for the highlight side of the snow and light ultramarine for the shadowed side. Next I use burnt carmine for the base color along the tree line, but I leave the paper showing where I will place the trees above the fox's head. Using the side of the pastel pencil, I start to block in the background snow with light ultramarine blue and cobalt blue.

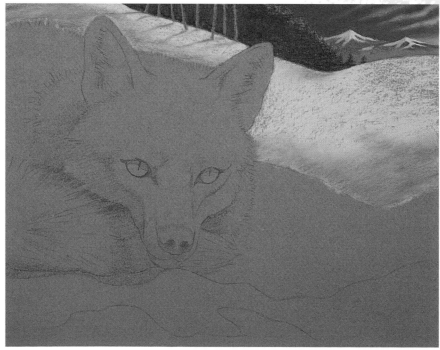

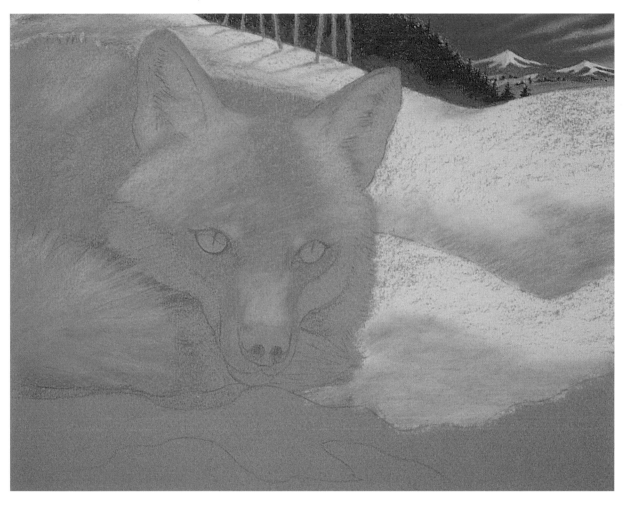

Step Three I continue building up values in the snow, and then I begin blocking in the fox's fur with sanguine for the darker areas and terra cotta for the lighter shapes, still using the side of the pencils. In this case, the texture of the paper will help me achieve the softness that I'm looking for. Then I darken the tree line with dark indigo, using heavy pressure to cover most of the red.

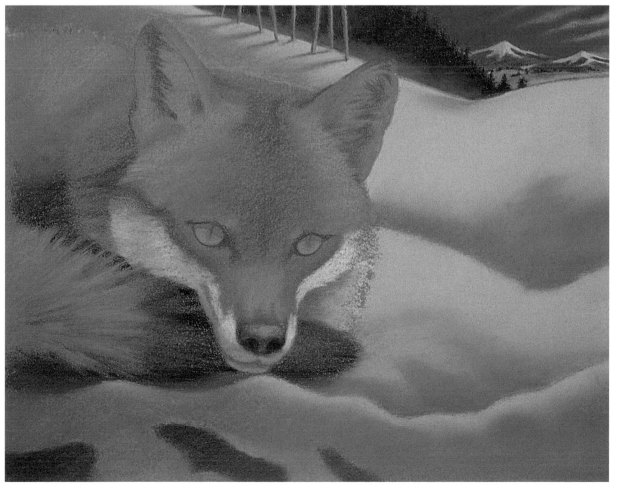

Step Four Next I add burnt umber and dark sepia on the tail, and place burnt umber shadows behind the tail and in the ears. For the ears, I draw the negative shapes around the hairs to define them. I use medium pressure and the side of my burnt umber pastel pencil to give more form to the face, darkening the areas between the ears and eyes. I also use burnt umber for the darks around the eyes, and I apply raw umber and terra cotta to the irises. I use warm gray and a bit of white for the area under the eyes and around the nose. Then I fill in the nose with Payne's gray and add a cold gray highlight. Next I fill in the foreground snow with cobalt blue and light ultramarine blue, and I use the point of my Van Dyke brown pencil to draw the tree trunks above the fox's head. I also use dark umber to indicate the bark showing through the snow at the bottom of the support.

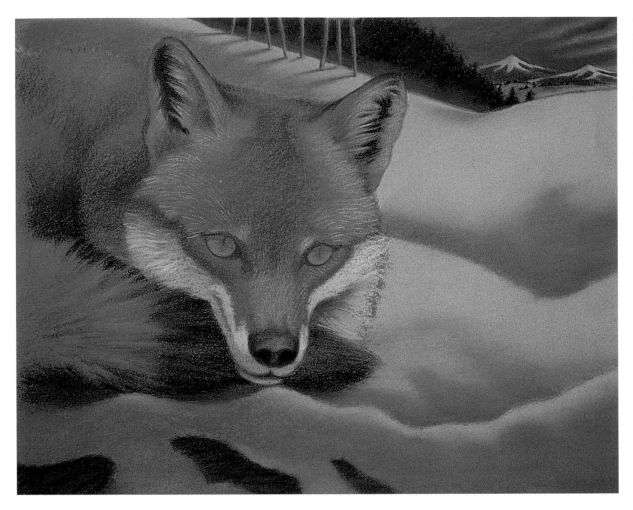

Step Five I start to create some highlights in the fur. I use light yellow ochre to draw a few individual hairs in some carefully chosen spots—above the eyes, on the snout, and below the ears. Then I switch to a cream pastel pencil to draw a few hairs on the inside of the ears, using the point of the pencil to make fine strokes. When the point of my pencil gets dull, I sharpen it with an electric sharpener.

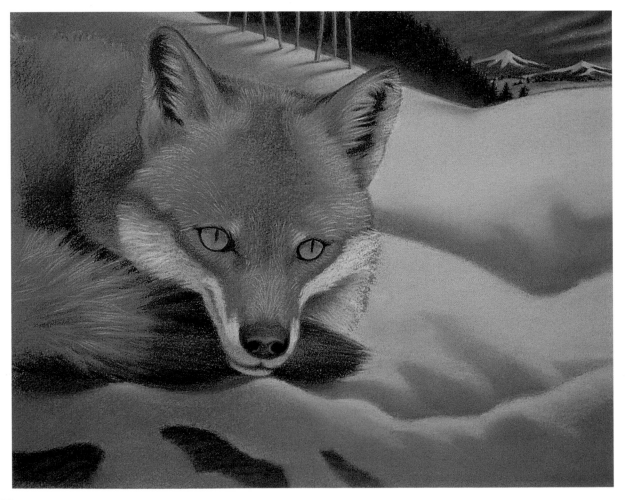

Step Six Next I darken the shapes around the eyes and the pupils with the point of a black pastel pencil. I press firmly, filling the tooth of the paper completely. Then I pick out a few highlights in the tail using the point of a yellow ochre pencil. I switch to a light blue hard pastel to define some interesting shapes in the snow, and then I apply a light ultramarine blue soft pastel for the highlights, blending slightly with my finger.

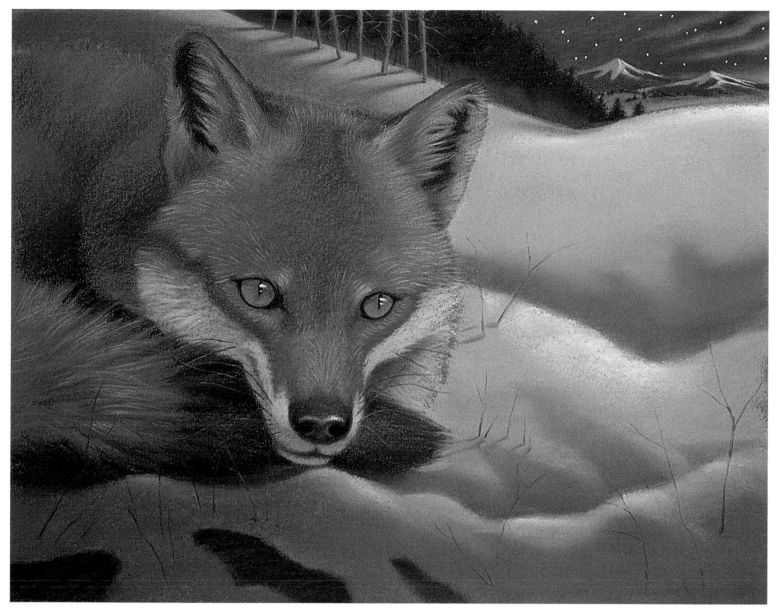

Step Seven I add stars in the sky with a sharp white pencil, pressing firmly and choosing the placement of each star carefully so they look natural. Then I add white highlights in the fox's eyes and on the nose. I draw a few whiskers with Payne's gray and create some grasses poking through the snow with Van Dyke brown and walnut brown. To finish, I give the grasses in the light subtle cast shadow with cobalt blue.

USING PASTEL PENCILS

Pastel pencils are somewhat harder than soft pastels sticks, but (depending on the manufacturer) they may also be slightly softer than hard pastel sticks. Because they can be sharpened to a point, pastel pencils can create finer lines than other types of pastel. They are ideal for detail work and crosshatching, but you can also use the side of the pencil to shade and fill in large areas, as shown here. Apply more pressure and make your strokes closer together for dense coverage, and lighten the pressure and loosen the stroke for more sparse coverage.

Painting a Self-Portrait

Artists have been painting portraits in pastel for centuries, but not all artists have the luxury of a model. Sometimes painting yourself is the best way to practice rendering features, skin tones, and proportions—and at least you're painting what you know! Creating a self-portrait will give you the opportunity to experiment as much as you like with various poses, angles, lighting, and expressions. Try to paint what you *really see* and not what you *think* you look like. You may find, as I did when painting this self-portrait, that you learn something new about yourself.

Working From a Photo Some artists prefer using a mirror to paint self-portraits from life, but I like working from photos. In this case, I asked my husband to take several photos of me from different angles and positions. Then I studied the photos to determine the correct proportions and main shapes of my face.

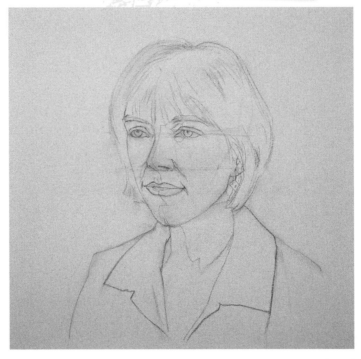

Step One I begin by sketching the head on a piece of steel gray paper with an Indian red pastel pencil. First I position the top of the head on the page, and then I place the bottom of the head and determine the width. I divide the head roughly in half horizontally, through the middle of the eyes; then I divide the lower portion of the head into two equal sections, from the middle of the eyes to the bottom of the nose and from the bottom of the nose to the bottom of the chin. I make sure that this is consistent with the proportions in my photo. I also divide the head vertically through the bridge of the nose. Using this foundation, I draw the hair shape, the eyes, nose, mouth, ears, and shoulder area. I also look at the drawing in a mirror—inconsistencies are more obvious in a mirror image.

Color Palette

SOFT PASTELS:
alizarin crimson
carmine
crimson red
light gray
medium neutral gray
permanent red light
raw umber
rust
Van Dyke brown
warm light gray
white

HARD PASTELS:
cocoa brown
coral
flesh pink
ivory
light blue
olive green
peach
rust
sandalwood
sepia
Van Dyke brown

PASTEL PENCILS:
Indian red

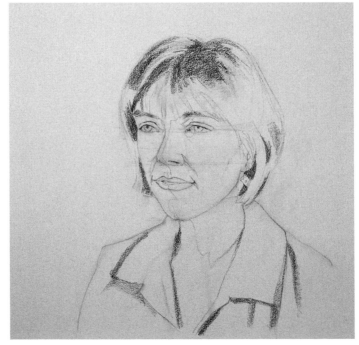

Step Two Next I establish the darkest values with a Van Dyke brown hard pastel. I use the length of the pastel stick using a light touch, letting the paper show through underneath. This way I can save my midtones and I won't saturate the paper at this point.

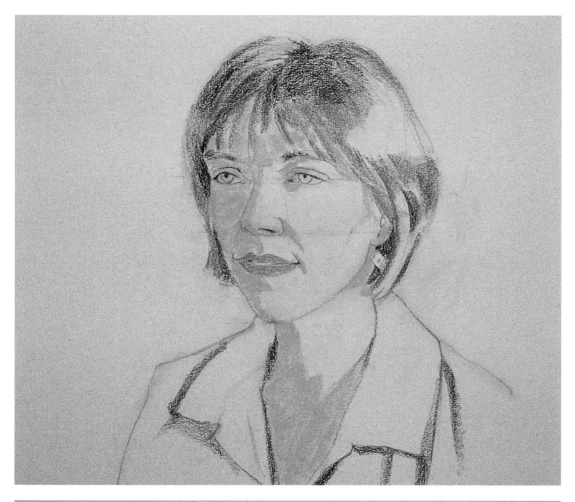

Step Three I block in the mid-value shadow areas with a sandalwood hard pastel. I use a coral hard pastel to add some initial color to the lips, and I begin to define the hair with cocoa brown. I start with the darker areas and work gradually lighter as I get closer to the light source. It's best to work in the middle and dark values for as long as possible in a portrait, as the lights and whites can look chalky if they are applied too soon.

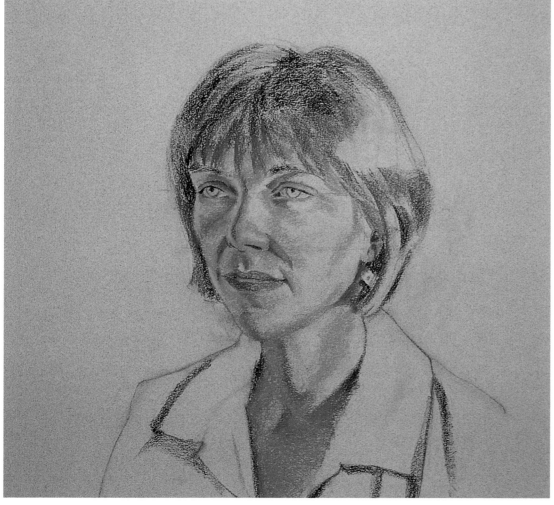

Step Four I build up the darks in the shadows, using rust for the warm areas and olive for the cool areas. I'm still using hard pastel sticks and blending by layering the color. Next I add some midtones to the side of the face with flesh pink. I use a light touch and leave some of the middle value of the paper showing at the edges of the darks.

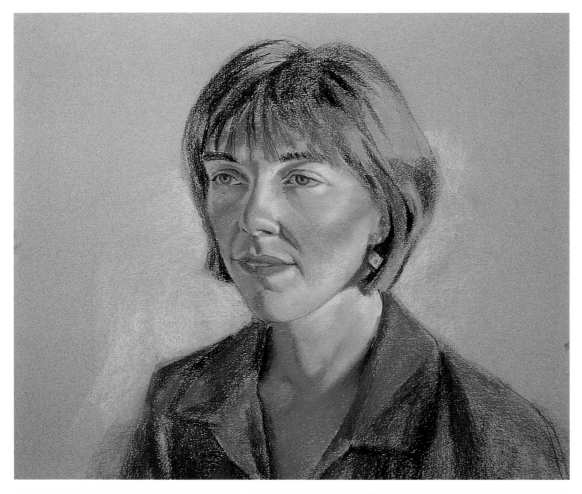

Step Five Next I begin slowly building up the skin tones with even pressure. I use raw umber under the mouth and at the core of the neck. I add some alizarin crimson where the cheek is in shadow, and then I create the eyes with layers of light blue hard pastel and olive green. I use peach and ivory hard pastels to build up the light side of the face, keeping the planes of the face in mind. I also add the red shirt, using rust for the main shapes in shadow and a combination of crimson red and permanent red light for the light shapes. I apply these colors in broad strokes, using medium pressure on the length of the pastel and letting the paper show through underneath. I also create some strokes in the background with light gray.

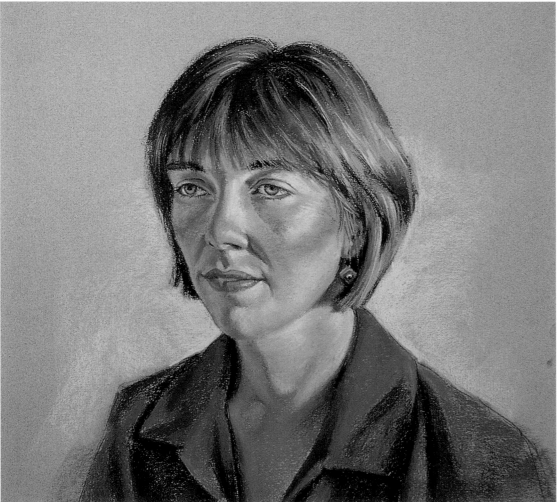

Step Six Next I add some reflected light under the lips with warm light gray, washing it over the small area carefully with very light pressure. I start to refine the hair by adding medium neutral gray highlights. I indicate a few individual strands, and then I use Van Dyke brown to darken the shadows in the hair and the eyebrows. I use the tip of the pastel stick for the eyelashes. Then I place the shadow of the earring with a sepia hard pastel and the stone in the center with carmine.

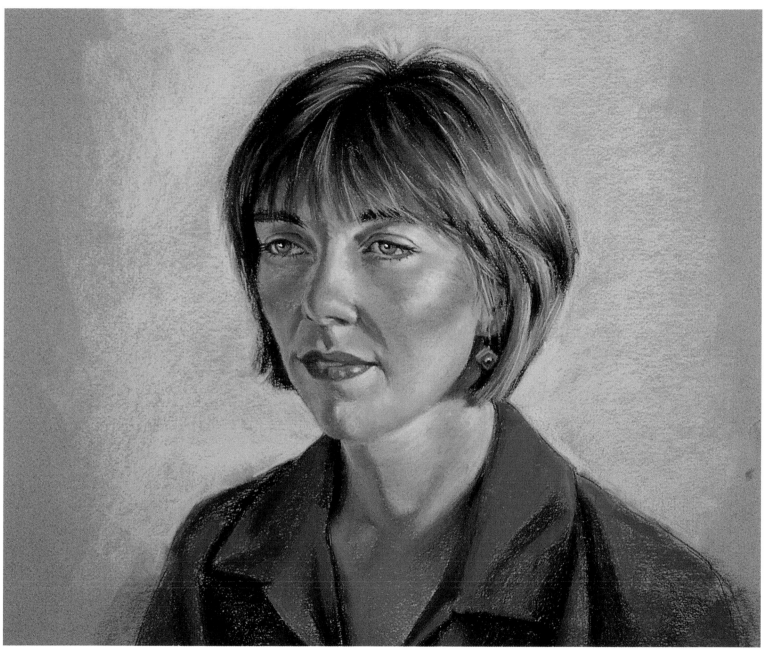

Step Seven I continue to refine the shapes of the hair; then I add white highlights to the eyes. I create the highlights on the lips with flesh pink and blend the skin tones a bit with my fingers. Finally I add some more light gray to the background and blend it into the previous layer with my fingers. When I step back to assess my work, I try to objectively compare the photo with the finished piece to make sure I've achieved a good likeness.

Details

Expressing a Theme

Sometimes using the same subject, color scheme, or style in a series of paintings can be a wonderful way to find focus in your work. Whether you want to make a bold artistic statement or simply capture a specific mood, expressing a theme is a great way to expand yourself creatively. It can also help you develop your own style: When you determine a cohesive idea for a group of paintings, you'll start to discover the characteristics that distinguish your work, such as a tendency to paint loosely or a preference for a particular group of colors. Your theme can be as simple as summer gardens, figures, or animals in the wild. I recently developed a group of paintings featuring different women in everyday settings. I began with a painting of a woman reading at home, and since reading is one of my favorite pastimes, I decided to make it a self-portrait. And because part of creating a theme is determining a style or approach, I chose to use bright colors and a more illustrative style to give these paintings an upbeat, contemporary feel.

Color Palette

HARD PASTELS:
light gray

PASTEL PENCILS:
black • burnt carmine • burnt umber
caput mortuum • cobalt blue
deep ochre • deep purple • earth green
Indian red • indigo blue • lemon yellow
light chrome yellow • light flesh
light turquoise green
light ultramarine blue
manganese violet • medium flesh
medium green
permanent green olive • pine green
pink carmine • raw umber • sanguine
terra cotta • turquoise blue
Van Dyke brown • violet • white

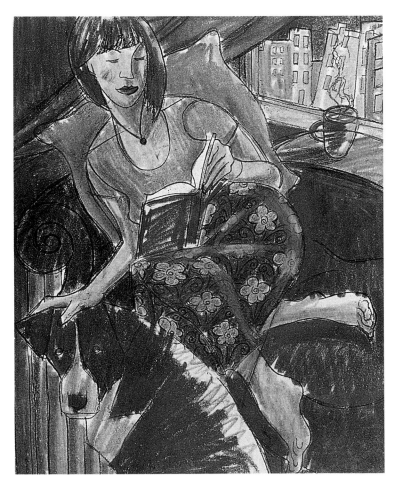

Step One I sketch my idea several times until I have what I want; then I enlarge the sketch on a copy machine. I want to add a pattern to the skirt, so I work out the floral pattern on a separate piece of tissue paper and tape it over the photocopy of the sketch with transparent tape. Then I create a color sketch, using markers to work out my color scheme.

Step Two Next I tone a piece of sanded paper with cadmium red light acrylic paint. While that dries (about 20 minutes), I rub the back of the photocopy with a light gray hard pastel, covering the entire sheet to create a carbon. When the red paper is dry, I tape the copy to it at the top, carbon-side down. Then I use a sharp graphite pencil to trace over the lines to transfer the sketch to the support.

◀ Step Three This painting is small (about 8" x 10"), and it has quite a bit of detail, so I decide to use only pastel pencils. While working, I place a clean sheet of tracing paper under my hand so I won't smudge my piece. I start in the upper left with the curtain, using turquoise blue for the darks and light turquoise green for the lights. I press firmly, using the tip of the pastel pencil and blending the two colors together where the edges meet. I use manganese violet for the night sky, earth green for the building on the left, and pink carmine for the other building, and I leave the paper showing in the windows.

▲ Step Four I color the pillow with permanent green olive and medium green, and I use Van Dyke brown for the hair. Then I color the shadowed shapes of the face, arms, and legs with caput mortuum. I leave a bit of the red paper showing around all the shapes to create an outline by not filling the shapes in completely. Later I will go back and create a more noticeable outline.

Detail

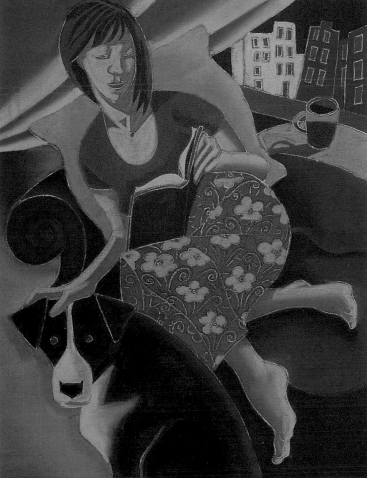

Step Five Next I use violet and manganese violet for the shirt, the ledge, and the coffee cup. Then I fill in the table with terra cotta and use a mix of burnt carmine and pink carmine for the couch. I fill in the dark areas on the dog with deep purple and black, blending the two colors slightly in some areas. Then I create the dog's lighter areas with light turquoise green and light ultramarine blue. I add medium flesh for the lights on the skin, and I place the darks in the hair with burnt umber. Next I fill in the pattern on the skirt with pine green and terra cotta, letting the color of the paper serve as the red lines in the pattern.

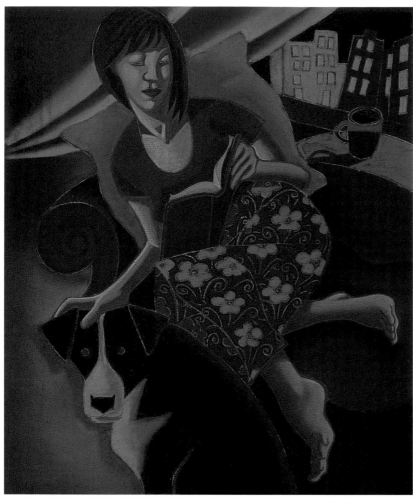

Step Six I place some highlights on the skin with light flesh, pressing firmly to cover the previous layers of color. Then I create the red mouth, using pink carmine for the lower lip and burnt carmine for the upper lip in shadow. Next I add the lights in the windows of the background buildings with light chrome yellow. At this point, I've filled in all my dark areas and mid-tones; next I'll focus on adding the lighter areas and the details.

Details

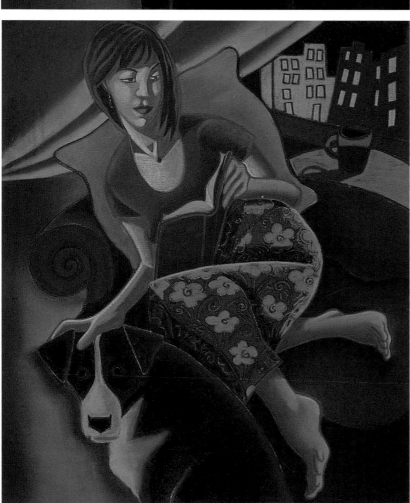

Step Seven Once the shapes are filled in, I outline the forms with a variety of colors. Sometimes I choose contrasting colors rather than similar ones to create variety and interest. Here I use indigo blue around the left side of the pillow and Indian red around the right side. Then I add sanguine to the skin and draw the eyes, using cobalt blue for the iris and light ultramarine for the whites. I add the eyebrows with burnt umber; then I indicate the earring, using burnt carmine for the teardrop-shaped bead and raw umber for the gold. I also add small, light strokes of light turquoise green for a highlight on the edge of the skirt.

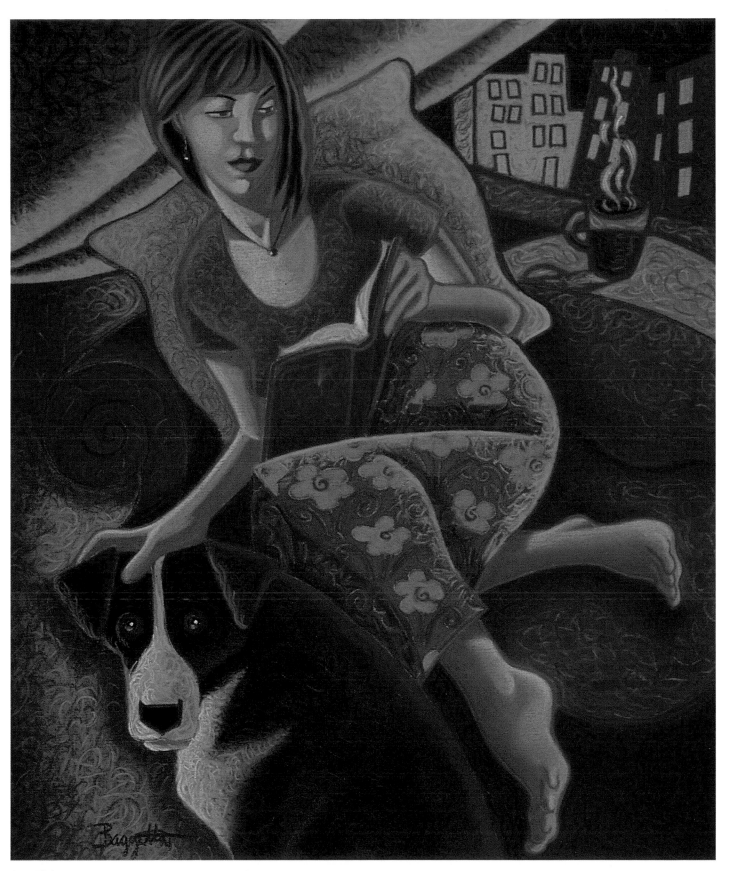

Step Eight For more interest, I add a swirling texture to all of the shapes except the skin areas. I apply the texture on the curtain with cobalt blue, pink carmine, and light turquoise green. For the pillow, I use light turquoise green and pine green. Then I add texture to the dog with cobalt blue and olive green. For the light areas of the couch, I use lemon yellow and pink carmine; for the areas in shadow, I use pink carmine and cobalt blue. I also complete the detail on the dog, adding the highlights in her eyes with deep ochre and white. Finally I add the steam from the coffee cup with light ultramarine and white, pressing firmly to cover the layers underneath.

Taking Artistic License

Once you've mastered the fundamentals of value, color, and composition, you can begin to take liberties with your subject matter. When an artist alters a subject by changing the viewpoint, adding or removing an element from the scene, or enhancing the color scheme, it's called "taking artistic license." As you become more comfortable with altering your subject, you may want to take artistic license a step further and try creating a scene entirely from your own imagination—in other words, exercise artistic license with reality in general. In this painting, I began with an image from a dream I'd had and then experimented with various shapes, colors, values, perspectives, and lighting in small thumbnail sketches until I settled on one that appealed to me. To convey a feeling of awe and wonder, I used simple, distorted shapes and bright, unrealistic colors, which added a surreal quality to the scene.

Step One I tone a piece of sanded pastel paper with a cadmium red light acrylic wash and let it dry for about 20 minutes. Then I carefully transfer my final drawing to the support with a light gray hard pastel.

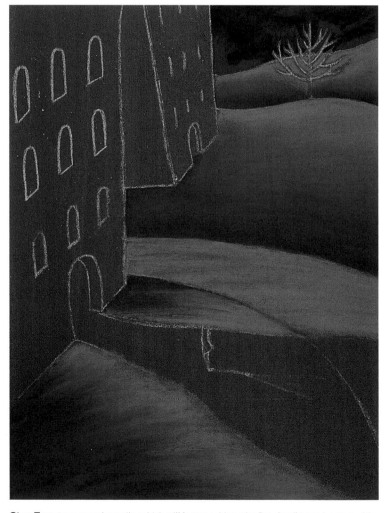

Step Two I use pastel pencils, which will let me achieve the fine detail I need. I start with black, ultramarine blue, and dark violet for the sky. Then I fill in the snowy hills with cobalt blue light and dark violet, starting with the hill in the background and moving toward those in the foreground.

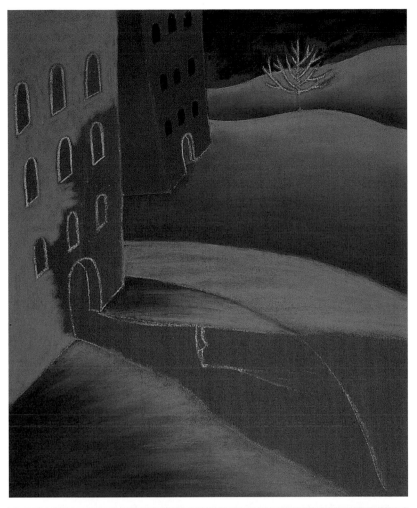

Step Three Next I work on the distant building, using cadmium red light for the front and magenta for the side. Then I use dark violet to achieve a slight gradation on the side of the building, which tones down the colors of the buildings a bit and allows the main focus to be on the figure. I blend the pigments as I work, pressing each color into the others around it. Then I fill in the windows with dark violet and black layered over one another. I also fill in the foreground building with bright olive green, pressing firmly to fill in the area thoroughly and evenly.

Details

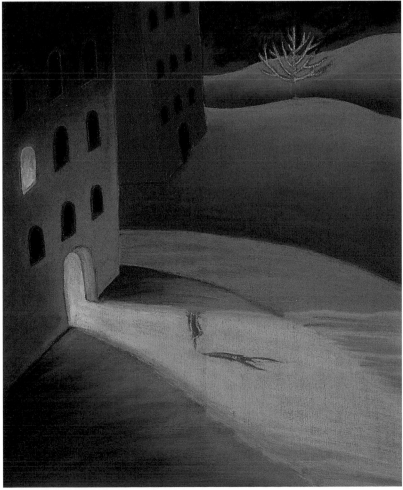

Step Four Next I use permanent green deep for a gradation on the face of the green building. Then I fill in the dark windows with ultramarine blue and black. I outline the windows with permanent rose deep; then I use deep yellow, cadmium yellow, and white to fill in the brightly lit window. I apply cadmium yellow to the entire path, the doorway, and the doorjamb, leaving the paper blank where the figure will be. I don't butt the cadmium yellow up to the edge of the green building; instead I leave a tiny red outline around the door. Then I add deep yellow to the doorjamb, using white for the highlight at the bottom. I also use deep yellow to indicate the edge of the path at the right.

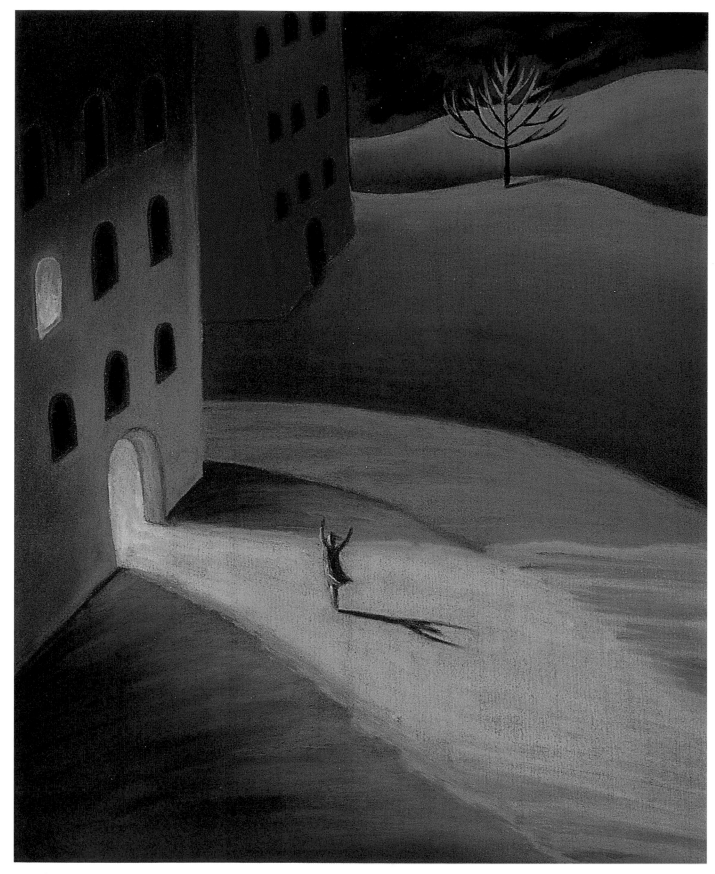

Step Five Next I carefully remove any remaining marks from the transferred drawing with a rubber eraser. Then I use black to draw the lower tree branches and ultramarine light to draw the upper branches. I fill in the entire shape of the figure with dark blue-green, and I use alizarin crimson to indicate reflected light on the shadow side of her shape. Next I add cadmium yellow to the light side and create the figure's cast shadow, adding alizarin crimson and dark blue-green where her body meets her shadow.

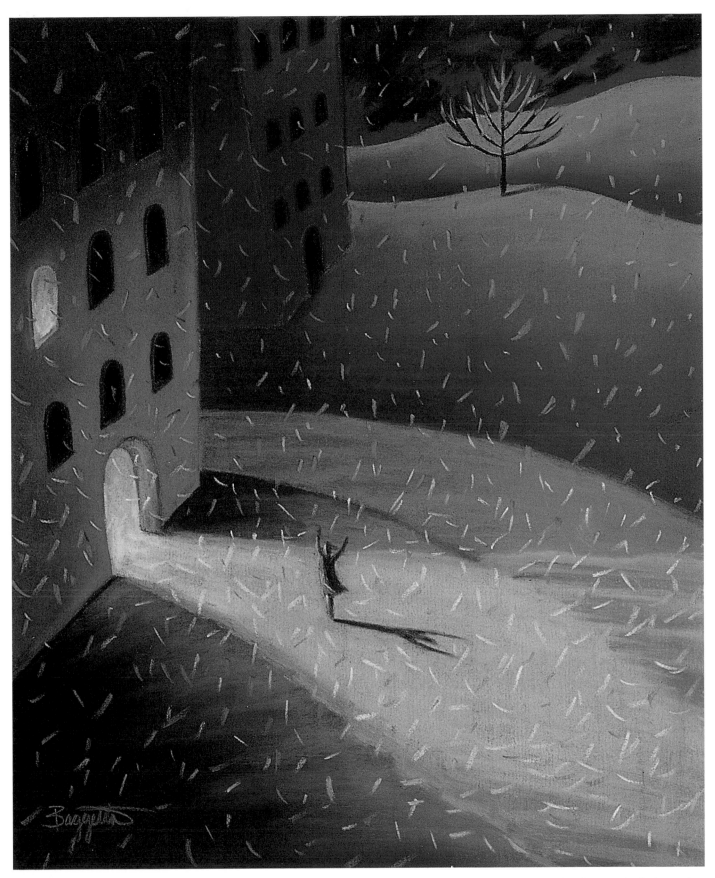

Step Six Now I draw the snowflakes using small strokes of light ultramarine blue, ultramarine blue, permanent green deep, and cadmium yellow, pressing firmly to make sure they are visible. I make smaller strokes to create more distant flakes, as well as larger strokes to indicate closer ones. The strokes are slightly curved to show that the snowflakes are floating gently downward.

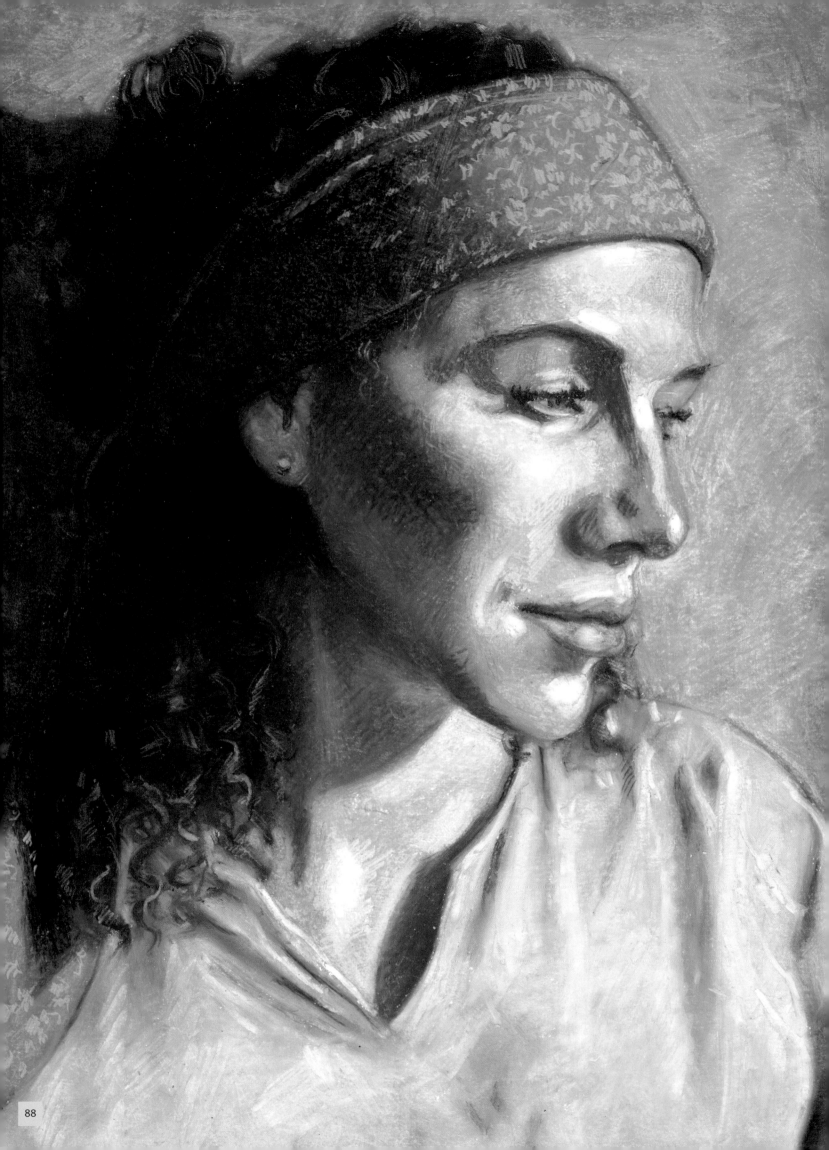

Oil Pastel
WITH NATHAN ROHLANDER

For the person who likes immediate gratification, oil pastel delivers. Designed to be one of the most direct forms of expression, it provides a full range of pigment in the form of individual oil crayons. Whether you label your finished oil pastel a drawing as Cézanne did or a painting like Picasso did, one thing is clear: the fact that these art masters used this medium proves it has much to offer.

As a lover of both painting and drawing techniques, I was inspired to work in oil pastel. The power of line and tone, combined with color and ease of use, make this medium rewarding. I discovered that I could work linearly and texturally, or I could layer and blend. And, if I felt really bold, I could employ both techniques in the same work. Some artists use oil pastels with solvents as the first step when creating a painting, others do this in the middle of a work. Some artists use oil pastels to make studies, while others use them to create finished masterpieces.

Oil pastel travels well and it doesn't make a huge mess. It removes the middleman and puts the artist directly in control of mark-making without using a brush—in my opinion, this is one of its strongest attributes. At its finest, oil pastel is both painting and drawing—two mediums in one.

BREAKING THE RULES

When we think of media that relate to children and art, the crayon is one of the first that comes to mind. Creativity and expression are most evident in childhood. Pablo Picasso believed it was the artist's job to maintain that childhood creativity. He understood society's tendency to bridle youth in etiquette and rules.

It's our job to break free from those rules.

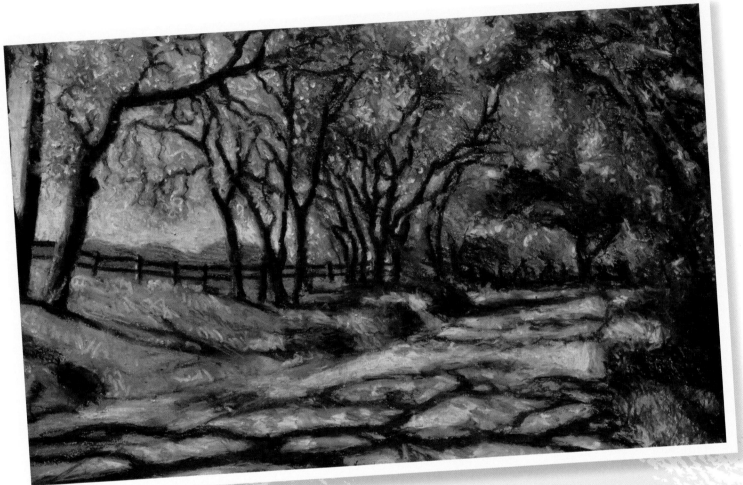

Every child is an artist.
The problem is how to remain an
artist once we grow up.
—Pablo Picasso

DRAWING WITHOUT A MASTER

Throughout 1912–1926, Japan experienced its Taisho period. It was during this time that theorist, author, and artist Kanae Yamamoto created his book *The Theory of Jiyu-ga,* which translates to "Drawing Without a Master." In his text, the theory is proposed that children should be more expressive with color and be free to draw.

In 1921, Rinzo Satake and Shoukou Sasaki, two brother-in-laws who were involved in education, sought new mediums of expression for their students with their new company, Sakura. With the consultation and involvement of Yamamoto they began the creation of a new crayon that was to be a combination of pigment and an oil binder. Variation in colors was important to Yamamoto's working theory of education. However, combining the attributes of drawing and painting in one tool did not come easily. It took about three years to create a good recipe for oil pastels, designed for use on just about any surface. They developed Cray-Pas® oil pastels, the first to hit the market created primarily for children. "Cray" stands for the simplicity of a crayon and "Pas" for the depth and color saturation of dry pastel.

ARTISTIC VISION

In Paris, Picasso became aware of this new medium and its versatility. In 1949, he had his friend and fellow artist, Henri Goetz, approach Gustave Sennelier about creating an oil pastel for the professional artist. In 1887, Sennelier opened an art store in Paris that is still a world renowned producer of art materials.

Although Sakura's Cray-Pas oil pastels were the first, many companies now make oil pastels. They have been perfected over the years by a variety of venders. Used by numerous artists, it's truly a wonderful medium that combines drawing and painting in one gratifying vessel. Cray-Pas oil pastels were used to create the images in this book. However, no matter what brand you choose, you will learn to love creating your own masterpieces with oil pastels.

Materials and Techniques

To begin working with oil pastels, you'll need a few basic supplies, listed below. While there are a number of techniques that can be achieved with this medium, the basics are shown here.

- Graphite pencils
- Conte black pencil
- Kneaded eraser
- Paper
- Heavy rag
- Gamsol
- Gesso
- Oil pastels: Vandyke brown, Prussian blue, gray, yellow, yellow orange, brown, white, black, pink, ultramarine blue, yellow ochre, olive brown, yellow green, vermillion, deep green, pale orange, green, Prussian blue, orange, lemon yellow, red, pale blue, cobalt blue, gray green, green gray, olive gray, and purple
- Acrylic paints: Ultramarine blue, burnt sienna, yellow ochre
- Matte medium
- Palette knife
- Ruler (to tear down paper to size)

Setting Up a Studio I use both a tabletop easel and a drawing board when working with oil pastels because this medium allows you to work on almost any table or surface. In my studio, for example, I set up my supplies on a converted Craftsman workbench. A good studio also needs fresh air and great light.

Scraping Back First put down a layer of color. (I used yellow green above.) Next, smudge this until it becomes a solid. Then, layer another color on top of it—here I used cobalt blue—and smudge it until it becomes a solid. Now, you can scrape detail back into your piece. I used a penny nail to carve through the top layer of color to reveal the yellow green beneath.

Blending with Oil Pastel Begin by covering one area with yellow. Next, add a layer of vermillion hue next to the yellow. Then, press hard and blend with the oil pastel crayon, using pressure in the middle where the two colors meet.

Crosshatching Crosshatching is a series of perpendicular lines layered on top of one another. Using a gray oil pastel, crosshatch a value and opacity shift. Pressure increases the saturation of pigment. This process can be used to both blend and gradate color.

Stippling Start with pale blue. Create an even tone by making dots over the entire surface. Next, begin on one side and stipple Prussian blue until you've made a gradual value shift like shown in the example above.

Draw Back Into Begin by crosshatching an even layer of color with orange. Next, use a Conte or Derwent® black pencil to draw on top of the orange, thus creating detail. You can also do this with graphite.

Smudge with Finger Put down an even layer of purple. On top of that, place a layer of yellow ochre, and then smudge/blend with your finger. Strive for even color.

Highlight A highlight is the chunk of light that is the lightest spot on your image. After creating your rendering, place the highlight appropriately. This grape was created with vermillion hue as a middle tone, Prussian blue for the shadow shape, and white for the highlight. The background is an even layer of yellow ochre with thick white on top.

Blending with Turpentine First, crosshatch a layer of green. Then, layer an even color application of lemon yellow on top. Finally, blend with a large flat brush, using a little Gamsol or Turpentine to create an even color.

Acrylic Toned Base First, mix a transparent layer of Ultramarine blue and matte medium. Next, use this to cover the surface. Then, create a gradient with olive brown—the pressure of application determines intensity. Notice the difference between opacity and optical blending.

Sunset

Inspiration can be found almost anywhere. I discovered the inspiration for this drawing while traveling down the Nile River—an area filled with beautiful scenery. The arid landscape of the desert juxtaposed with the fertility of the river valley, creating a rich visual contrast. At dusk, the sun hung heavy in the sky, its warmth both melting and surrounding us, the clouds filling the air with an almost magical haze—sparse landscape, glittering water, glowing sunset.

▶ **Mixing Techniques** I decided that the best way to capture this vivid image would be to incorporate some painting techniques into my drawing, using a transparent even wash along with pastel. I used both solvent and brush in some of the following steps to help even tone and color.

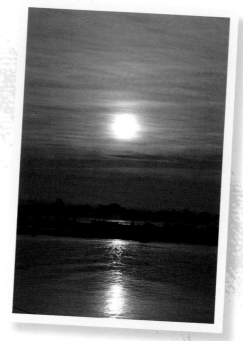

Color Palette

OIL PASTELS:
Vandyke brown
Prussian blue
gray
yellow
yellow orange
brown
white
black
pink

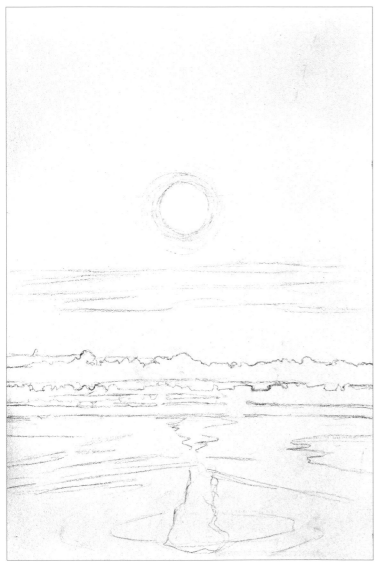

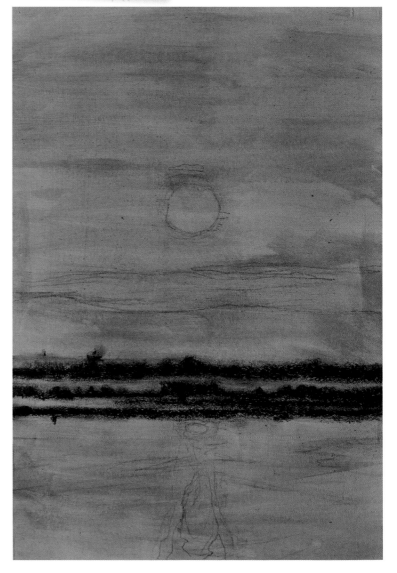

Step One For my first step, I make a quick rough sketch in graphite. This establishes all the major light and dark shapes like the sun, the land mass, and the reflections on the water. For this project, I used gessoed rag paper, 17.75 by 11 inches.

Step Two Next, I toned the paper with a transparent layer of matt medium and acrylic violet. This cool hue will later cause the sun to glow with warmth. If my original sketch has faded at this point, I will sometimes go back and reapply graphite to the drawing. Then, I establish my darkest darks by using Prussian blue. I vary the opacity of the pastel to create different values, and then smudge with my finger a little.

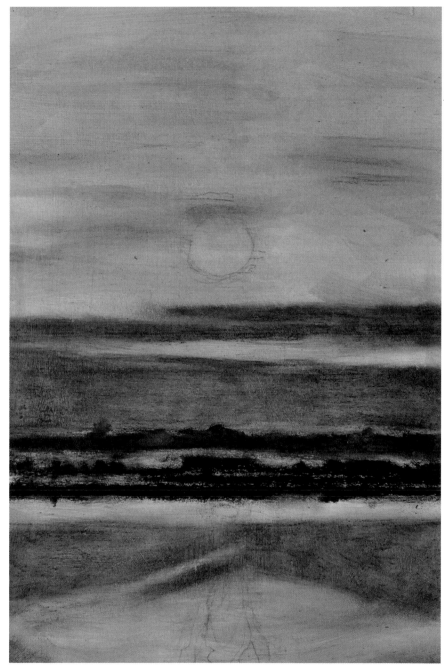

◀ **Step Three** I increase my dark values by adding a layer of Vandyke brown over the Prussian blue, again smudging with my finger. Then I lightly dust the sky and water darks with Prussian blue. After dipping a large flat brush in Gamsol, I wash the Prussian blue in the sky. Then I smudge with my finger—back and forth—until I create the desired affect.

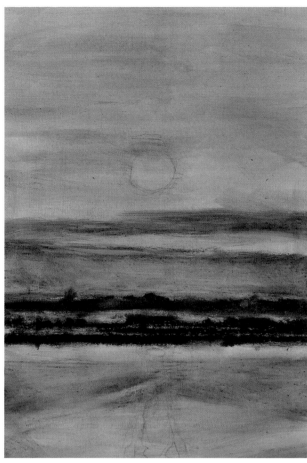

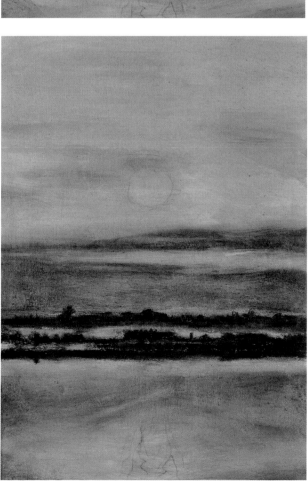

Step Four At this point, I lightly add Vandyke brown to the sky, and then blend in with my finger. If I add too much, I use a paper towel and continue to blend in, removing a little pigment at the same time.

Step Five With gray, I lightly dust the light in the sky. Then with a brush dipped in gamsol, I blend in the gray. As the final part of Step Five, I take Prussian blue and add detail back into the land and trees.

Detail

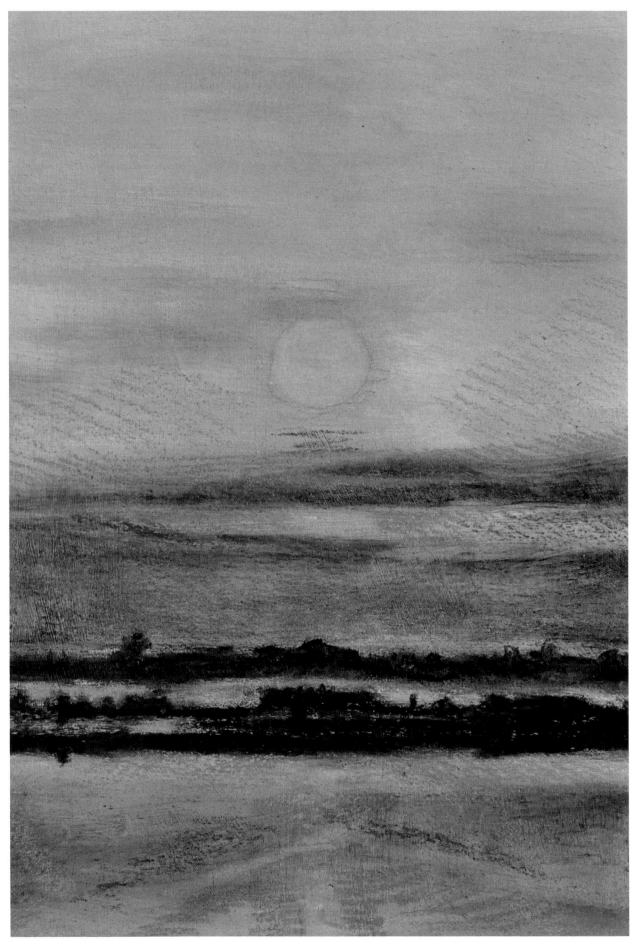

Step Six Now I start to bring in the warm colors. I use yellow, yellow orange, and brown to warm up the sky and water.

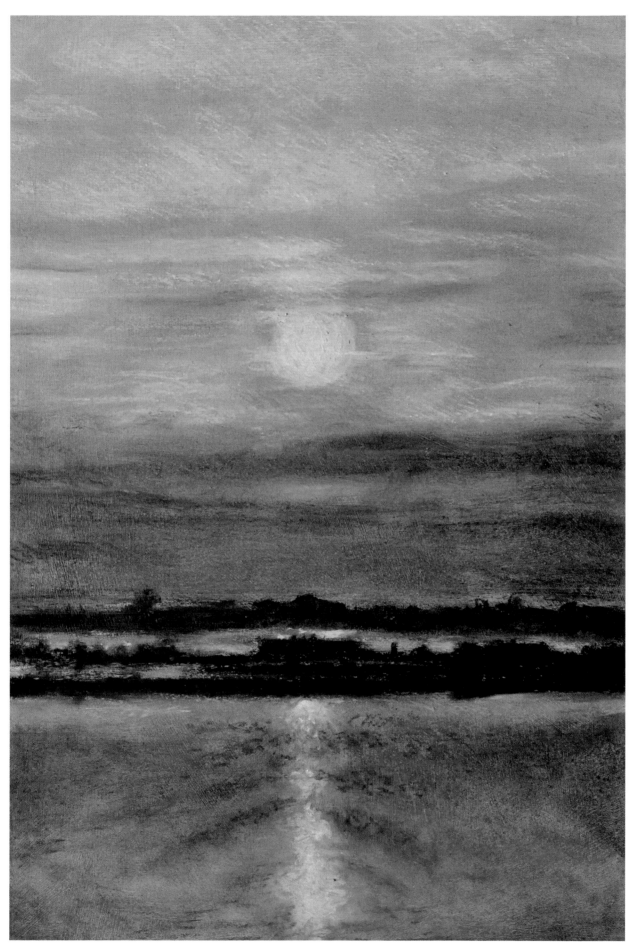

Step Seven With white, yellow, and yellow orange, I start to saturate the sky—remembering to squint as I work. I blend vigorously with my fingers and pull those lights. Next, I use a little black to darken the nearest land and trees, reinforcing an atmospheric perspective. With Vandyke brown, I then darken areas in the water and sky, as necessary. I use a little pink in the sky and water to lighten areas in the center. Finally, with white I add more light to the clouds and the top of the image.

Floral Arrangement

The floral arrangement—a time-honored and traditional subject matter—has been captured by artists throughout history. For this project, I decided to use a polychromatic palette—I felt that this would jazz up the arrangement and add a sense of energy. Tight cropping on the image filled the page with petals and updated the more traditional subject matter. The final composition reveals only a portion of the vase, thus making the flowers the focal point. Altogether, the color and the cropping work together to create a striking image.

▶ In this project, I updated a traditional subject through the use of color and cropping. The vital importance of mark making and the necessity for variety, emotion, and gesture were examined as well, with the intent of breathing life into the final piece.

Color Palette

Matte medium

OIL PASTELS:
ultramarine blue
Vandyke brown
yellow ochre
olive brown
yellow green
yellow
vermillion
deep green
pale orange
green gray
white
pink
Prussian blue
orange
lemon yellow
red
brown

Step One I began by creating a construction drawing that defined the shapes and the flowers. At this point, variation in line weight was essential, and I used it to suggest value. I included as much detail as possible. Throughout the process, the image will become more loose, so I sought to be as specific as possible for as long as possible. For this project, I used gessoed rag paper, Reeves® BFK, 19 by 13 inches.

Step Two Using a workable fixative, I sealed the drawing. Then I toned the drawing with a transparent mixture of matte medium and ultramarine blue. This cool color helped the warmth of the flowers pop with each new color added. To minimize the loss of my drawing, I limited my brush work. A couple of thin transparent layers work better then a thick dark one. A gradual progression is best.

◄ **Step Three** Next, I used Vandyke brown to begin my darkest darks. This helped separate and establish the figure/ground relationship.

▲ **Step Four** I layered Prussian blue on top of the Vandyke brown, then smudged them together. The colors blended to create a rich dark without holes or gaps that would allow the paper to show through.

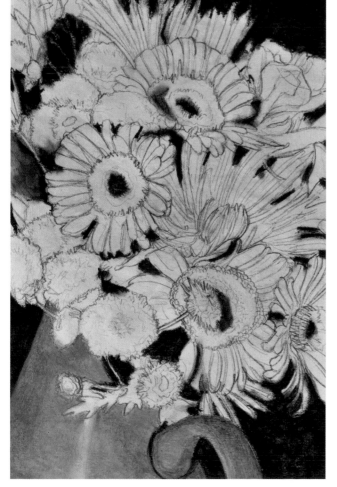

Step Five Yellow ochre was the base color for the vase. I put a layer of it all over the vase, then smudged it. Next, I used Vandyke brown for the darker areas of the vase and blended it with my finger. I then toned down the yellow ochre with a little olive brown in its brightest spots and smudged.

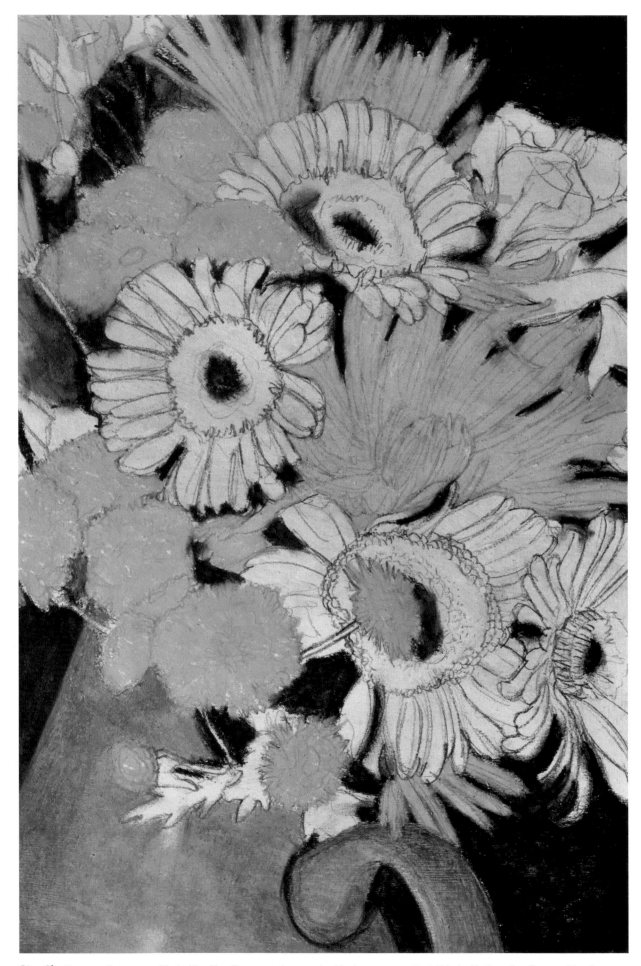

Step Six The green flowers were blocked in with yellow green, then smudged to close any gaps. Next, I blocked in the yellow flowers with yellow.
I filled in any dark negative spaces that may have been missed in previous steps.

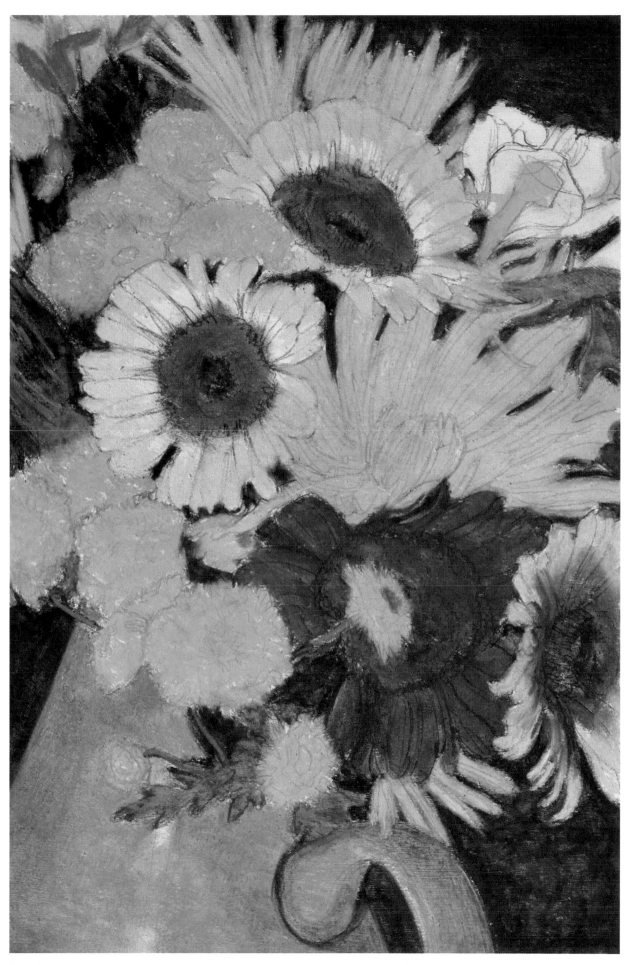

Step Seven At this point, I began to block in the reds of the flowers with vermillion, and then smudged them. The dark green leaves were done with deep green, and then smudged as well. I continued to fill in any spaces between the flowers, as mentioned in Step Six. With pale orange, I then blocked in the pinkish parts of the flowers. The grayish leaves at the top were done in green gray.

Step Eight In this step, I drew the white flower in the upper right corner, using white, yellow green, and deep green. Beginning with the white, I then layered the other colors on top. Next, I added pink on the inside of the pink flowers, following it with a layer of red on top, and finally blending with my finger. I continued using Vandyke brown to adjust the drawing and contours of the flowers.

Detail

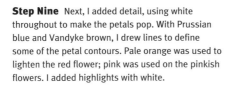

To create the pollen in the pink flowers, stipple with orange, pink, and white.

Step Nine Next, I added detail, using white throughout to make the petals pop. With Prussian blue and Vandyke brown, I drew lines to define some of the petal contours. Pale orange was used to lighten the red flower; pink was used on the pinkish flowers. I added highlights with white.

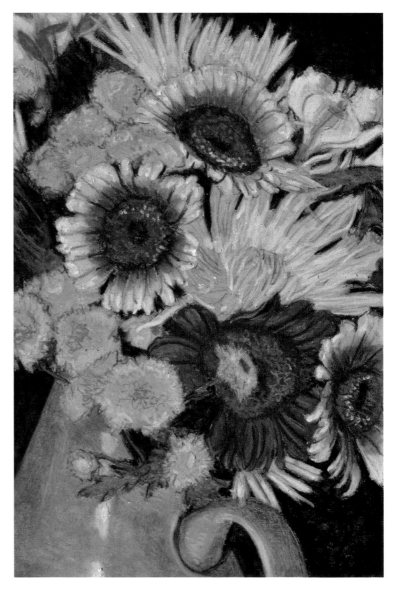

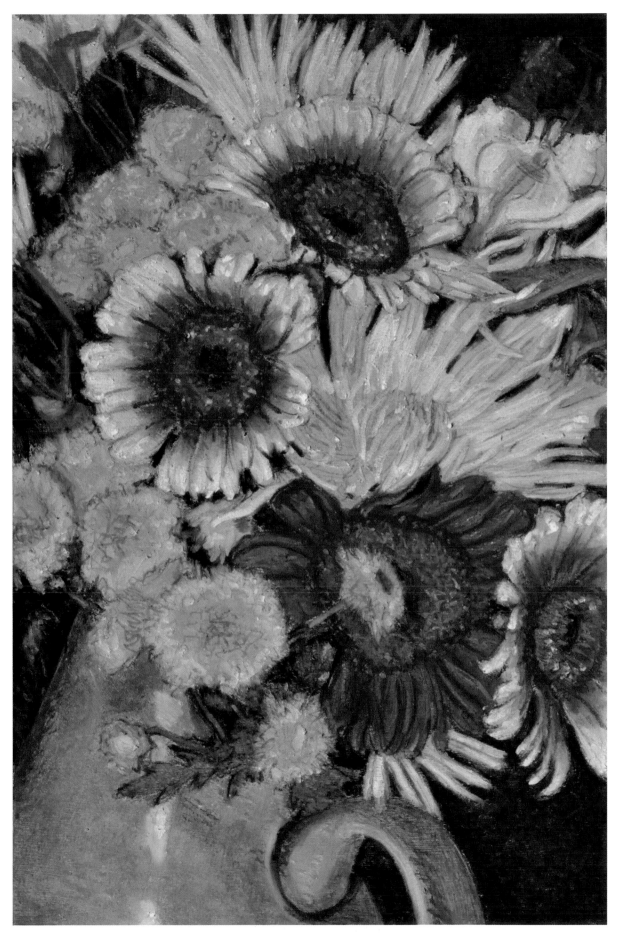

Step Ten The final step was the touch-up round. With green gray and yellow green, I lightened the darkest negative shapes—suggesting a little green in the shapes. I continued to create small marks in the petals using all colors as necessary, and I added white where needed. Another layer of Vandyke brown was added to the bottom right; pollen was touched up with orange. Then I lightened the green flowers with lemon yellow. This was my last chance to catch any mistakes or touch-up. With red, I lightened the shadow shape in the top pink flower, minimizing it. I touched up the vase with Vandyke brown, and I allowed my mark making to suggest texture. Finally, I used brown to separate the pollen from the petals in the pink flowers. I continued with all colors until I was satisfied with the final appearance. I made marks and pushed hard to leave chunks of oil pastel.

Bedouin Camel Portrait

Steeped in mystery and brimming with beauty, the archeological site of Petra, Jordan, is still home to a culture thousands of years old. While standing in front of the Al Khazneh, an ancient building carved out of sandstone, I found myself surrounded by the local Bedouin and their animals. It was a spectacular and magical environment, and some of the photos I took were the inspiration for this camel portrait. I was particularly enticed by the dramatic lighting and beautiful Bedouin blankets that adorned the camel. However, I soon discovered that it was difficult to capture a perfect shot with a moving target. This is why I created a composite—the merging of two different reference images to create a more appealing portrait. I used one image of the camel for the face and another for the body and surrounding environment. The exotic nature of this desert animal created a portrait that suggests adventure.

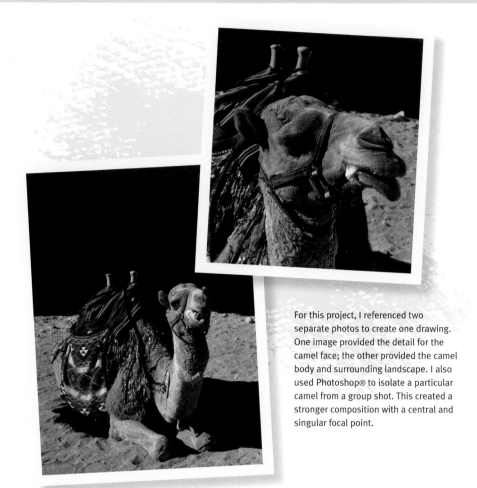

For this project, I referenced two separate photos to create one drawing. One image provided the detail for the camel face; the other provided the camel body and surrounding landscape. I also used Photoshop® to isolate a particular camel from a group shot. This created a stronger composition with a central and singular focal point.

Color Palette

Matte medium
yellow ochre acrylic paint

OIL PASTELS:
Vandyke brown
yellow ochre
brown
white
ultramarine blue
cobalt blue
Prussian blue
orange
gray green
red
lemon yellow
black
gray

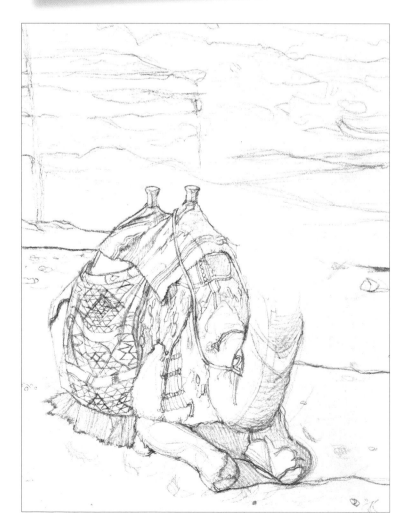

Step One
I began the drawing with graphite—omitting the camel head. I focused on shape: light shapes and shadow shapes. Using a heavy weighted line, I suggested the shadows, and with a lighter line I illustrated the lighter values. Crosshatching can also be used to establish the shadows. For this project, I used gessoed rag paper, 17 by 13 inches.

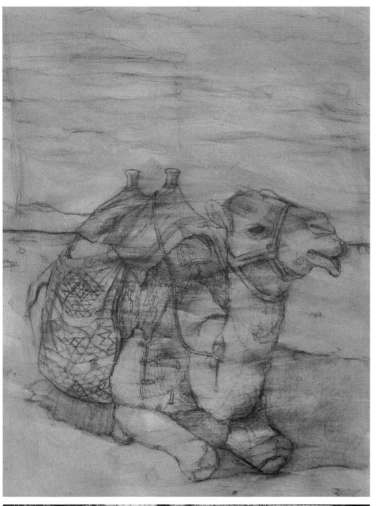

◀ Step Two Next, I added the head. While I used the second image as a reference point—capturing the detail of the camel's facial expression—I found that I needed to make some adjustments to the background. I moved a rock that now sat in front of the camel's face, so that it didn't look like he wanted to eat it, and I raised the horizon slightly. I also used a little value to help separate the shapes and bring reason to the madness of lines. Full value isn't needed yet, for that will begin when the oil pastel is added. At this point I like to mix a transparent layer of yellow ochre acrylic paint with matte medium to seal and tone the drawing. I carefully paint over the complete image area—too much brush work will destroy the drawing. Now I have a unifying color and tone. I also now have the option to scrape back to my original sealed drawing, if desired.

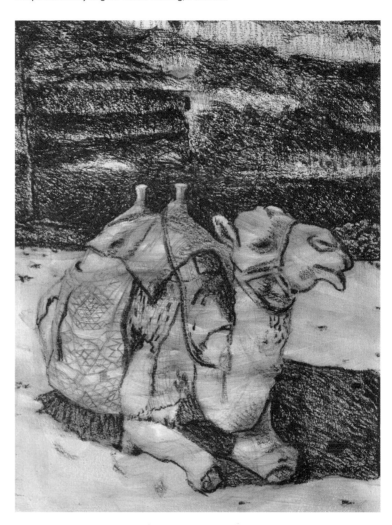

Step Three For this step, I need to squint frequently while looking at my reference photo, a process that allows me to successfully determine where to mass my values. By using variation in my line weight and layering with the Vandyke brown, I now rediscover and solidify my drawing, thus establishing the dark values.

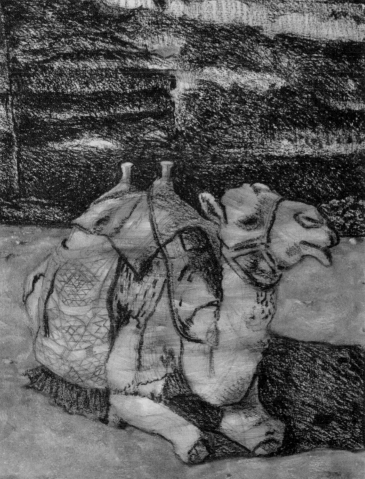

◀ Step Four First, I add a light layer of yellow ochre oil pastel over the sand area, then a light layer of brown over the previous layer. Next, I blend the two colors by smudging and rubbing them with my fingertips. Taking a broken chunk of white, I use the edge to carve the beginning of a light pattern in the sand. I then blend this with my finger to create a desired affect. I also highlight a few of the stones at this point too.

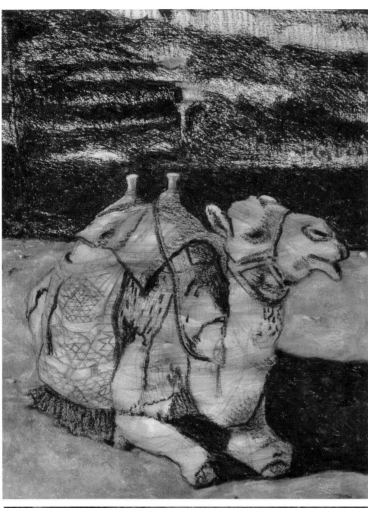

◀ **Step Five** In this step, I add ultramarine blue over the previous layer of Vandyke brown, paying particular attention to the casting shadows and darkest darks. Finally, I smudge the colors together in desired areas.

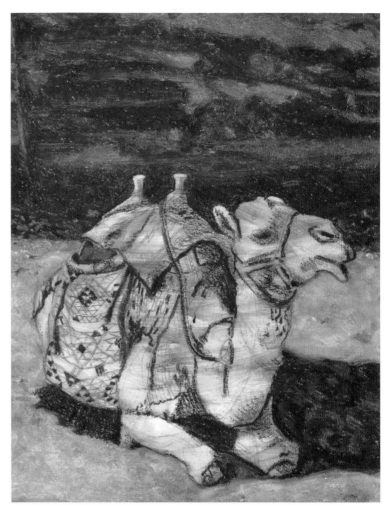

Step Six With brown, I lightly go over the top of the image and sandstone wall in the background, then smudge with my finger. Next, I use yellow ochre oil pastel to bring out the pattern in the sandstone. The same color is used to soften the shadow edges and bring light into the casting shadow of the camel. I also add some more shapes of the same color in the light areas of the sand and warm up the white from before. I then begin working on the Bedouin blanket using cobalt blue for the light blues and Prussian blue for the darker blues and shadows. After that, I fill in the triangles with Vandyke brown as needed.

Detail

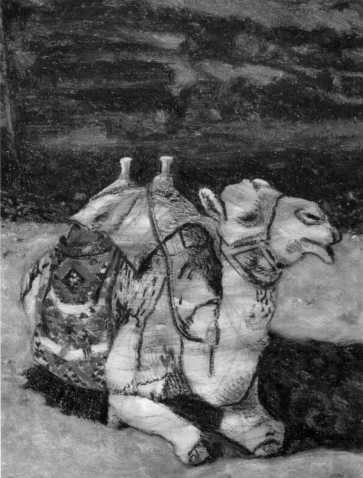

◀ **Step Seven** I keep working on the side blanket, now adding orange, gray green and brown to the appropriate areas using a sharp edge on the oil pastel stick. If needed, I will use a blade to create sharp spots by shaving the stick.

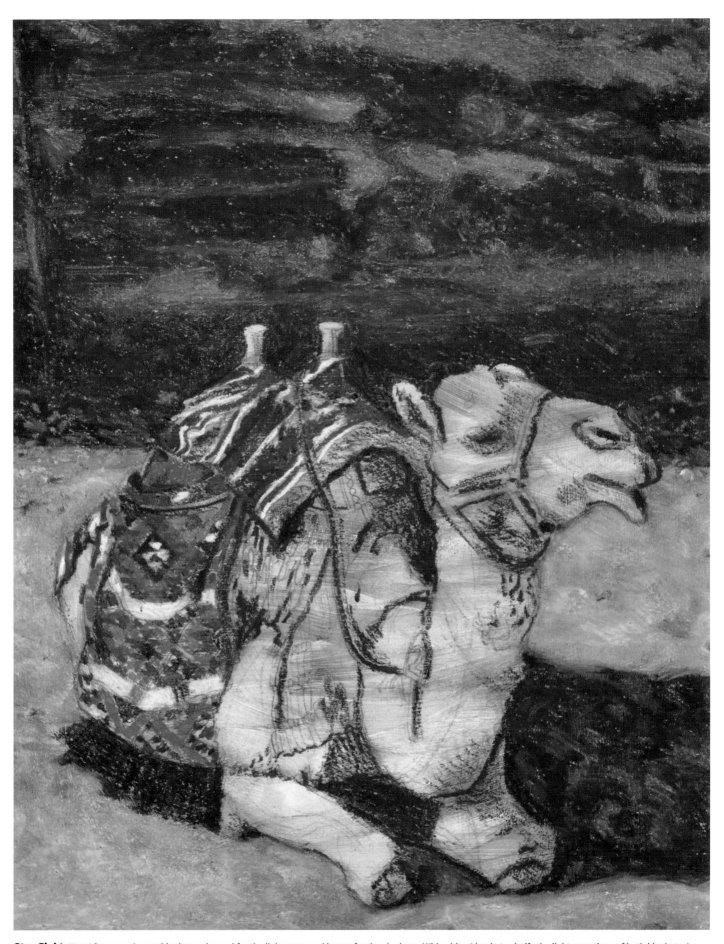

Step Eight Now I focus on the top blanket, using red for the light areas and brown for the shadows. With white, I begin to clarify the lighter sections of both blankets. I also allow the yellow ochre under painting from Step Two to show through for richer lights.

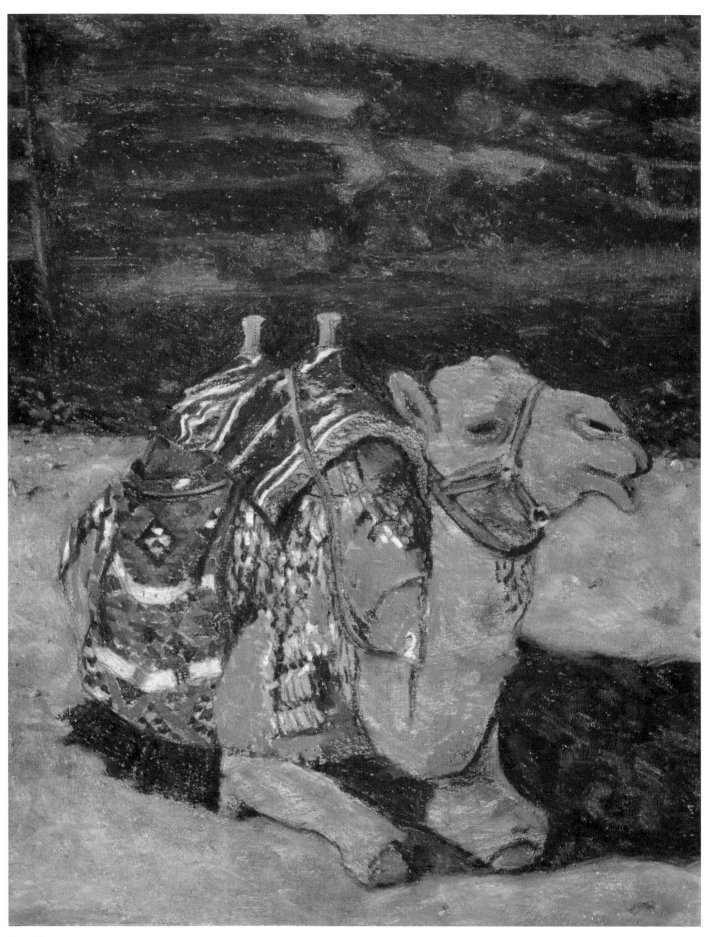

Step Nine With gray, brown, and Prussian blue, I jab at the paper, creating a stippled effect for the metal and straps. Using white, I then add the highlights and fill in the number 2. I lightly cover the camel hair with yellow ochre oil pastel and blend with my fingers.

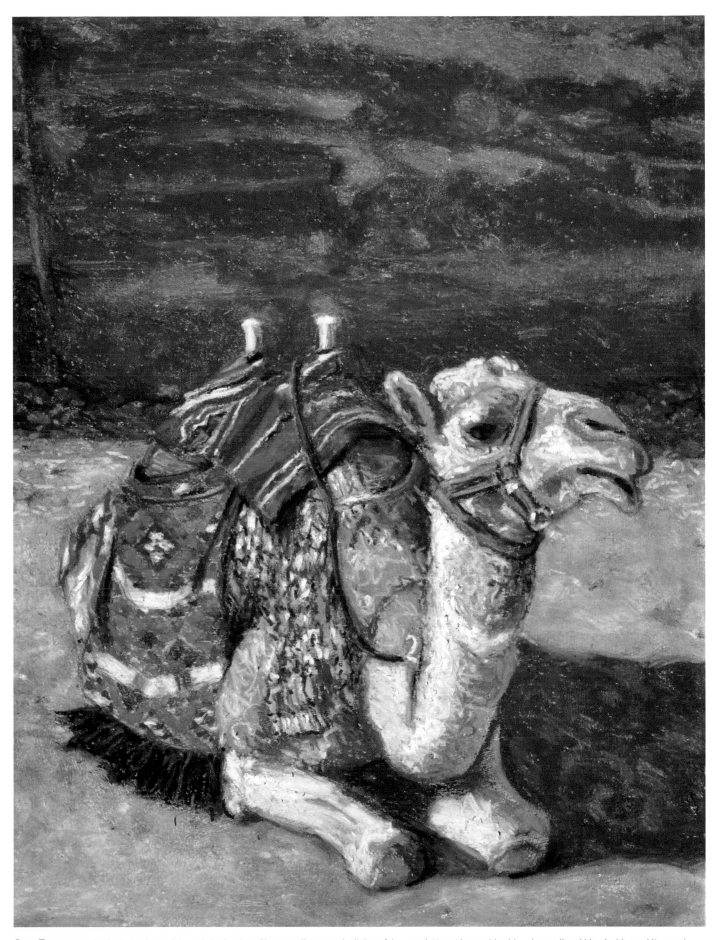

Step Ten I begin the final step by applying a light dusting of lemon yellow over the lights of the camel. Next, I layer with white, then pull and blend with good line work. This technique brings the camel to life. I use Vandyke brown and ultramarine blue to fix shadows throughout. Then I create definition and depth to the top blanket by adding orange for lights. I continually go back and forth on the Bedouin blanket, layering and correcting all colors used. With black, I finally push the darkest blacks to sharpen the image. I then add gray green to the metal number plate that sits in the crook of the camel's neck. Gray and white are both used as I continue working on the metal. As a final note, I remember to create the feeling of texture by varying my mark and blending method.

Pasadena Bridge

Having lived in Pasadena for many years, I've long admired the Colorado Street Bridge. A historic city landmark built in 1913, it has been portrayed by many artists. Capturing classic architectural beauty, history, and Old Town charm, the bridge spans the Arroyo Seco canyon. Basking in the warm glow of the California sun, it makes the perfect subject to draw.

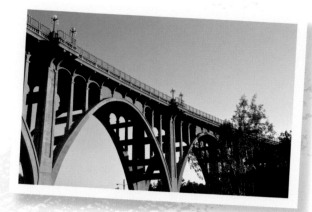

With the Colorado Street Bridge as a focal point, I utilized perspective to create depth and movement through the piece. I recommend taking advantage of the point of view when creating a composition—this can greatly increase the overall dynamic impact of the finished work.

Color Palette

Matte medium
ultramarine blue acrylic paint

OIL PASTELS:
Vandyke brown
yellow ochre
gray green
pale blue
cobalt blue
white
gray
deep green
yellow
Prussian blue

Step One The first step involves the creation of an accurate construction drawing. I exercised artistic license throughout the piece, omitting small architectural elements. Oil pastel is clumsy and thick, so I took my time to make strong shapes. As a result, this drawing served as my map through to completion. I used a heavier line weight to suggest shadow shapes, then sprayed a little workable fixative to help seal the drawing before the tone. I used gessoed rag paper for this drawing, and created a taped-off picture area that measured 11 by 17 inches.

Step Two Now I toned the paper, using ultramarine blue acrylic paint mixed with matte medium. This process creates a transparent layer of color. The mixture was mostly made of matte medium and very little ultramarine blue acrylic paint. This also protects the drawing and seals it permanently.

Step Three Next, I did a value study with Vandyke brown. It takes a lot of practice to create a delicate and detailed drawing with oil pastel. I layered the Vandyke brown to increase opacity for the darkest darks. Using a delicate touch, I drew in the lighter values.

Step Four Using yellow ochre, I added the warm light on the bridge, watching the direction of my strokes to make a beautiful drawing. I also used this color to bring warmth into the tree trunks. Next, I created a layer of color, using gray green in the trees. I finished this step with a pass of Vandyke brown to adjust the value shapes.

Step Five For the next step, I used pale blue and cobalt blue to crosshatch layers of color, then smudged with my fingers. As necessary, I used a kneaded eraser to pull out colors that got mixed in when smudging. Then I crosshatched layers of white, working the gradient from light to dark in the sky. Notice, the reference image gets bluer towards the top of the sky and whiter closer to the ground. I smudged again with my fingers to even out colors and then went back over with soft strokes. For the best effect, a combination of smudging and mark making should be used together. White was also used to lighten the bridge. Using gray, I drew the shadow side of the bridge lanterns, and then added white on the light side.

Step Six Next, I darkened the trees, using deep green. Yellow was used to brighten the light in the trees. Squinting helps me see the logical place to add light in my drawing.

Step Seven In the final step, I used white, yellow ochre, deep green, Vandyke brown, and Prussian blue. I built opacity and thick oil pastel in the foreground, allowing it to be slightly thinner in the background to show perspective. Vandyke brown and Prussian blue were layered to create the darks. I continued working on the trees, punching holes in the leaves with the sky. Yellow ochre was the last step, used to bring the light into the bridge shadows. At this point, I did all the necessary touch-ups, using any color from this palette to fix inaccuracies.

Portrait

When drawing a portrait, I try to capture a pose that triggers emotion in the viewer. I find that subtle expressions can transcend the moment and provide a more lasting appeal than dramatic expressions, such as a smile. In this portrait, the unsmiling model glances down and away. To emphasize the introspective mood, I use a strong light source to create intense highlights and shadows. When setting up a portrait, experiment with various poses, expressions, angles, and lighting. It often is helpful to refer to the masters for compositional ideas. Vermeer's *Girl with a Pearl Earring* was my inspiration for this portrait.

Lighting the Model I used a single, strong light source when setting up the lighting for this reference photo. Placing the light at the right distance from the model will control the darkness of your shadow shape. A close distance allows for high contrast, while farther away creates a lower contrast. A solid background allows for only a gradient of light and shadow to be seen. This will keep the focal point on the portrait.

Color Palette

OIL PASTELS:
Black • brown • deep green • gray • green • green gray • lemon yellow
olive brown • orange • pale blue • pale orange • pink • Prussian blue
ultramarine blue • Vandyke brown • white • yellow ochre

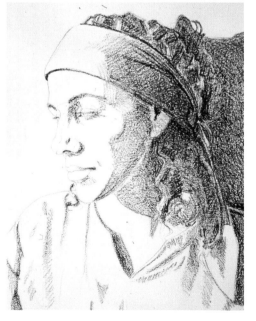

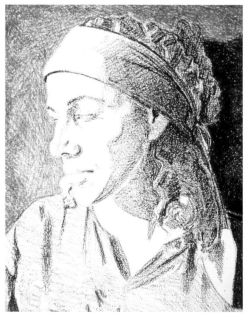

Step One I create a white border around the painting by taping the edges of the picture. Then I apply an even layer of acrylic gesso with a soft brush to the paper to increase its archival quality. After the gesso dries, I lightly sand away any brushmarks for a smooth surface. With an HB pencil, I transfer the portrait onto the gessoed paper, focusing on the planes of the face and the shadow shapes (see page 94 for more on transferring an image).

Step Two Now I start applying color by blocking in shadow shapes. Using Vandyke brown, I apply an even layer of tone over the hair, collar shadow, ear, and areas of the facial features. Then I push the darker shapes back further by layering more Vandyke brown. I use Prussian blue for the cast shadow in the background and the deepest shadows on the face, neck, and folds of the shirt. I apply deep green to the shadowed side of the scarf, using the sharp edge of the oil pastel to define the folds in the fabric. Then I layer Prussian blue over the Vandyke brown in the ear and collar shadow, pushing these darkest areas closer to black. I crosshatch strokes in light layers to ensure an even application of color.

Step Three Next, I block in the background with an even layer of lemon yellow. Then I crosshatch green gray over the entire background, applying it on top of lemon yellow and the blue cast shadow of the head. I add another layer of Prussian blue near the hair to create a darker value. Then I lightly cover the shirt with green gray, applying heavier pressure to the shadowed folds.

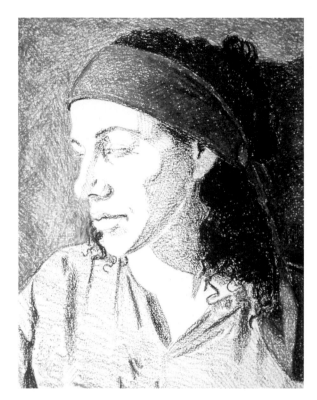

Step Four With a green oil pastel, I cover the entire scarf, layering over the shadowed side. Then I work back into the darks of the scarf using deep green. I cover the hair with brown, then return to the darkest areas of the hair with Vandyke brown and ultramarine to create greater contrast. Using Prussian blue, I fill in the gaps in the hair.

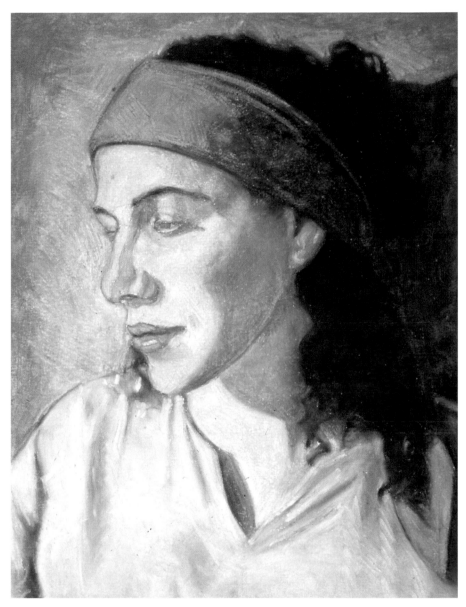

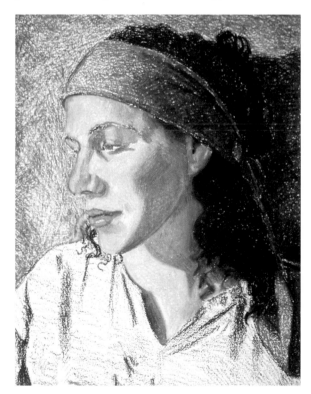

Step Five Now I cover the light sides of the face and neck with pale orange. I scrape out any dark pigment that mixes in accidentally with a palette knife. I make sure to clean the pastel regularly with a cloth to keep unwanted colors from mixing onto the face. Now I go over the shadowed areas of the face with pale orange, using firm pressure to mix the pigments together. I work back into the dark areas with ultramarine blue, smudging with my finger to close up gaps, mix colors, and blend edges. I use the knife to remove any unwanted color. Then I add pink to the cheekbone, lips, nose, eyelids, ears, and clavicle. I fill in the irises with yellow ochre.

Step Six I go over the light areas of the shirt with white and blend the white and green gray with my finger. I also apply and blend white into the shadows and folds of the shirt. Using the smudging technique, I blend edges in the hair, shirt, and cast shadow of the head with my fingertips. I use the clean edge of the white pastel to define hard edges and wrinkles in the shirt, creating a variety of hard and soft edges. With gray, I crosshatch over the background and blend the pigments with my fingertip. I use the knife and scrape gently to lighten or remove pigment. Then I use white to create stronger light in the background, blending and scraping colors. Now I crosshatch over the lighter areas of the scarf with pale blue. I cover up any white showing through the pigment and soften edges throughout the drawing by smudging with my fingertip. Then I use a little olive brown to cover any white areas around the eye.

Details

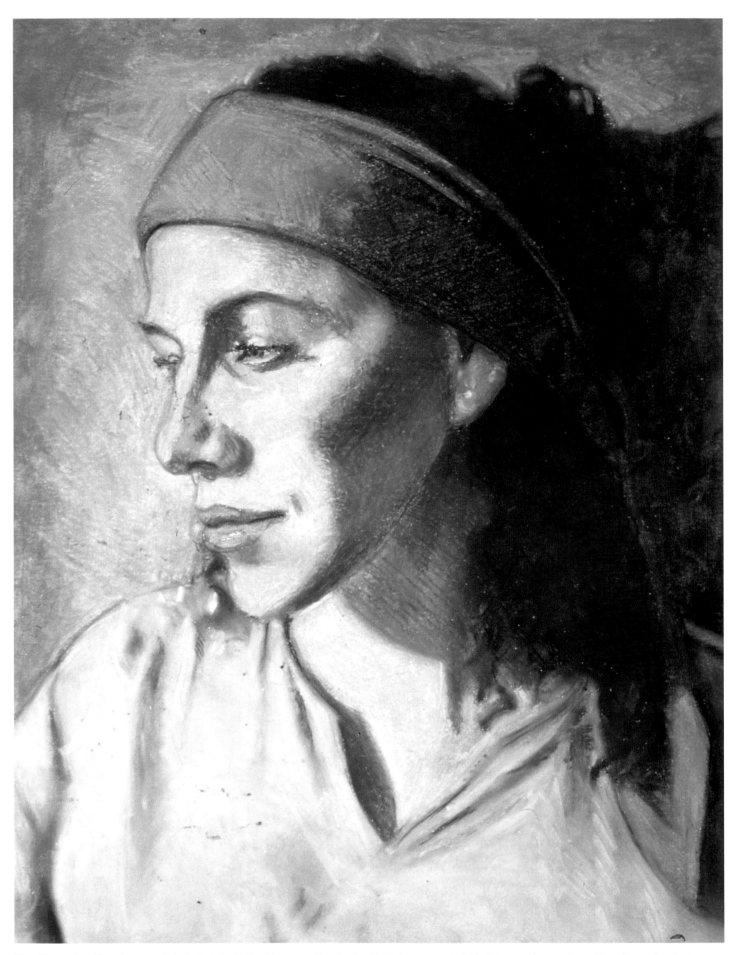

Step Seven Now I introduce more darks in the hair with Vandyke brown. Then I go in with black to suggest individual strands, blending them with my fingers. I neutralize the blue shadows on the face by lightly crosshatching brown and Vandyke brown over the pigment and blending various areas. I warm up the shadow edges with brown, then use black to accentuate the lashes and eyes. I delicately scratch and blend edges as I work, keeping in mind that this process requires both finesse and patience. I focus on the darks in the shirt using the least amount of black possible to sharpen some of the folds.

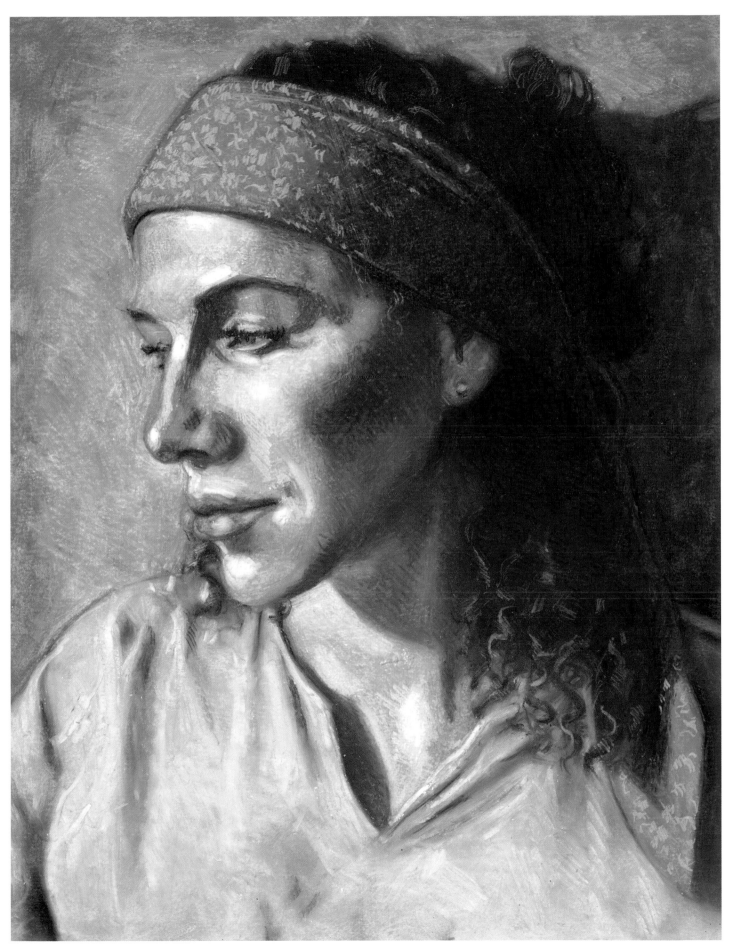

Step Eight Using black and Vandyke brown, I create more detail and push the darks even further. I apply Vandyke brown to the shadows on the scarf and face to neutralize them more. With the palette knife, I scratch and scrape out light areas in the face and hair, as well as create details on the scarf. Then I add some highlights in the hair and reflected light in the jaw's shadow with orange. Now I use white to create highlights in the face, accentuating the strong light source. In these final touches, I pay close attention to detail, scraping and blending my way to the finished piece.

Wooded Road

The beautiful dappled light drew me to this wooded road. The singular perspective of the road helps develop deep space. I've always loved the aesthetic of California's rolling hills and oaks, so this landscape made a perfect subject. Because of the many branches and small light and shadow shapes, it was important to make my working surface large to accommodate for the nature of drawing with oil pastel. This allowed more room for detail, gesture, and expressive mark making when I created the drawing. Variation in my marks, value, and color helped create emotion in the piece.

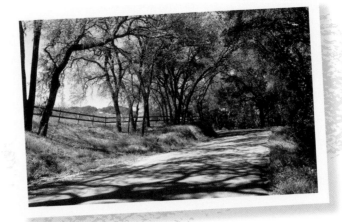

Dappled Light This wooded road, laced with shadow, provided an excellent opportunity to study the contrast between cool shadow and warm light. The project also allowed me to capture and interpret light using impressionistic techniques.

Color Palette

Matte medium
ultramarine blue acrylic paint

OIL PASTELS:
Vandyke brown
ultramarine blue
Prussian blue
gray
white
yellow ochre
deep green
olive brown
yellow green
green gray
lemon yellow
pale blue
yellow
black

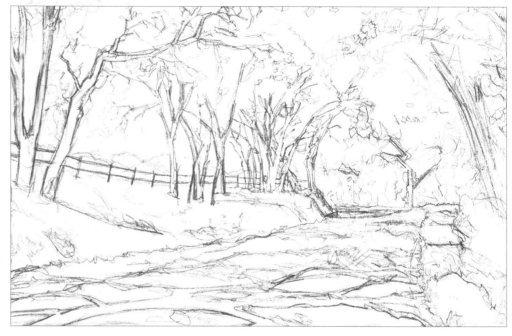

Step One First, I needed to establish an expressive and gestural drawing. To achieve this, I began by separating the major shapes of light and dark, figure, and ground. Variation in line weight was extremely important at this point.

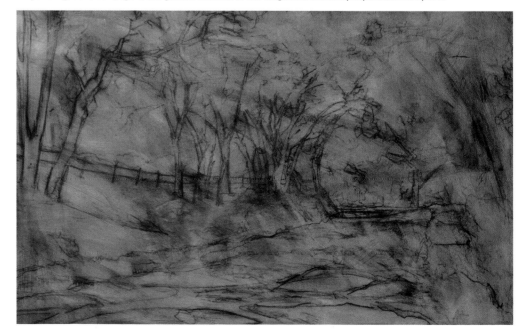

Step Two Next, I painted a transparent layer over the drawing, using matte medium and ultramarine blue acrylic paint. This process sealed the drawing, toned the image, and unified the colors. Ultramarine blue is a good color to use for landscapes as a base.

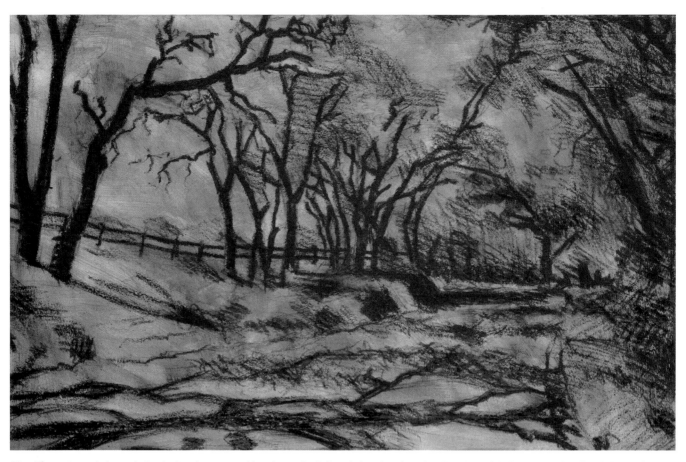

Step Three By squinting at the inspiration photo, I was able to locate the darkest darks. I then drew them in with Vandyke brown. I continued squinting as I began to separate the shadow shapes using ultramarine blue. Then I layered ultramarine blue on top of the Vandyke brown to create a darker color. I used a variety of marks, crosshatching, and gestural movements, always maintaining variation in line weight. At this point, the only oil pastel used on the foreground shadow shapes was ultramarine blue. I wanted to keep the shadows cool—that way, when I would later block in the light sections, they would be warm. As necessary, I used a kneaded eraser to correct my oil pastel application, always striving for proper shapes and line.

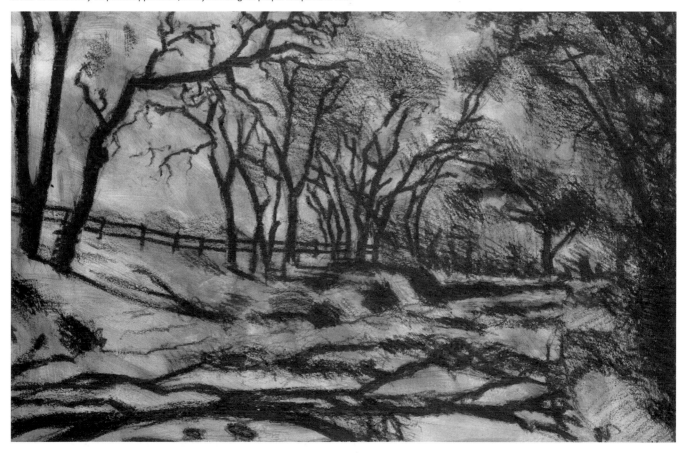

Step Four With Prussian blue, I kept working the darks and shadow shapes. As needed, I would go back in with Vandyke brown to correct and darken. I continued working the overall shadow shapes in the trees and on the ground, correcting the drawing as I proceeded.

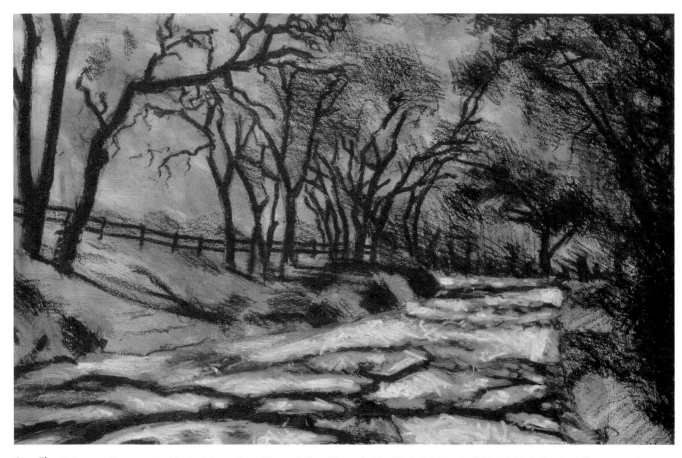

Step Five Using gray, I began to block in the light sections of the road. Then, I layered with white to brighten the lightest lights in the street. If necessary, I would blend slightly and remove excess oil pastel with my finger. After finishing the white in the road, I began working on the shoulder of the road. Here I used yellow ochre as a base, adding white over that.

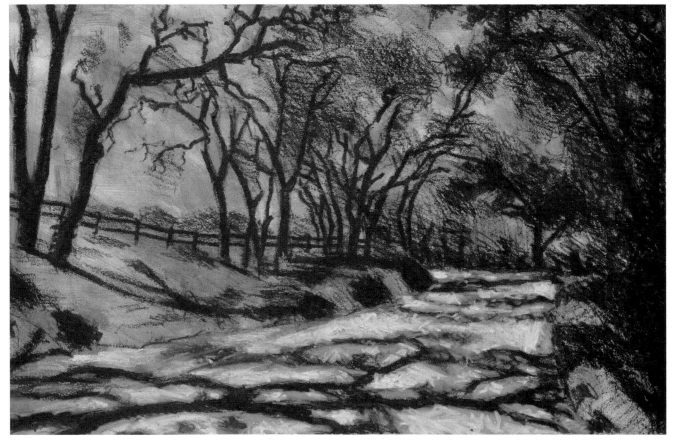

Step Six In this step, I adjusted the foreground branch shadows, making them a bit darker with Vandyke brown. Then, using deep green, I layered the darks in the trees, ground, mountains, and everywhere as needed. I continued to employ crosshatching and variation in line weight by alternately pushing harder, then softer, when making marks. Variation continued to be critical in value, mark, and color.

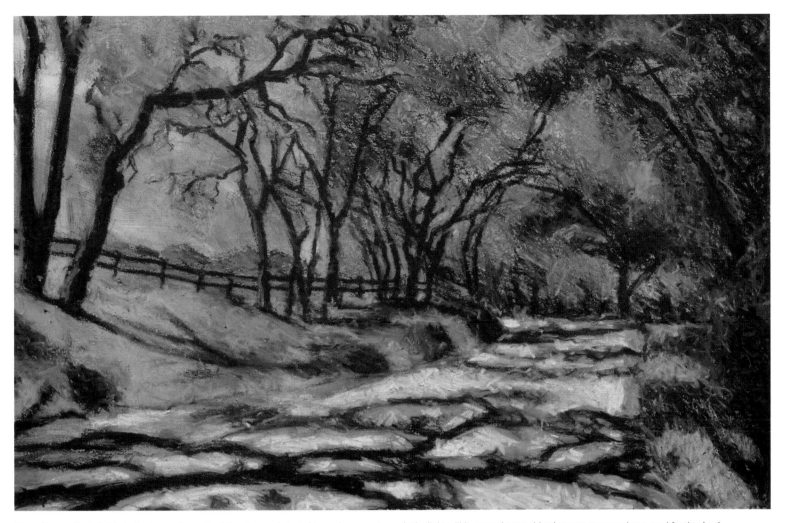

Step Seven Next, I added olive brown throughout the piece and started to work my way towards the lights. This created a transition between tones and was used for the dead branches and dry grass. Then I added yellow green in the grass, layering it to saturate the color. Finally, I moved into the trees using a gestural stroke that mimics trees and branches. This application was not as aggressive as the grass, more manic for variation.

I layered the green and blended, using the pressure of my mark making. This created an even tone. Make sure to keep your crosshatching and directional marks uniform.

Notice the texture that can be created by the mark of an oil pastel. I used this to my advantage to increase the contrast of the shadow. The display of viscosity in this medium can be beautiful.

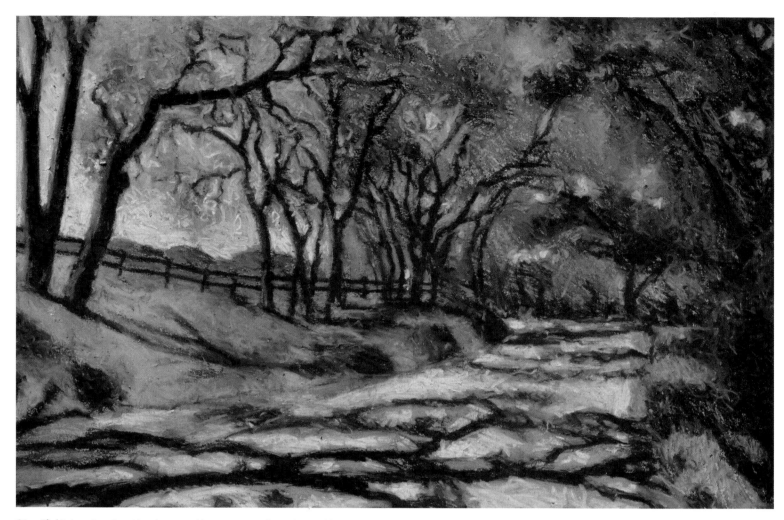

Step Eight I continued working the trees with green gray, yellow ochre, and lemon yellow. Then, I followed the light pattern and scratched away mistakes. At this point, I pressed hard to layer the oil pastel. Next, using a palette knife, I began to scrape away the oil pastel in the sky shapes in the trees. Then, I used pale blue to block in the sky shapes. It was important to remember that the blue is darker at the top of the image and gets lighter as it approaches the horizon line. To accomplish this, I applied white at the horizon line and transitioned to the pale blue. I then corrected the sky shapes using yellow green.

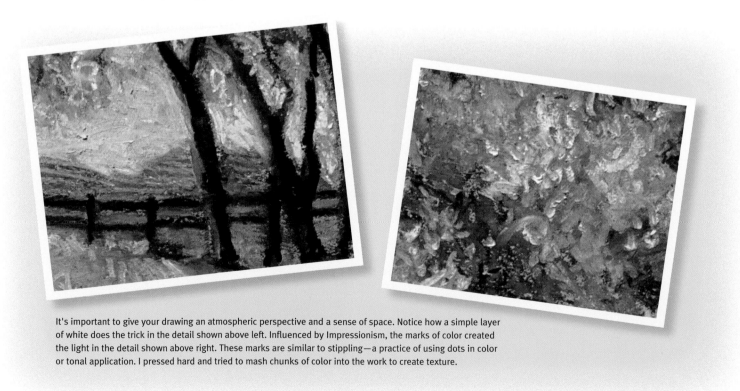

It's important to give your drawing an atmospheric perspective and a sense of space. Notice how a simple layer of white does the trick in the detail shown above left. Influenced by Impressionism, the marks of color created the light in the detail shown above right. These marks are similar to stippling—a practice of using dots in color or tonal application. I pressed hard and tried to mash chunks of color into the work to create texture.

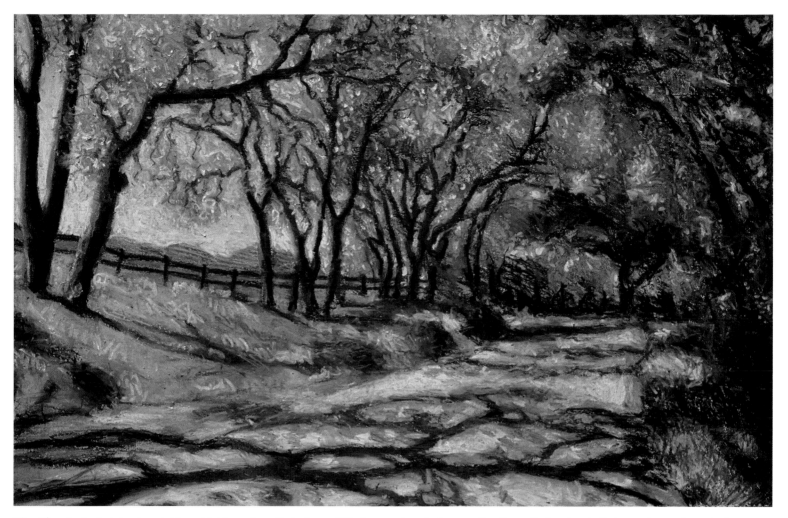

Step Nine For the final step, I used white and lightly went over the background hills for more atmospheric perspective. Then, with the palette knife, I scraped away oil pastel to increase the lights with yellow, yellow ochre, pale blue, and white. I made these marks by jabbing and pushing to create stippling, dots of light. Then, I cleaned up the tree darks with Prussian blue. I softened and worked the shadow shapes in the grass to make them more irregular. With Prussian blue and Vandyke brown, I softened the dappled light on the road. I used my finger to blend and soften edges, then used white to increase lights. Finally, I used black to solidify the darkest darks.

Capitalizing on the beauty of line and variation in line weight, the depths of the shadows were pushed with black. It's good to have variation in your line, combining hard and soft edges. This can be achieved by blending a selection of your lines with your finger to soften the hard edges.

Laundry Line

For an artist, finding inspiration in Venice, Italy, is like looking for sand on the beach. It's everywhere. When I saw this laundry line hanging from a building I felt compelled to draw or paint it. The quaint scene evoked a timeless connection with our past. The variety of textures and earth tones made a beautiful subject matter, especially when combined with the strong contrast in form and lighting. To capture the many details in this image—like the brick, the wrought iron and the shutters—I drew on top of the oil pastel after it had been laid down. Using a sharp tool, like a graphite pencil or Conte pencil, allowed me to scratch detail into an even layer of oil pastel.

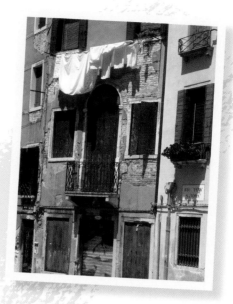

Using a Variety of Tools and Media For this project, I chose to use a variety of tools and media to create a particular affect. By employing the right tool, detail rendering can be easily achieved.

Color Palette

Matte medium
yellow ochre acrylic paint
Conte pencil in black

OIL PASTELS:
Vandyke brown
brown
deep green
Prussian blue
gray green
yellow green
gray
pale blue
yellow ochre
white
red
vermillion
lemon yellow
brown
purple

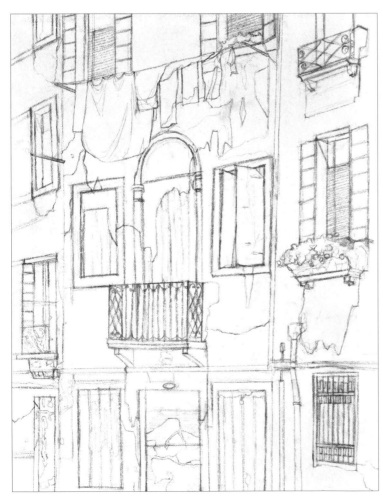

Step One Creating a strong drawing is always the best place to begin. This scene had much detail, so it gave me a solid base for my composition. I used line weight to suggest value and to separate shapes. Sometimes I place a sheet of paper under my drawing hand while I work, to prevent the movement of my hand from smearing the graphite. Workable fixative can also be used at this point to help control smudging. For this project, I used gessoed rag paper, Reeves® BFK, with a picture plane that measured 22 by 15 inches.

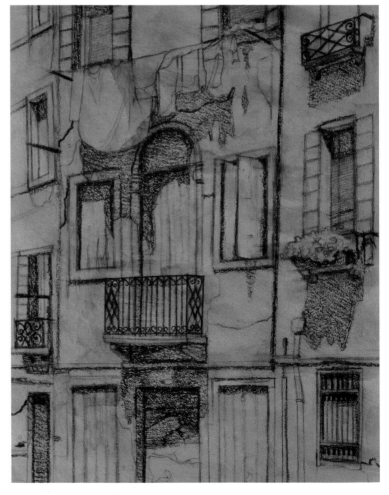

Step Two Next, I created a transparent mixture of yellow ochre acrylic paint and matte medium, and then brushed a layer of this over my drawing. This process both toned the paper and sealed the graphite. It's important to apply this carefully, without much brush work, or the drawing will be lost. I find it works best if I do a couple of layers. Then I grouped my darker values together using Vandyke brown. By varying the pressure of my marks, I was able to achieve darker darks—always striving for an even application of the oil pastel. As needed, I used a ruler to make straight lines. Since it is difficult to draw thin lines with oil pastel, I used a Conte pencil in black to draw the railings.

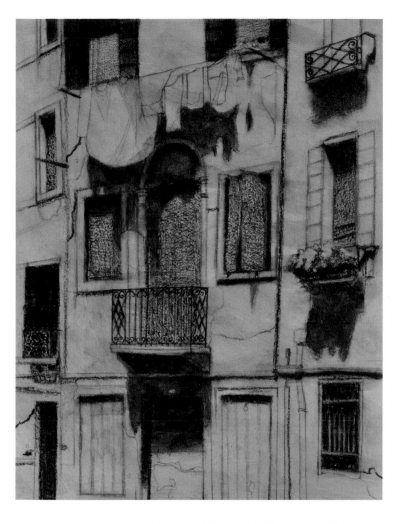

◄ Step Three Here I covered the sienna doors with an even coat of brown. Then, using deep green, I focused on all the greens that were close in value, layering darks where appropriate. I added deep green on top of the Vandyke brown in the windows, as needed. Later I would separate the greens by layering other colors on top, and then smudging. For now, I lightly added a layer of Prussian blue over the shadows and darks. Then, using my finger, I smudged the oil pastels together, thus evening the tone. After smudging, I drew back in with the Prussian blue to recover the drawing. A kneaded eraser can correct smudging errors.

Step Four Next, I put a layer of Vandyke brown on top of the three center windows and blended accordingly. I then smudged, and followed this by drawing back into the doors with all the colors used thus far. I continued working shadows throughout, gradually replacing and smudging colors. Brown was added to the brick areas; Vandyke brown to the bars over the bottom right window. Finally, I worked on the metal door, smudging and drawing with Vandyke brown.

Detail

◄ Step Five In this step, I filled in the two upper left windows with gray green, then smudged. Next, I added a layer of yellow green on top to create the light. As needed, I re-drew the railing with Conte pencil. I then used gray on the three bottom middle doors. At this point, I used only gray on the center door, but the two other bottom doors were smudged and layered with Vandyke brown, focusing on the darker areas of these doors.

◄ Step Six I then drew all the pipe with gray and smudged. I used gray green to draw the shutters on the window on the right, and then smudged. Using Prussian blue, I focused on details and darks. Then, I introduced a small amount of pale blue to the bottom doors. I added a little gray to the shadowed edge of the white window frames and the white arch around the center door. With yellow green, I touched up the barred window and any other areas needed. I also added a little gray on the window bars.

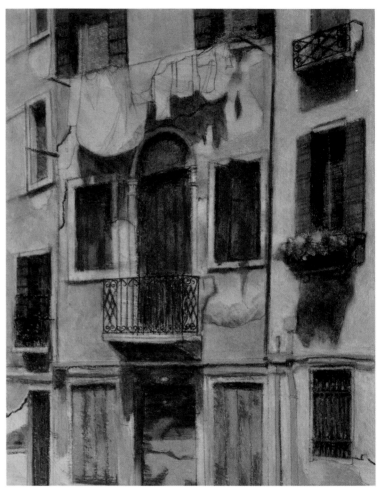

Step Seven Now I focused on the walls, using yellow ochre oil pastel lightly over them all. I then added a layer of gray to the stucco on the left, and blended. On the right, I added a layer of white and blended. I also worked on the lower portion of the image, on the casting shadow of the pipe, smudging the rail and window on the lower left.

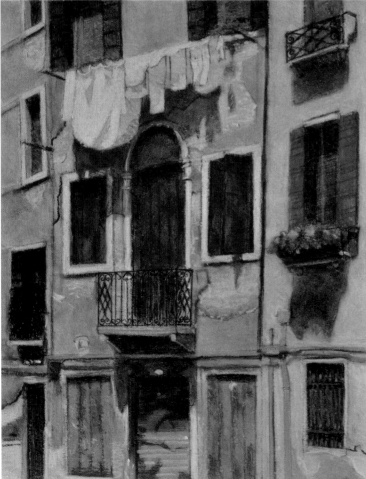

Detail

◄ Step Eight This is the point where I brought in the white. All window frames were given a thick layer. The light sections of the laundry were also given a thick layer. For the white portions on the wall and the brick, I used a varied mark to simulate texture.

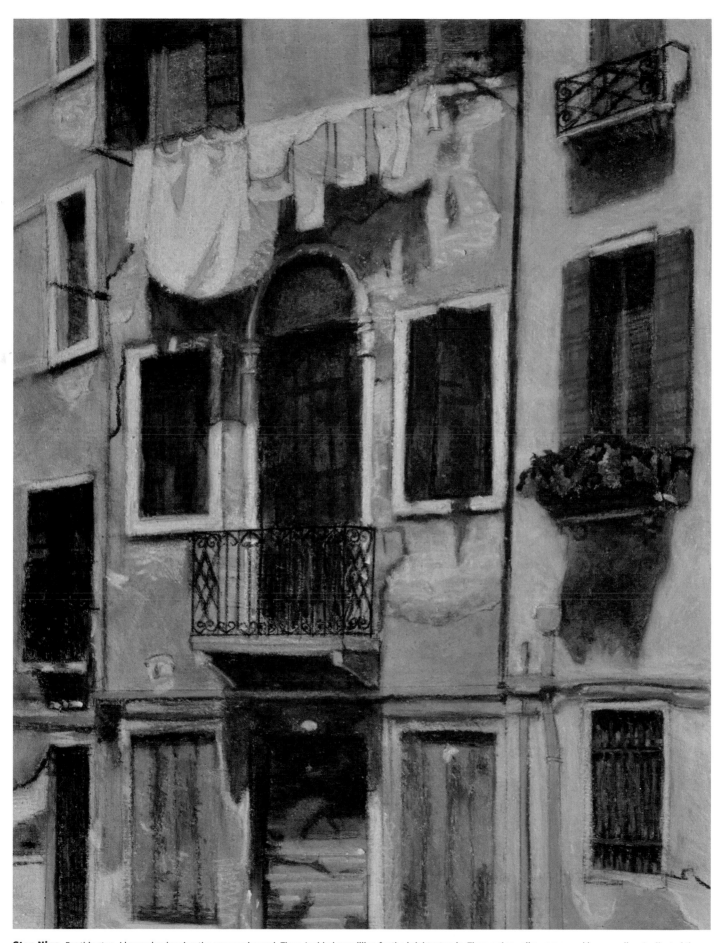

Step Nine For this step, I began by drawing the roses using red. Then, I added vermillion for the brightest reds. Then, using yellow green and lemon yellow I adjusted the color of the plants in the top window. With brown, I added more detail to the brown doors. I also used brown to color in the flowerpots.

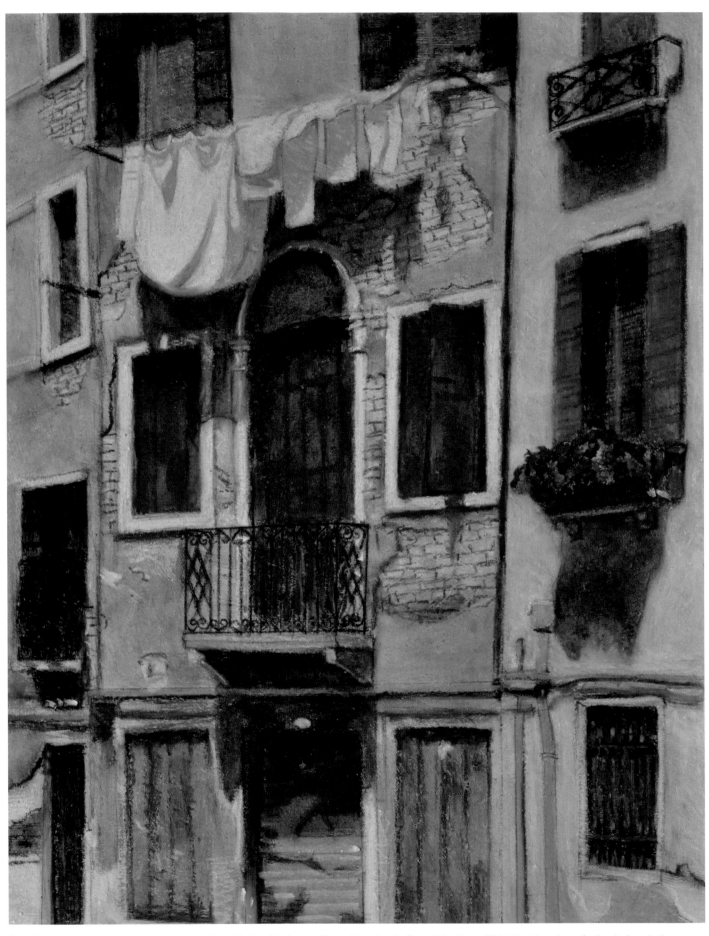

Step Ten I drew the bricks delicately using the edge of the Vandyke brown oil pastel, keeping the line weight thin and light. Next, I used gray for the shadows in the hanging laundry. Then with Prussian blue and pale blue, I adjusted the laundry shadows to show the cool light. I added highlights on the window railings with yellow ochre oil pastel.

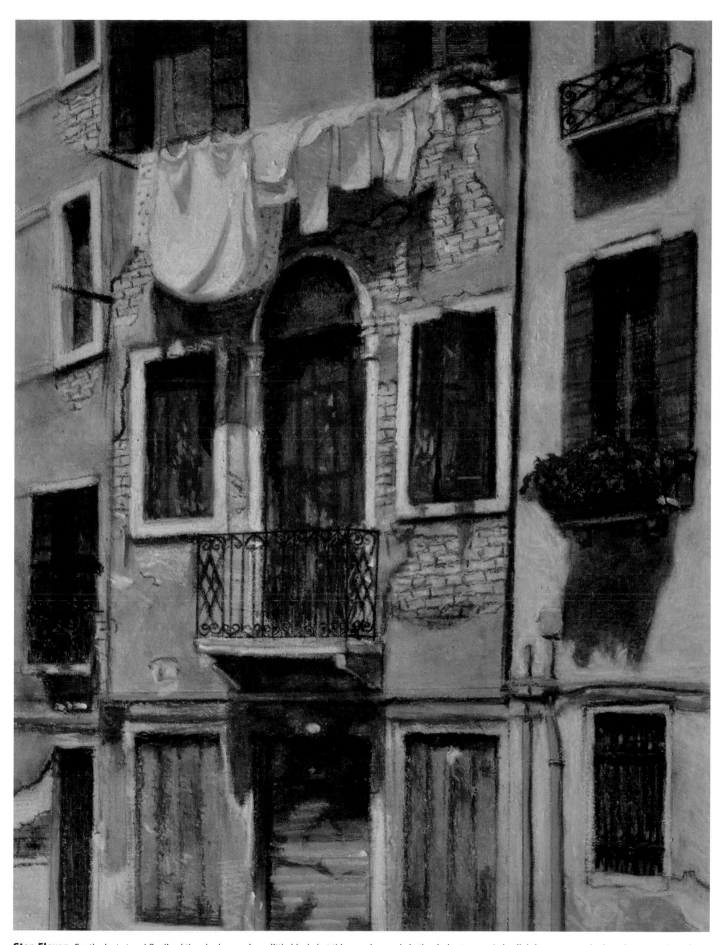

Step Eleven For the last step, I finalized the shadows using a little black, but this was done only in the darkest areas. I also lightly went over shadow shapes on the red doors to increase darkness. Yellow ochre oil pastel was used to warm up the light areas on the brown doors. It was important to create the appropriate contrast between light and dark on the brown doors. I added nicks with both gray and yellow ochre oil pastel to the doors and throughout the entire piece. With Vandyke brown, I added dots on the two pieces of laundry that were spotted. Stucco on the bottom right was adjusted with white. I made sure all pipes had casting shadows. Then, I walked away from the piece for awhile and came back to it later. This allowed me to see any mistakes or missed work. At this point, I added purple in the flowers in the upper window.

Perfume Bottles

I stumbled upon this beautiful still life in a perfume oil shop in Cairo, Egypt. The lighting and the delicacy of the bottles was so gorgeous, it was almost as if I *had* to draw it. It's perfectly acceptable to get your still life inspiration from someone else's placement and arrangement. As the artist, however, you must consider point of view and cropping as part of the process—there are many decisions to make along the way. To create the atmospheric perspective, I used a solvent and brushed over the thin layers of oil pastel. I placed the focal point on the foreground bottles, with the other bottles dissolving into the background. You can almost smell the sensuous bouquet when you look at this image taken in an exotic, distant land.

Color Palette

Matte medium
burnt sienna acrylic paint

OIL PASTELS:
Gray
white
Vandyke brown
olive brown
yellow ochre
white
orange
lemon yellow
pink
pale blue
brown
Prussian blue

Enhancing Colors Transparent objects, like these bottles, can be tricky to draw, but this lesson will make the process easier. I'll also show how you can create a more striking piece by enhancing the colors. Note: It isn't always what we see, but rather, how we respond to what we see, that makes the difference in our artwork.

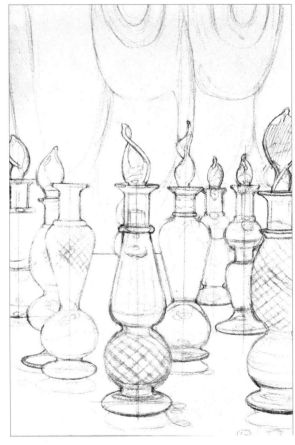

Step One It was essential, while creating the construction drawing, to have a center line on the bottles. This process ensures that both sides will be equal. Also when drawing the ellipses, I made a cross in the center, using a line perpendicular to the center line, thus creating a major and minor axis for the ellipse. This enabled me to judge the correct arch for each bottle. I then used variation in line weight as I slowly and accurately constructed my drawing. At this point, I sealed the drawing with workable fixative. For this project, I used gessoed rag paper, and taped off a picture area of 17 by 13 inches.

Step Two
I prefer to create a common ground by toning my gessoed paper. For this, I used a transparent mixture of matte medium and burnt sienna acrylic paint. Using the matte medium both strengthened the piece and protected the drawing, so I could scrape away sections of the oil pastel as needed, without damaging the original piece. A couple thin layers works best. This mixtures dried fast and I was able to begin working with oil pastels soon afterward.

Step Three

First, I added a thin layer of gray for the glass counter. Then, I layered white on top of that and blended them together with my finger. With Vandyke brown, I began defining the background shapes. I wanted to surround the figures/ bottle and separate them from the background.

Step Four

I continued using the Vandyke brown to define darks throughout. Then, I put a layer of olive brown across the entire background. I also added yellow ochre to certain areas and increased the saturation of Vandyke brown.

Step Five

Using my finger, I smudged and blended everything. Then I drew back into it using Vandyke brown.

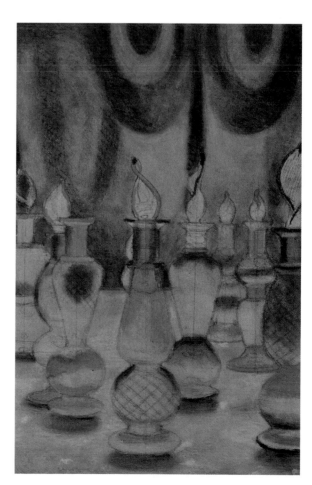

Step Six

I added a thin layer of yellow ochre on the glass counter top and blended. At this point, I added white for the highlights.

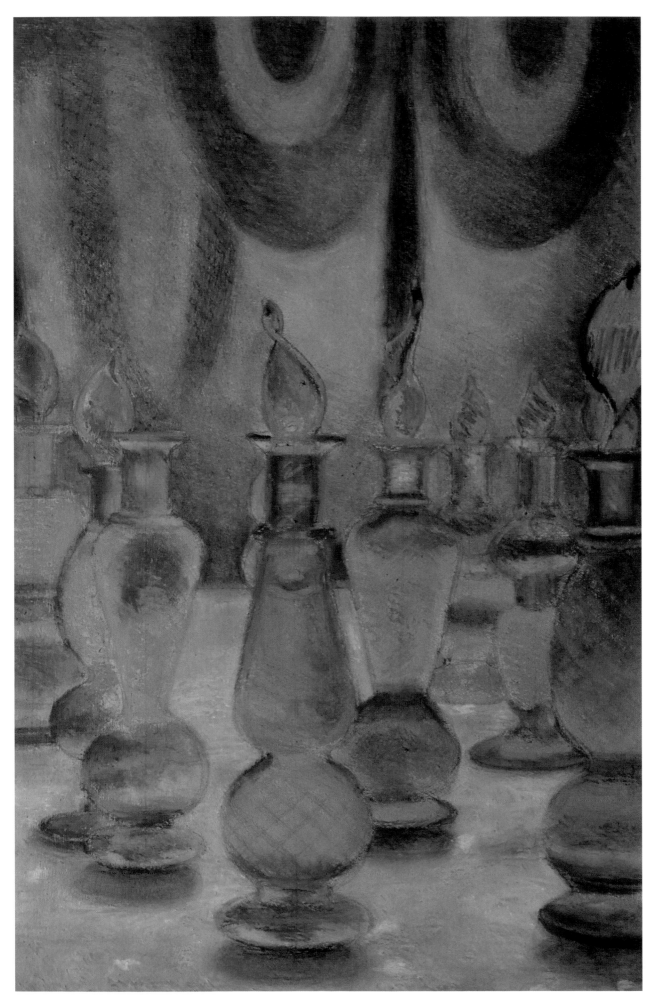

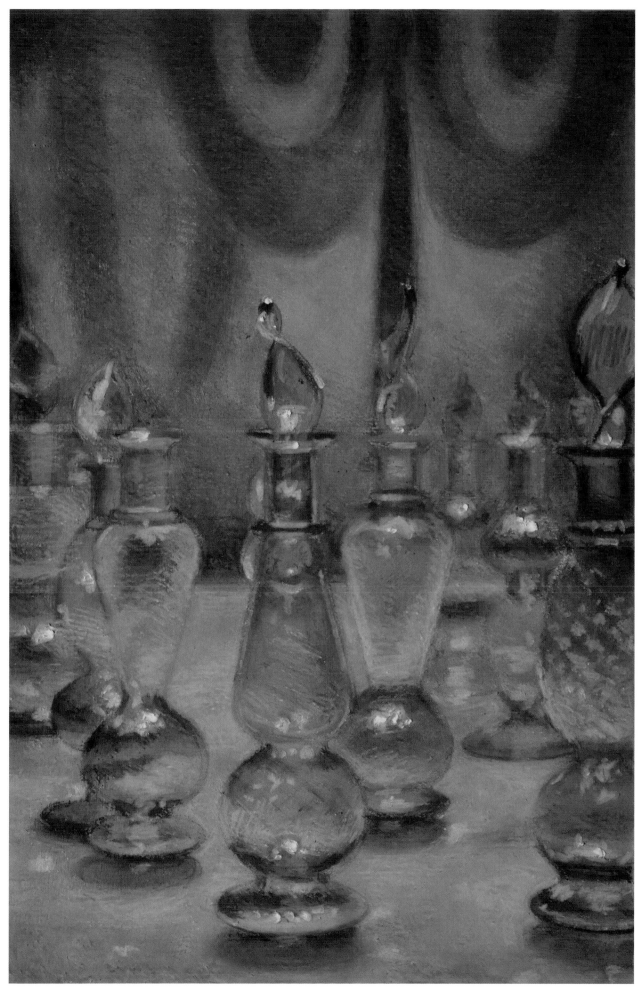

Step Eight Now I smudged everything and blended with my fingers. I used yellow ochre to help push the glass into the environment and cover-up unwanted pencil lines. I created darks with Vandyke brown, and then introduced Prussian blue for the darkest darks. Finally, I used white to create highlights. I pushed the white so hard that it crumbled and left a chunk on the paper. I also used light layers of white to make the bottles look transparent. Using yellow ochre, I made the background bottles recede and covered up any left-over graphite that might show through. Blending the background bottles helped them appear out-of-focus. I also smudged the background shapes and lightly covered them with yellow ochre. At this point, I used all the colors, touched up and rendered detail in the bottles, seeking a final atmospheric look.

Detail

Water Reflections

The attraction in this image resides in its abstract quality. While cruising down the Nile River in Egypt, I found myself surrounded by feluccas, small lateen-rigged sailboats. The complexity of form and color transformed this reference image into visual candy. The complexity made me slow down and get in touch with my intuition. This project reminded me how important it is to rely on my senses and be expressive. Feel it, be it, don't over analyze it.

Working With Reflections This project offers the opportunity to learn how to portray reflections in water. Also, it shows how to make sense of complicated subject matter: editing confusing and unnecessary information.

Color Palette

Matte medium
ultramarine blue acrylic paint

OIL PASTELS:
Pale blue
cobalt blue
white
ultramarine blue
olive brown
Vandyke brown
gray green
brown
orange
vermillion
Prussian blue
deep green
yellow
black

Step One I began by creating a construction drawing, building up slowly with a light line and then progressing towards a heavier line. I separated major masses and shapes, trying to make sense of all the information. It wasn't necessary to draw every rope, rather I focused on the major information that needed to be defined. I decided to edit some of the mess and confusion. The use of a little spray fixative helped the graphite from smearing. For this project, I used gessoed rag paper, and taped off a picture area of 14.5 by 11 inches.

Step Two Landscapes and natural settings benefit from a base of ultramarine blue. So, I made a transparent mixture of ultramarine blue acrylic paint and matte medium to seal the drawing.

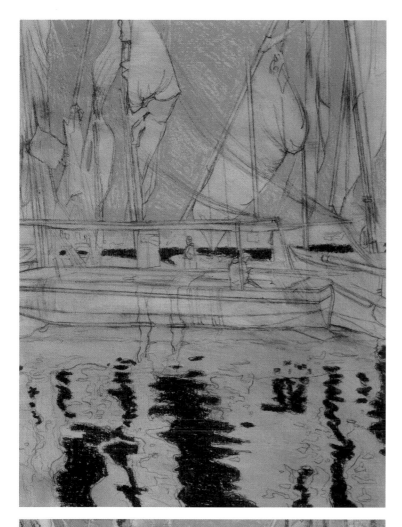

◀ Step Three In this step, I wanted to start the process of separating the figure/ground relationship, separating the boats from the environment. Using pale blue, I blocked in the sky, and then using cobalt blue, I blocked in the blue of the water.

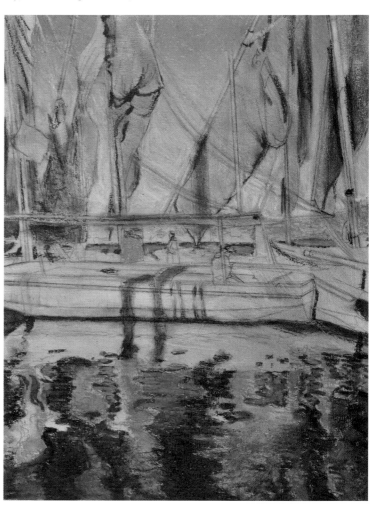

▲ Step Four Next, I added white in the sky, starting a gradient from light to dark, from the bottom up. I brought the white into the water to adjust color. Then with ultramarine blue oil pastel, I darkened the top of the sky, smudging a bit with my fingers, leaving some of the marks. I also added ultramarine blue oil pastel to the bottom of the image to darken the water a little. Olive brown was added to the reflections and then smudged with my finger. Be careful not to accidentally make green by mixing colors. A little olive brown was added to the sails. Then with Vandyke brown, I started defining the darks. Finally, I used my fingers to smudge all the areas I just laid in, closing any gaps and making sure the paper didn't show through.

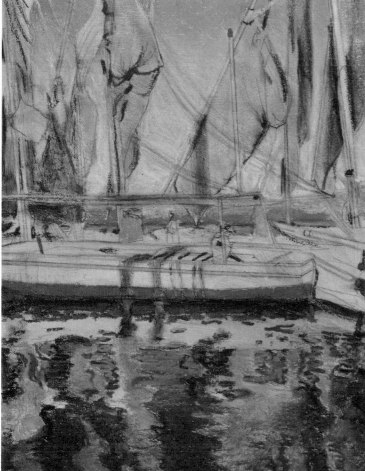

Detail

◀ Step Five Using gray green, I added the foliage on the horizon line and smudged. Then, I mixed a little brown and olive brown for the hill in the far background. The pale blue line on the boat was added next. I used orange for the underside of the boat in the foreground. For the reflection, I used vermillion, gradating to orange as I worked away from the boat. Touches of vermillion and orange were then used throughout.

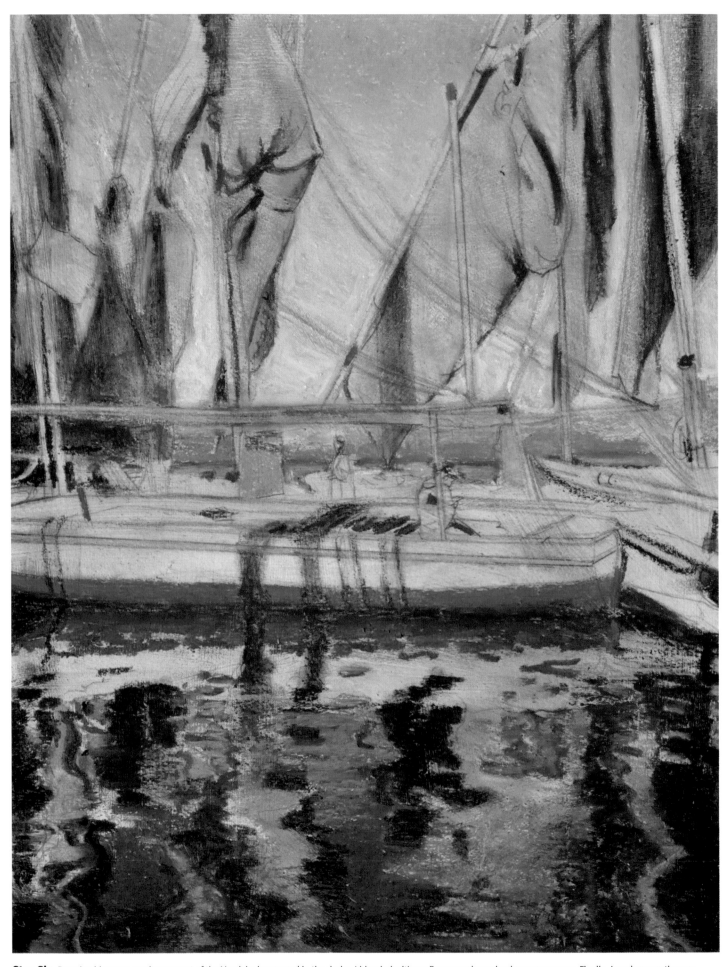

Step Six Prussian blue was used over most of the Vandyke brown and in the darks. I blended with my fingers and smudged away any gaps. Finally, I made corrections as necessary with the other colors already used.

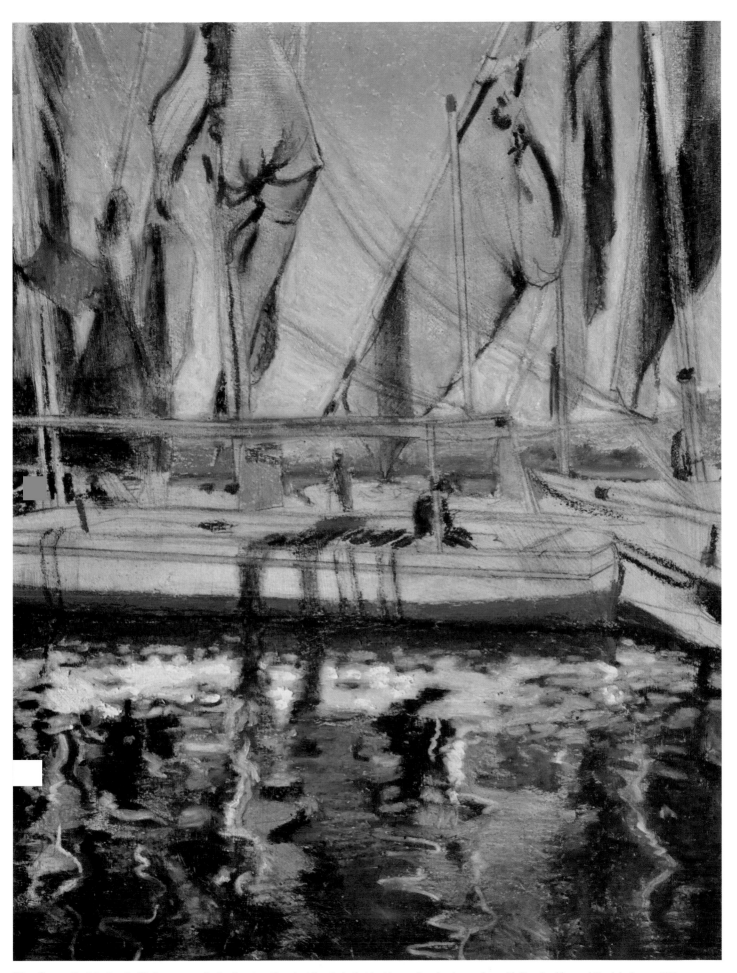

Step Seven For this step, I added gray green for the flag. I continued adding darks that had been missed as I moved on with Prussian blue and Vandyke brown. Little touches and details of deep green were added around the piece. I worked on the reflections in the water, first with white, then olive brown, and pale blue. I layered colors, blending, going back and forth, varying the colors. The white was heavily layered and used to lighten colors that had gradations of value.

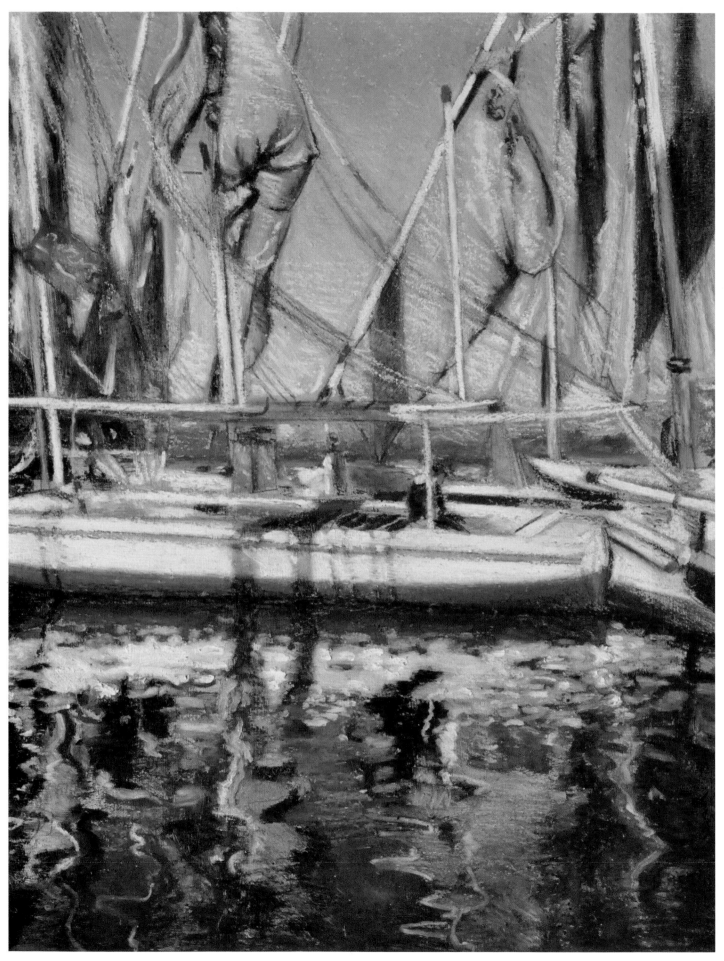

Step Eight I continued working on the reflections. With white, I started in on the boats and sails. Brown added color to the middle of the boat. Next, with delicate care, I began to build the light on the sails, adding ropes with Vandyke brown and alternating with white, as I followed the value patterns. Yellow was added to the bottom of the foreground boat; I placed it next to the white, just a little for the glow. Also, yellow was used on the few ropes and poles that had that color.

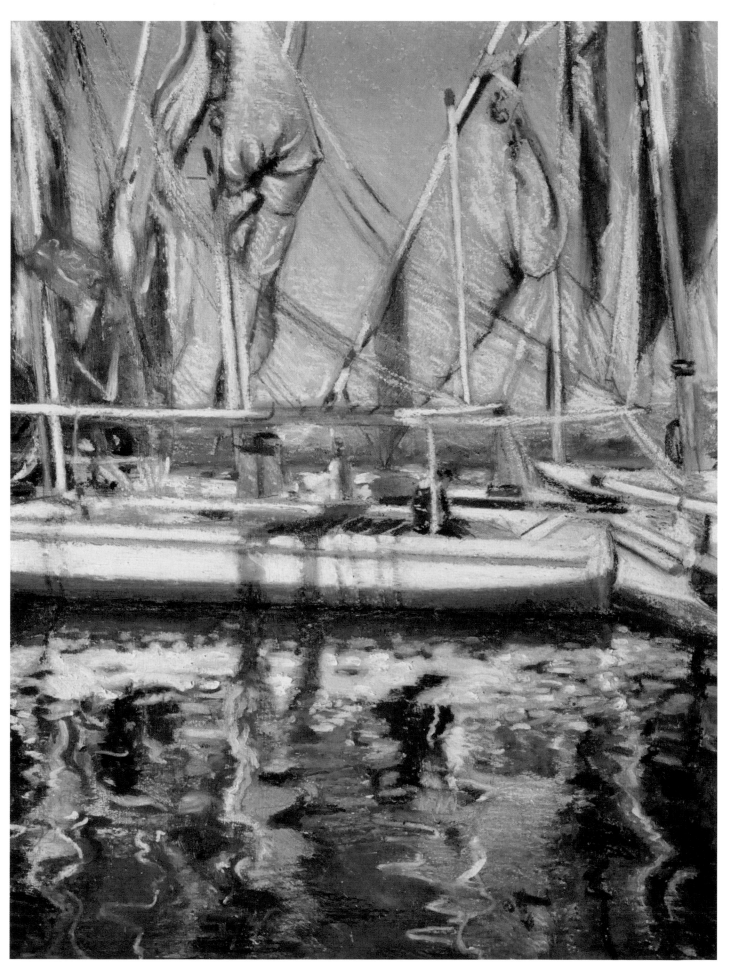

Step Nine In the last step, I add black in the foreground, but I am careful not go too heavy. I pumped up the opacity and thickness of the colors, adding little specifics like ropes, small shadow shapes, and smaller details.

Gondola

When I took a trip to Venice, I hoped to capture and convey the feeling of solitude and romance. It took some searching, but I finally found the perfect moment of history, beauty, and silence. Except for the water lapping against the bricks and foundation of the ancient city, everything was still and serene. The strong contrast and textural diversity worked together to make this moment magical and give this image strength.

Creating a Compositional Study For this project, I focused on the Venetian gondola as a compositional study. I utilized the space division based on the Golden Section—an approximate ratio of 0.618 to 1.000—and placed the center of the two columns so they would intersect with the front of the gondola at the critical point. Throughout history many artists have used this approach to composition.

Color Palette

Matte medium
burnt sienna acrylic paint

OIL PASTELS:
Vandyke brown
Prussian blue
green gray
black
gray
olive gray
yellow
brown
ultramarine blue
deep green
orange
white
olive brown

Step One I began with my construction drawing. This can be sealed with fixative if you wish, a process that will help prevent the oil pastels from smudging. For this project, I used gessoed rag paper, with a taped off picture area that measured 13 by 17.5 inches.

Step Two I toned my drawing and paper with a transparent mixture of matte medium and burnt sienna acrylic paint. Make sure to do this in a few layers, rather than just one, and concentrate some color on the bricks. This will make the brick wall easier to do later.

Step Three Using Vandyke brown, I grouped and separated the shadow shapes. At this point, it was important to strive for even tone and to layer my marks with crosshatching. I also blocked in the darks.

Step Four At this step, I added Prussian blue over the shadow shapes and blended with my finger. With green gray, I colored in the water and smudged with my fingers. Then I was able to crosshatch over the shadows that were cast upon the water.

Step Five Using a lot of pressure, I liberally layered black on the gondola until I could smudge the thick oil pastel. Then with gray, I made my way through the piece, addressing parts of the gondola and smudging with my fingers. Next, I continued up the wall, using a kneaded eraser to correct mistakes. I scraped with a palette knife to remove any unwanted pigment. I pushed the gate back with a smudged layer of Vandyke brown.

Step Six In this step, I layered olive gray on top of the cement sections of the wall and the post, then blended with gray using my fingers. I added a little yellow for the gold trim on the gondola, the vase, and in the post. With brown, I began to focus on the bricks, using a heavier saturation at the top and gradually decreasing toward the bottom, where the color is more neutral. I blended in selected areas with my finger, but left a lot of the image rough.

Details

Step Seven Here, I started by adding a little deep green for the base of the flowers, then orange for the flowers themselves. I also used orange on the gondola handle. White and ultramarine blue were used to bring form to the water. Next, I blasted white throughout the drawing—a fun part of the process. I carefully layered marks, creating opacity on the gondola, the wall, and throughout the drawing.

Notice how the olive brown and white created a lighter value from the color of the bricks underneath. This increased the appearance of the directional light coming from above. Strong light patterns create form and depth in observational art.

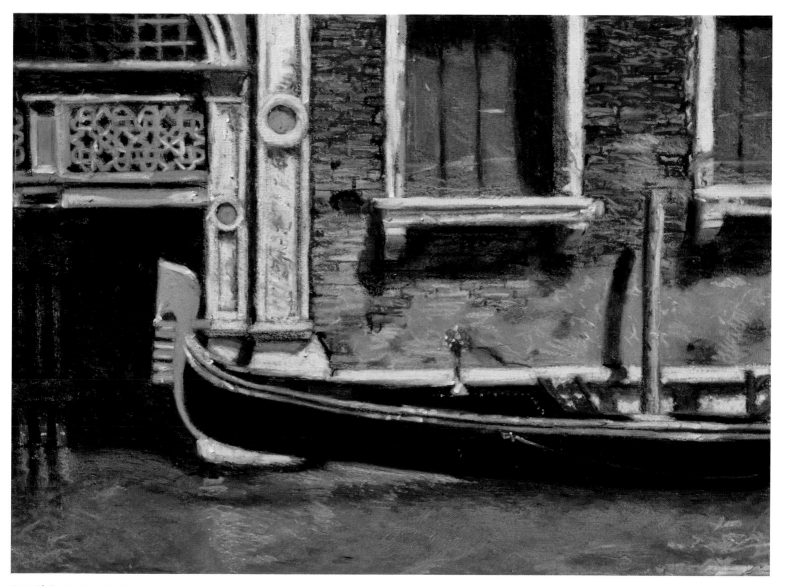

Step Eight Finally, with olive brown, I added some warmth into the top of the bricks. Using black, I focused on the dark sections and the cracks. At this point, I made my final corrections with all the colors used thus far.

In this detail you can clearly see how adding black into your darkest darks will increase form. This is used to clarify your drawing, to add detail, and to show the true contrast of the sunlight. Always strive for elegant mark making.

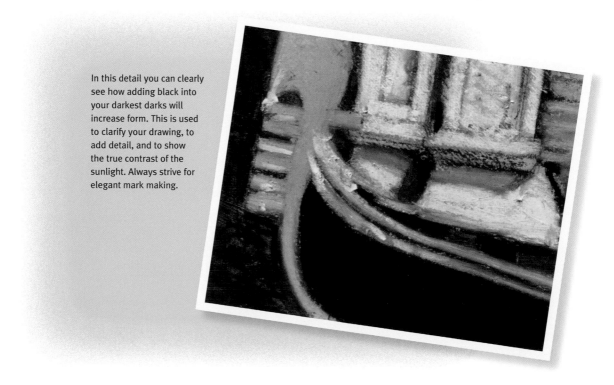

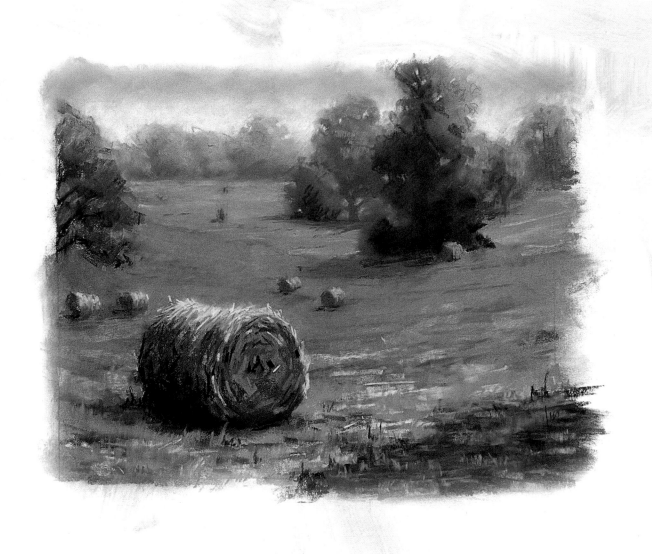